Ian Jeffrey
read history at Manchester University
and studied Italian Renaissance art at the Courtauld Institute,
London. He lectured and was head of art history at the
University of London Goldsmiths' College (1970–87). His
other books include *Landscape* (1984), *The British Landscape
1920–1950* (19
*Photographs from Russia by Boris* ...
organized a n...
Great Britai...
Gallery, 197...
origins

Printed in Singapore

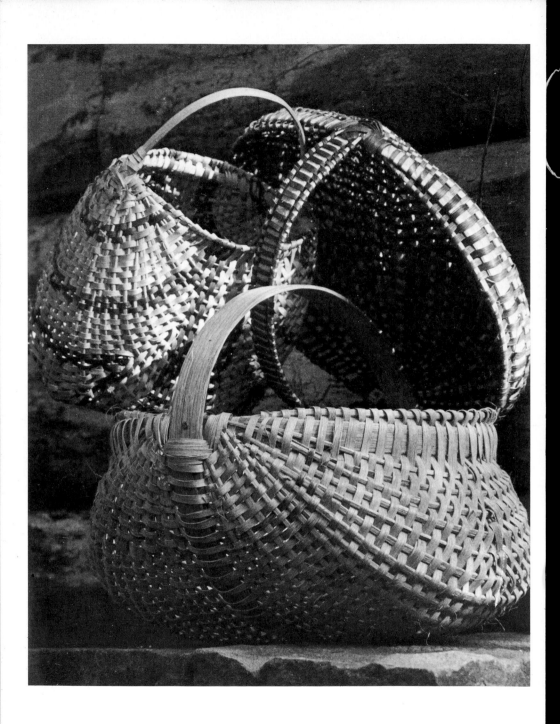

IAN JEFFREY

# PHOTOGRAPHY

## A Concise History

*136 illustrations, 8 in color*

## THAMES AND HUDSON

I wish to acknowledge financial assistance for travel and
research in the preparation of this book from the Arts Council
of Great Britain and from the Research Committee of the
University of London Goldsmiths' College. I am also grateful
to Dorothy Bohm, Michael Hoffman and Alan Trachtenberg
for help and advice, and to the Photographers' Gallery and the
Victoria and Albert Museum for their assistance over a
number of years.

IAN JEFFREY
Rodmell, Sussex
March 1981

© 1981 Thames and Hudson Ltd, London

Published in the United States of America in 1985
by Thames and Hudson Inc., 500 Fifth Avenue,
New York, New York 10110
Reprinted 1996

Library of Congress Catalog Card Number
88-51227
ISBN 0-500-20187-0

Printed and bound in Singapore

*Frontispiece:* 1  DORIS ULMANN "Baskets" Possibly
taken in 1933–34 when the photographer was
working in Virginia and Kentucky on a survey of
southern handicrafts. Fifty-eight photographs from
this project were published posthumously in
*Handicrafts of the Southern Highlands* (New York
1937).

# Contents

# Introduction

THERE ARE DIFFICULTIES involved in writing a survey-history of photography. There is, it is true, a generally agreed photographic canon, which includes the work of Alfred Stieglitz, Paul Strand and Walker Evans in the United States, August Sander in Germany, Eugène Atget in France and Bill Brandt in Britain. But no one could claim with any confidence that we know all of the major photographers who have ever worked, or that we ever will. Whole careers have been cancelled out, disposed of when photo-agencies, archives and newspapers have rationalized or moved house. Sometimes such bodies of work are relocated and assessed, but whole swathes of the photographic past have been lost for ever.

Collectors and historians of photography have also discriminated against certain kinds of practice. Architectural photography, for instance, has only recently begun to shoulder its way into a position of respectability. In 1978 the Rheinisches Landesmuseum in Bonn exhibited pictures from the twenties and thirties by Werner Mantz, only one of many distinguished architectural photographers from that era. Photo-journalists have also been consistently overlooked, especially if they worked for local newspapers or for the mass-circulation press. Few of them had the time or inclination to tend their reputations as artists. They also worked constantly against the pressure of deadlines and, as a result, their negatives vanished into archives from which, in some cases, they never emerged again. Among their number are some outstanding artists: James Jarché, for instance, one of Britain's most resourceful picture-makers during the 1930s.

Other difficulties arise. There is the question of photography's basic unit of account, which historians and commentators have commonly understood to be the individual photograph – as though photographic history was the history of painting writ small. Yet not all photographers thought of their work in this way. They took pictures to go alongside texts, or to be set in sequences and groups, where the arranging was done by a picture-editor. Thus 'the photographic work' can as easily be a book or photo-essay as an individual picture. One of the supreme achievements in the medium is Walker Evans's book *American Photographs* (1938). Separately Evans's pictures are handsome and interesting; together, in the order chosen for them

by Evans and his advisers, they add up to a major work of art. It is, however, relatively difficult to see one's way back to the beginning, for pictures are frequently republished in new formats and contexts. Material which never before saw the light of day is introduced, handsomely printed; dull careers, through judicious editing, are given startling new looks. In Europe and America photographic archives provide us with a wealth of raw material from which we ceaselessly construct new pictures of the past, often as an idyllic time with many lessons to teach an imperfect present.

Nor has there ever been a mainstream in photography, only strong currents evident here and there for brief periods. Around 1900 there was, for a time, an international movement in which Europeans and Americans participated, influencing each other through exhibitions and illustrated journals. In the late twenties there was another moment of internationalism, during which Germans, French, Russians and Americans shared a common style and a common interest in architecture and design. There have also been vigorous local movements, such as that sponsored by the Farm Security Administration in the United States during the 1930s. But photography never advanced on a broad front, and some of its outstanding exhibits are the work of isolated artists, content to persevere with the styles they assimilated in their early years.

Photographers took their cues from many sources. Pioneers, the Frenchman Charles Nègre for example, sometimes turned from painting to photography in a search for new markets. They experimented with many different subjects and their work can often look inconsistent, even erratic. The art photographers of 1900, by contrast, drew heavily on the example of such symbolist painters as Puvis de Chavannes. Indeed much of the ambitious photography of the nineteenth century depends on the examples of painting and etching. Their contemporary and successor Eugène Atget, the great documentarist of Paris in the early years of this century, continued a practice of architectural recording established in the 1850s, but wrought miraculous changes within that practice – changes which were the work of his own genius. British photo-journalists of the 1930s often seem to belong to cartooning rather than to reportorial traditions. French 'human interest' photographers of the same era and after belong to a local history, in which the film-makers René Clair and Jean Renoir are innovators and major participants.

Photography, a flexible medium, has followed every twist and turn of market and ideological forces since it was developed in the 1840s. It would be possible, and perhaps justifiable, to write a history in which individuals scarcely appear, one in which credit is given to impersonal ideological

determinants. Such a history would be centrally concerned with news, advertising and fashion, and would be both fascinating and intricate; it would also be concerned with non-visual matters, opinion forming and social control. I have not written such a history, but have chosen to focus, in the main, on those photographers who have both sustained and supplemented (and even sometimes contradicted) photography's dominant modes.

Colour too presents problems within any history of photography. It seems for the most part to be peripheral, to play scarcely any part in photography's major movements. Yet from the beginning of this century colour pictures were a possibility. The autochrome process, developed by the Lumière brothers in 1903, put on the market in 1907 and used until 1932, allowed such photographers as J. H. Lartigue to make images of great serenity. This seems VIII to have been the strength of colour and also its flaw. Polychrome worlds are both radiant and genial. They easily imply atmosphere and suggest immediate access to that place with its weather. Few photographers were so untroubled or readily satisfied by the glowing surfaces of things. Monochrome promised insights, visions of reality purified; or it allowed photographers freedom from the contradictory richness of full colour, and a means towards emphasis and control – advantages not lightly sacrificed. Nevertheless, colour photography has its achievements. Lartigue's autochromes of the twenties embody luxury and ease as few other images do. John Havinden, in Britain during the thirties, explored volume and weight IV in colour pictures which deserve to be considered with the best of British art at that time. Even so colour plays a relatively minor part in the history of photography as an artist's medium until the recent past, that is.

## Seeing Nature

*Discoveries by Fox Talbot and Hippolyte Bayard*

PIONEER PHOTOGRAPHERS found themselves faced, from the outset, by a serious problem – that of their medium's automatism. Photography, referred to at that time and subsequently as an invention, was more accurately a discovery of nature's capacity to register its own images. This was reflected in names and terms coined to describe the new process. Camera images were called 'sun pictures' and said to be 'impressed by nature's hand'. Whereas earlier pictures were made or willed into existence, photographs were 'obtained' or 'taken', like natural specimens found in the wild.

Photographers were involved in a partnership with nature. At the same time they were artists, and both they and their audiences were familiar with well-established traditions of picture-making. Nature had somehow to be curbed and brought into line with tradition. Thus the pioneers looked for phenomena which appeared to be already composed; they were especially attracted by symmetrically branching trees and by reflections – ready-made compositions. Then, to give meaning to their pictures, to make sure that they amounted to more than random notations by 'the pencil of nature', they began to make use of the suggestive powers inherent in signs and symbols. Thus emphases could be made, attention restricted and understanding guided. Picture-making itself also became a subject. Working with a medium which called so much in art and representation into question, photographers found themselves attending, even if in passing, to the special conditions which obtained in their medium.

These considerations are evident from the beginning, in W.H. Fox Talbot's photographically illustrated book of 1844, *The Pencil of Nature*. Fox Talbot, an English scholar and scientist who had developed the negative-positive process of photography in the late 1830s, published his famous book serially between the summer of 1844 and the spring of 1846. It includes twenty-four mounted photographs, each with an accompanying text.

Compared with much that comes later *The Pencil of Nature* is uneven, as though its author was in several minds as to what constituted a saleable photographic book. He proceeds at random, turning from a view of a corner of Queen's College, Oxford, to the boulevards of Paris, and then on to articles of china, glass and statuary. A picture of a haystack follows a facsimile

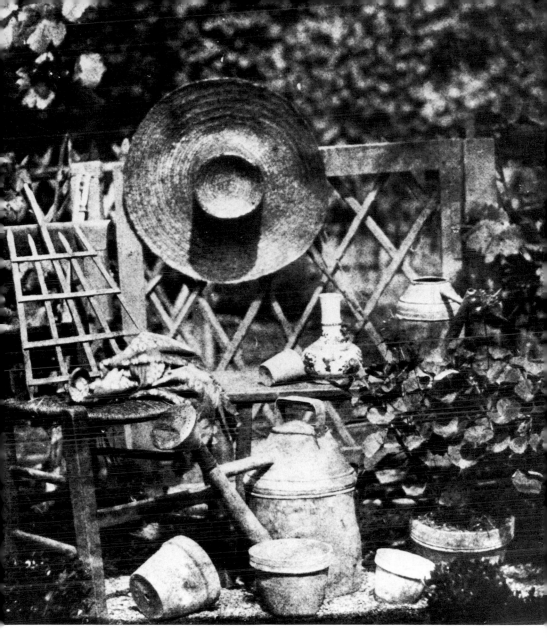

2   HIPPOLYTE BAYARD 'Garden Tools and a Straw Hat' 1843 or 1844. One of
Bayard's photographs from a negative.

of an old printed page. Lacock Abbey, Fox Talbot's home in Wiltshire, makes several appearances. The book tails off with a view of the swarthy towers of Westminster Abbey, a copy of a drawing of *Hagar in the Desert* from an original by F. Mola, and 'A Fruit Piece' of apples and a pineapple in baskets on a table top.

His commentaries are just as uneven – no more, in some cases, than desultory remarks. His principal theme is photography, its possibilities and difficulties, but he also writes at length on the history of Lacock Abbey, founded by Ela, Countess of Salisbury, widow of William Longspee, son of King Henry II and Fair Rosamond. *The Pencil of Nature* is by turns a romantic family history, an advertising brochure, antiquarian tract, guidebook, news sheet and rudimentary technical treatise. Fox Talbot imagined an audience with varying interests like his own.

He was also prompted by the photographs themselves, which raised distracting questions. They depicted Parisian boulevards, Oxford byways and majestic ruins, but with the main matter came a mass of telling minutiae, incidentals which had to be accounted for. With his first selection, a part of Queen's College, he felt obliged to comment on damaged stonework: 'This building presents on its surface the most evident marks of the injuries of time and weather, in the abraded state of the stone, which probably was of a bad quality originally.'

He relished these incidentals. They provided mysteries to be deciphered. In front of 'View of the Boulevards at Paris', the second picture in the set, he went to work in earnest, and his commentary is worth quoting at length, for it shows just how tangential photography might be without proper control:

This view was taken from one of the upper windows of the Hotel de Douvres, situated at the corner of the Rue de la Paix.

The spectator is looking to the North-east. The time is the afternoon. The sun is just quitting the range of buildings adorned with columns: its façade is already in the shade, but a single shutter standing open projects far enough forward to catch a gleam of sunshine. The weather is hot and dusty, and they have just been watering the road, which has produced two broad bands of shade upon it, which unite in the foreground because, the road being partially under repair (as is seen from the two wheelbarrows, etc. etc.), the watering machines have been compelled to cross to the other side.

By the roadside a row of cittadines and cabriolets are waiting, and a single carriage stands at a distance a long way to the right.

A whole forest of chimneys borders the horizon: for, the instrument chronicles whatever it sees, and certainly would delineate a chimney-pot or a chimney-sweeper with the same impartiality as it would the Apollo Belvedere.

And that was just the trouble: fascinating irrelevancy. 'Sometimes inscriptions and dates are found upon buildings, or printed placards most

3   WILLIAM HENRY FOX TALBOT 'A View of the Boulevards at Paris' 1843. A salt
print from a calotype negative. Plate II in *The Pencil of Nature* was taken from
much the same angle, but from a higher level in the same building.

irrelevant, are discovered upon their walls: sometimes a distant sundial is
seen, and upon it – unconsciously recorded – the hour of the day at which the
view was taken.' To judge from his commentaries, Fox Talbot enjoyed such
incidentals. At the same time, though, they were troublesome, for they
meant that the instrument was only partially under control, recording
disinterestedly in despite of its operator's intentions. How, in this case, could
photographers lay any claim to be artists? And how disconcerting for 'the
spectator'. Expecting a view of Paris the photographic audience finds instead
a scene to be deciphered, a matter of road repairs, hot weather, water carts,
cabriolets and a mysterious solitary carriage. Such pictures as that of the
boulevards at Paris demand careful attention, raise question after question,
and settle very little. They presuppose an active and enquiring audience.
Principally they are disconcerting in that they reveal an unexpected

fascination in the small print of daily life. We go to admire major monuments and find ourselves entranced by what is commonplace and peripheral.

Fox Talbot, perhaps nervous of the disturbing implications of this side of photography, published few pictures of this sort. They do, however, occur in his unpublished work. In 1843, for instance, he photographed in the Place de la Carrousel in Paris, and two of these negatives survive in the collection of the Science Museum, London. They show a paved square leading to an intricate range of buildings, their gable ends a mosaic of advertising placards. He then shifted his position to take an overlapping picture of the square. Gable ends and placards recur, but from one moment to the next there have been subtle alterations, signs of life, movements in the street.

Lured by hallowed reputations, photographers stationed their instruments in front of abbeys, castles, palaces, beauty spots – and came away with untidy evidence of building projects, repair work, scaffolding, stonemasons' yards, street trade and tumbledown housing. At least they did so in the beginning, before they learned, or felt compelled, to control and to suppress. The first French photographic book appeared in the early fifties, before the medium had been brought to order. Entitled *Album photographique de l'artiste et de*

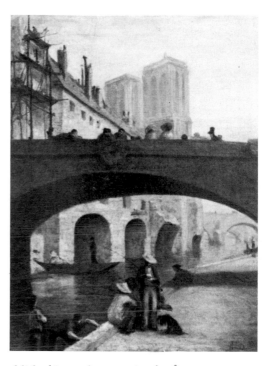

4 ANONYMOUS 'The Apse of Notre-Dame, 8 December 1852' The eighth of thirty-six illustrations in Blanquart Évrard's *Album photographique de l'artiste at de l'amateur* (1852).

5 HONORÉ DAUMIER *Vue du Pont Saint-Michel et de l'Hôtel-Dieu à Paris: dans le fond, Notre-Dame* Oil painting on canvas, c 1840 (Musée Calvet, Avignon).

*l'amateur*, it includes thirty-six pictures published in twelve parts by the firm of Blanquart Évrard in Lille. It is as heterogeneous as *The Pencil of Nature*, including pictures of a wax head attributed to Raphael, Hindu temples, Muslim architecture in Delhi, Van Eyck's *St Barbara* in Antwerp, and Roman painting in Naples. The eighth picture in this set, dated 8 December 1852 and unattributed, is of the apse of Notre-Dame. At least the apse of Notre-Dame appears in the distance. What fills the picture is a long row of delivery carts parked along a kerb in the foreground. To the right an unsteady sign on an awning reads *commerce*. Working early in the morning, this anonymous photographer intent on Notre-Dame has ended up with evidence of routine commercial life in the city. Other photographs of the castle at Falaise, 'cradle of William the Conqueror', and the market place at Ypres are similarly encumbered by disorderly incident.

Photographers quickly became wary of this irreverent capacity in their medium. Conscious of pictorial propriety, they learned to compose, to edit and to avoid many of those distracting irrelevancies to which Fox Talbot referred. If anyone explored this informal option touched on by the photographers, it was Honoré Daumier, the Parisian lithographer and painter, a notably secretive and subversive artist. His paintings, in particular,

are comparable to instantaneous documentary pictures of our own century: they feature hurrying, commonplace incidents in the streets, quaysides and alleyways of Paris. At times his arrangements bring pioneering photographs to mind. In a picture of *Notre-Dame* (Musée Calvet, Avignon) of the late 1830s he made use of just the sort of inverted structure found by Blanquart Évrard's cameramen: the cathedral stands as a remote silhouette beyond a foreground peopled by the same idlers as crop up in the foregrounds of early photographs.

Daumier, a sharp critical observer of his society, notes a gap and a tension between official culture and street life. Photographs, made without due attention, could easily provide similar evidence, and for this reason they were shunned. For the remainder of the century photographers concentrated on publicly approved subjects: well-ordered views of hallowed sites, seascapes, celebrity portraiture and majestic still-life arrangements. The times were unprepared for those unsettling, unprecedented questions posed at the outset by Fox Talbot and his contemporaries as they struggled to come to terms with their disrespectful equipment.

Subversive, or inadvertent, documentary, indeed, only accounts for a fraction of pioneering photography. To look through any collection of work from the 1840s is to realize that Fox Talbot did most of his picture-making at home, and little of it out on the streets. Hippolyte Bayard, another major experimenter, took pictures in and around the byways of Montmartre but he, like Fox Talbot, made some of his most intriguing photographs in the privacy of his own grounds.

6  E. BENECKE 'Un des Cèdres de Salomon sur le Mont Liban' (One of Solomon's Cedars of Lebanon) No. 34 in Blanquart Évrard's *Album photographique de l'artiste et de l'amateur* (1852).

7  FÉLIX TEYNARD 'Abou- ▷ Simbel. Partie Centrale de la Façade' Plate 50 in Vol. II of *Égypte et Nubie. . . . Atlas photographié* (Paris 1858).

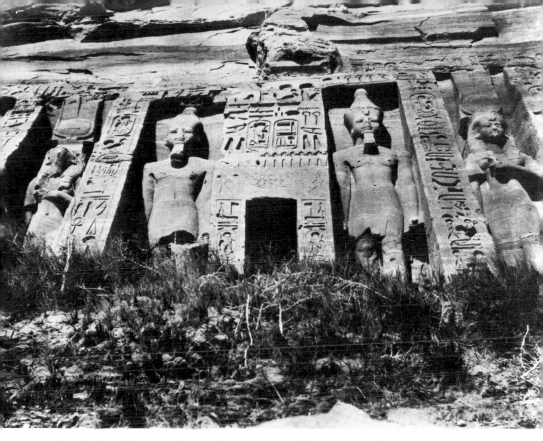

Beached sailing craft, rudimentary buildings, workshops, farm
implements and groupings of such prosaic items as ladders, baskets and
garden tools crop up again and again in this early work. Sometimes Fox
Talbot, and others, ventured further afield to take pictures from nature. In
particular they photographed trees, isolated trees rather than thickets and
woodlands. These were studied less for their organic properties than for the
sake of those patterns which branches make against light skies or against
darkened grounds. In 1851–52 a French civil engineer, Félix Teynard,
travelled up the Nile into Nubia to record ancient architecture. In the mid-
fifties Goupil and Company in Paris published his imposing *Égypte et Nubie.
Sites et monuments les plus intéressants pour l'étude de l'art et de l'histoire. Atlas
photographié.* Teynard, one of the most severe of all architectural
documentarians, rarely turned his attention from the geometries of cut stone.
He turned aside only to photograph riverside palm trees, to which he was
drawn, as he explains in a commentary, because of regular, symmetrical
divisions in their branching. In 1852 another French traveller, Édouard

17

Benecke, photographed a Cedar of Lebanon, No. 34 in Blanquart Évrard's *Album*. This tree makes the same sort of ordered showing which Fox Talbot had found in a fan-shaped group of oaks at Carclew Park in Cornwall. Fox Talbot came across other, naturally produced, compositions in bands of trees reflected in water. Thus nature was searched for its own compositions. The world out there was shown to be arranged, and not merely a random continuum. By taking advantage of nature's own compositional capacities photographers tried to deny what their medium readily suggested – that things simply cropped up.

It is this same search that accounts for photographers' sustained involvement with architecture. Buildings invariably display a high degree of patterning, symmetry and purpose and suggest a widespread impulse to composition and meaning, which stands against those implications of chaos which photographs insinuate. Teynard sought such assurances. His book, of which few copies seem to have survived, is a most scrupulous document, dedicated to the age of the pharaohs which he considered 'la belle époque', succeeded by Roman decadence and Christian barbarism. His Egypt is an austere place apart, an alternative world virtually of his own choosing and making. Teynard was the first photographer to use the medium in this way. He had many successors: artists who in series and sets of photographs constructed composite pictures of preferred worlds from those fragments of reality delivered up to them by the camera.

Whilst Teynard was examining Egypt his contemporaries Gustave Le Gray, Édouard-Denis Baldus and Henri Le Secq were engaged in a project to document the threatened architectural heritage of France. They were appointed in June 1851 by the Comité des Monuments Historiques and asked to photograph main façades of endangered buildings and some selected details. Other commissions followed during the 1850s, which became an outstanding decade for architectural photography. In 1852 Charles Nègre, an independent photographer, began a survey of the Midi, its monuments and scenery. By early 1853 he had completed 200 negatives; although the project was unsuccessful when he attempted publication in 1854, it was innovative. Nègre was the first photographer to concern himself with the totality of a region, its ancient and modern buildings, ports, coastlines, landscapes and local industries. Nonetheless it is mainly a survey of architecture, for buildings are the principal visible traces of passage left by man. Nègre's subject, however tentatively, was society. It was a subject which would increasingly absorb photographers, and which eventually culminated in the New Photography of the 1920s.

The other great architectural photographer of this first phase was Maxime

8 MAXIME DU CAMP 'The Eastern Part of the Peristyle of the Temple of Rameses – Meiamoun. Medinet-Habou (Thebes)' Plate 51 in Du Camp's *Égypte, Nubie, Palestine et Syrie* (Paris 1852: from photographs taken in 1849–51).

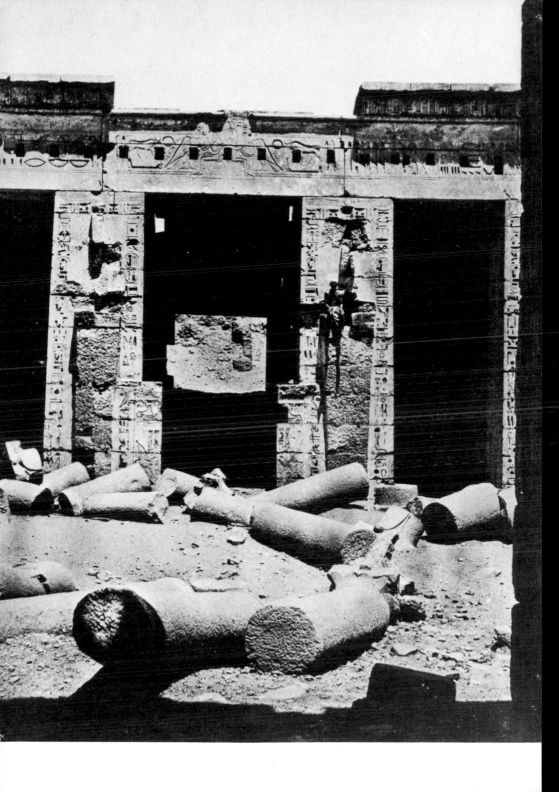

Du Camp, whose *Égypte, Nubie, Palestine et Syrie. Dessins photographiques recueillis pendant les années 1849, 1850 et 1851* was published in 1852 by Gide and Baudry in Paris. Du Camp's Egypt is altogether less rigidly pictured than Teynard's. Like Fox Talbot and Bayard his attention was held equally by his ostensible subjects and by photography's ways of picturing those subjects. In anticipation of Teynard he aimed to be exhaustive, covering major sites from many angles. At times, though, his photographs of intricate ruins are exceptionally baffling. He seems to have preferred to work from directly frontal viewpoints, from which the depth of buildings is difficult to gauge. Interior details, further walls and columns, can only be surmised in some of his pictures, from hints given by cast shadows. His photographs have to be scrutinized and exact configurations carefully deduced. He also made exceptional studies of low-relief sculptures, which he pictured as schematic drawings traced out by dark bands of shadow on sunlit walls. At midday in Egypt the sun made bold marks: marks traced with relish by the pencil of nature.

Pioneer photographers sometimes arranged their pictures. One of the most successful, or widely known and reproduced, of these arrangements is 'The Open Door', Plate VI in *The Pencil of Nature*. It features a broom, horse-harness and lantern placed around a darkened threshold. Together they have the look of portentous elements in a rustic tale. Fox Talbot comments thus on 'The Open Door':

This is one of the trifling efforts of its [photography's] infancy, which some partial friends have been kind enough to commend.

We have sufficient authority in the Dutch School of art for taking as subjects of representation scenes of daily and familiar occurrence. A painter's eye will often be arrested where ordinary people see nothing remarkable. A casual gleam of sunshine, or a shadow thrown across his path, a time-withered oak, or a moss-covered stone may awaken a train of thoughts and feelings, and picturesque imaginings.

Implicit in this sentimental account of his composition is a reflection on that question of how a picture might be made out of a photograph. Fox Talbot, writing to guide his audience, shows how 'The Open Door' is intended. Its simple elements are there less for their own sake than for the sake of those 'picturesque imaginings' to which they give rise. This photograph, by means of significant details, merely suggests, and memory does the rest. Lantern, broom and halter all readily carry associations. They stir memory, and thus the impoverishment of a photographic moment is mitigated. A synthesis of sorts is achieved against the grain of a medium which deals exclusively in instants.

'The Open Door' is a stage waiting to be peopled. The lantern awaits

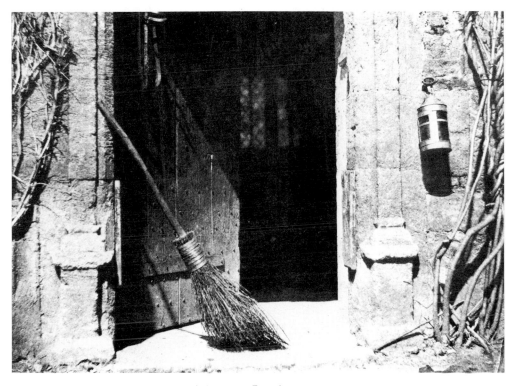

9　WILLIAM HENRY FOX TALBOT 'The Open Door' Plate VI in *The Pencil of Nature*
(London 1844).

darkness, the broom a user, and the doorway an occupant. Fox Talbot,
hampered by his medium, is not at liberty to show his story through to its
conclusion. Instead he signifies absences, and indicates just how those
absences are to be completed in imagination. Such significant and suggestive
elements are staples in photography, both because they extend the possible
meanings of pictures, and because they restrict and guide interpretation.

Something more of the working out of this problem can be seen in the
early 1850s in albums by John Dillwyn Llewelyn, a distinguished
photographer and relative of Fox Talbot, from Penllergare in South Wales.
Dillwyn Llewelyn left a full and idyllic record of upper-class family life. His
albums include pictures of sand, pools and steep rocks along the seashore.
Often these show discreet traces of human involvement: creels and fishing
nets usually. Such elements give indications of scale, but they are also
pictorial cues, suggesting how these scenes might be interpreted. Landscapes
rich in geological evidence are thereby qualified; the seashore presented in

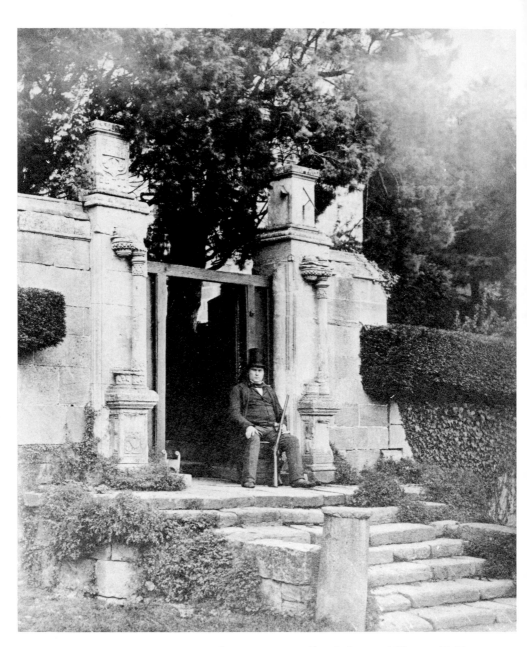

10 PHILIP H. DELAMOTTE and JOSEPH CUNDALL Frontispiece to *A Photographic Tour among the Abbeys of Yorkshire* (London 1856).

this way becomes the seaside, a place for shrimpers rather than for naturalists. As Fox Talbot noted, cameras record disinterestedly. Without guidance or some sort of emphasis, what are we to make of their findings? Hence such restricting elements as these baskets and nets on Dillwyn Llewelyn's coastline.

By the 1850s, though, photographers were becoming adept in such matters. They were beginning to rely on a pictorial code, the chief element in which was a marker figure gazing at or resting among monuments. In addition to giving pointers to scale, such figures indicated that the subject, abbey or wooded vale, was primarily a site for reverie rather than detailed examination. Remote figures, seated, reading or scanning the distance, spoke of awe and reverie. Turned towards the camera, they signalled a closer, practical relationship with their setting. This pattern was established in England by 1856 and can be seen, in that year, in *A Photographic Tour among the Abbeys of Yorkshire* by Philip H. Delamotte and Joseph Cundall. Their tour took in Fountains Abbey, Bolton Priory and other ruins 'celebrated in romance and poetry'. The first of their twenty-four pictures features a stern custodian seated with a shotgun by an estate entrance. Practically involved, he confronts the camera, as do other estate workers later in the series. Meanwhile, literary tourists, grave in top hats and dark coats, muse as though oblivious of the camera. This system seems to have suggested itself from the outset: Fox Talbot's gentlemen-sitters, in unpublished pictures, maintain themselves thoughtfully in worlds of their own; his estate workers hold themselves upright and face the lens, as specimens in their master's woodyards. By the 1860s these schemes were in common use. Photographers relied increasingly on such formulae, and as risk and uncertainty receded cliché entered.

In the 1840s, though, there were few models to be imitated. Photographers pleased themselves, followed their own intuitions. Justifying 'The Open Door', Fox Talbot referred to Dutch painting. It does look like a section from a painting by De Hooch or by Hoogstraten. But what might he have said of other compositions in this vein? He, like Hippolyte Bayard in France, photographed assemblages of garden tools. So, too, did Dillwyn Llewelyn. At one level these arrangements are no more than illustrations of country life. Early photographs often refer to labour and handwork. Either the boulevards are under repair, or the cathedral is encumbered by scaffolding. Nineteenth-century business, to judge from photographic evidence, was carried out in improvised circumstances, amidst heaps of cut stone and lumber. There is, however, something more than illustration involved in these assemblages of wicker baskets, rakes, brooms and spades. In

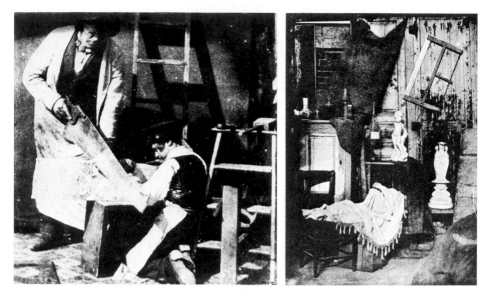

11   WILLIAM HENRY FOX TALBOT 'Carpenters on the Lacock Estate' *c.* 1842.
12   HIPPOLYTE BAYARD 'Studio' A corner of Bayard's atelier: a print from a negative, *c.* 1846–48.

part their import is metaphoric: they refer to artists' as well as to journeymen's work. Fox Talbot and Bayard insist on handiwork, on the kind of manual operations implied a century earlier by Chardin in his paintings of foodstuffs readied on slabs and kitchen tables. Chardin pointed to affinities between the work of the painter and the work of the cook, between art and everyday life. Fox Talbot's pointers to handicraft are, if anything, more marked. Yet there is something perverse about this insistence on the part of an innovator whose new process looked set to do away with those manual operations traditionally involved in picture-making. It is as though he was preoccupied by the very practices challenged by his invention – Fox Talbot, who had stressed in his introduction to *The Pencil of Nature* that his pictures were 'formed or depicted by optical and chemical means alone . . . impressed by Nature's hand . . .'

  Photography was mysterious, a hybrid difficult to situate. It resulted in artefacts, in pictures which resembled those of the Dutch School; yet, on the other hand, these pictures came into being 'naturally'. Inevitably this very obvious paradox became part of the subject matter of early photography. Hence Fox Talbot's attention to the primitive operations involved in handwork. His joiners and gardeners are unmistakably fabricators who belong to that old order of making which precedes photography's

automatism. Hence, too, other photographs which juxtapose tools, artefacts, buildings and inchoate nature: implements by a hedgerow, verdure overhanging the precise half-timbered lines of farm outhouses. Which is to say that he refers to that distinction between nature and culture which photography had newly called into question.

Hippolyte Bayard, as intriguing an artist as the Englishman, also composed with whatever came conveniently to hand. Bayard's fame is that of a 'forgotten pioneer'. He was the first to exhibit photographs in public, in July 1839, but unfortunately his was a direct positive process, inflexible by comparison with Fox Talbot's invention. In France he was overshadowed as an inventor by Daguerre. Nonetheless, using Fox Talbot's process in the 1840s, he took outstanding pictures. They, too, have photography as their subject, even if they seem to be, at first sight, as diffident as Fox Talbot's improvisations. Bayard took a number of pictures of windmills on Montmartre. Such picturesque local sights might be expected to attract any photographer, but Bayard looked to Montmartre less for quaint archaisms than for pointers to photography's time-bound condition. The sails of his mills alternately blur and stand in outline against the sky, as evidence of an extended moment. Equally they point to those local conditions of air and atmosphere which photography at that time could only cope with by means of signs. Looking at his three mills on the ridge of Montmartre we know what sort of conditions obtain, or at least we can calculate those conditions. In other words, photographs also need to be deciphered.

Indeed, many of Bayard's photographs seem to have been arranged to invite decipherment. At the very beginning he photographed heterogeneous collections of statuettes against dark draperies. Perhaps they were no more than studio props or convenient ornaments – anything to make a picture. But these statues, of varying sizes and supported at varying heights under strong top lighting, set quite elaborate visual problems. Scale gives one sort of information on depth, but that is promptly contradicted by other evidence. Smaller, and by implication distant, groups of figures rest on pedestals which Bayard's lighting system indicates to be in advance of those supporting their larger neighbours. Tasselled fringes make equally puzzling traces through these ambiguous ensembles.

Bayard composed with what came readily to hand, and the results look quite unlike any other art of that period. He anticipates such selfconscious picture-makers as the Cubists in that his photographs, like Braque's paintings, display a whole range of ways of picturing. Pale objects, frontally lit, facing the camera against dark grounds show themselves as negative silhouettes. Side-lit against light grounds they appear in the round. Flat

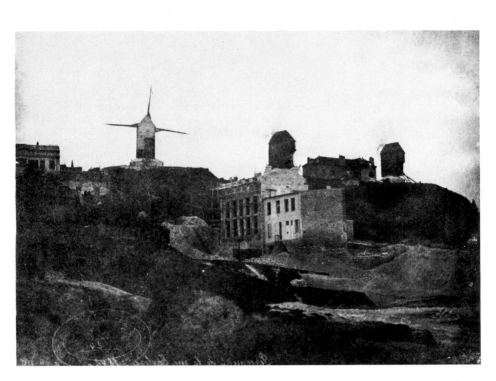

elements, a cross-cut saw in one composition, flat against upright surfaces, cast no shadows and show themselves diagrammatically. Other objects, angled against the light, cast shadows and thus appear in two versions.

Bayard's interest in analytical picture-making extended beyond the controlled environment of the studio. His architectural photographs juxtapose silhouetted sections and modelling in the round. One picture, of the Place J.-B. Clément, is especially intriguing. Rarely published, it is of a small basilica at the top of a flight of steps. Two lateral walls, a thickset building and a flight of steps: what could be more ordinary? But Bayard's camera is slightly off centre and this obscures one side of the stairway. Its dimensions can only be gauged by reference to a spectator looking into the scene from adjoining rough ground off to one side. Similarly the ground plan of the basilica can only be surmised from the evidence of its elevations visible over the further wall, beyond which the man peers. Bayard's preoccupation is with deductive seeing. He lingers over the facts of perception.

Demonstration pictures of this kind characterize early photography. The mode was not sustained. It is as though photographers had startled themselves and, for a while, been made acutely alert to seeing itself. Bayard and Fox Talbot, in particular, leave us in no doubt that we see, and that

13 HIPPOLYTE BAYARD 'The Cutting of the Rue Tholoze', 1842, with the three windmills of Montmartre. From a negative in the collection of the Société Française de Photographie.

14 HIPPOLYTE BAYARD 'Place J.-B. Clément' Undated, *c.* 1845.

seeing is an active process in which we check, compare and calculate. They exult in appearance. There is no other way of accounting for much of Fox Talbot's work. His great picture of 'The Haystack' (Plate X in *The Pencil of Nature*) is nothing more than a celebration of sheer presence, boldly charted by the sun's cast shadows which climb the trimmed gable of the ponderous stack.

Other artists at that time were as preoccupied by matters of presence and by the very act of seeing. In Britain, Pre-Raphaelite painters worked directly from the object, 'not merely for the charm of mere finish, but as a means of studying more deeply Nature's principles of design' – Holman Hunt on his painting of the *Rienzi*, 1849. In his *Isabella* of the same year J.E. Millais depicted Renaissance Florence as a many-hued paradise, where the senses are fully catered for. His protagonists, good and bad alike, are sentient beings who touch and stare and taste. Sight itself becomes the subject in his painting of *The Blind Girl* from 1856. In France the realist painter Gustave Courbet attended even more persistently to mere being, in painting after painting of those who watch, wait, concentrate, listen, rest and sleep. Contemporary photographers were far less wide-ranging. They attended to appearance, to the thing seen, to the act of vision and to its circumstances of time and light.

## Instantaneous Pictures

*Problems and advantages of instantaneity with reference to art, portraiture and topography, after 1850*

A PHOTOGRAPH may be a matter of moments, but at the outset these were long moments, minutes rather than seconds. During the 1840s and well into the 1850s the photographic moment was more schematic than instantaneous. Cast shadows against their objects gave the sun's position; clock faces and Fox Talbot's distant sundials told the time. Nature's more transient effects, swirling smoke, rippling water, blown clouds, failed to register. As a result such areas as Teynard's Egypt were doubly purified. Photography's insensitivity and Teynard's simplifying taste combined to present a world stripped of incidentals. His photographs, and those of Du Camp, are in this respect unnatural: they show only a residuum of stone and sand, and do no more than hint at ambience. To Teynard at least, devoted as he was to the purity of ancient architecture, this lack of sensitivity on the part of his medium must have seemed more of a strength than a weakness.

There were others who benefited from this discriminating capacity in early photography, in particular the Scottish portraitists David Octavius Hill and Robert Adamson. Hill was a landscape artist and book-illustrator. Adamson was a young photographer schooled in the process by his brother, a professor of chemistry at St Andrews University and friend of Sir David Brewster, who was Principal of that university. Brewster, a noted scientist, was in close touch with Fox Talbot. Hill and Adamson began their brief but very productive partnership in 1843. The occasion was a turbulent General Assembly of the Church of Scotland, during which 155 of the 907 assembled ministers broke with the established church. Hill determined to paint a collective portrait of the dissenters, and Brewster suggested that he make calotypes of his subjects before they dispersed to their congregations. The term 'calotype' was a new coinage by Fox Talbot: from the Greek word *kalos*, meaning beautiful. Edinburgh's professional calotypist was Robert Adamson. Their subsequent collaboration soon became a partnership in which Adamson took the pictures and Hill supplied the artistic direction. They worked together for four and a half years, until Adamson grew unwell towards the end of 1847. From their years together 1400 paper negatives have survived, although they probably took many more. Hill took very few photographs after his partner's death in January 1848.

15 ÉTIENNE CARJAT 'Honoré Daumier' Published in Goupil's *Galerie Contemporaine*, *c.* 1860. Daumier, the caricaturist, turned entirely to painting in 1860.

Rembrandt's was the name most frequently invoked by admirers of Hill and Adamson, and not without reason. Their portraits, marked by strong tonal contrasts, certainly look like those of Rembrandt, as well as having something of his spirit. Their sitters, ministers, physicians, engineers, scholars and artists, were eminent and, in many cases, honoured – and this is clear even without benefit of captions. The dissenting ministers, recently involved in heroic action, present themselves as formidable individuals, adamant, shrewd and learned. Likewise the professorial element, and the physicians. Hill's artist friends look, if anything, even more imposing; one or two have a pensive air, but most hold themselves like commanders in the field. However, what unifies this distinguished cast list and what sets these photographs apart is their spiritual authority. These notables of the 1840s seem to have fitted readily into the heroic roles imagined for them by Hill, the artistic director. Yet Hill was greatly aided by the medium itself, which dissolved material details and dramatized the action of light against darkness. His subjects emerge as creatures of the light, defined against a circumscribing darkness. In photography's next phase portraiture became very much a matter of coat buttons and fine fabrics, a matter of outward show. By contrast Hill and Adamson found a form for inwardness.

Hill's own assessment of their work was, however, quite modest. In a letter of 17 January 1848 he wrote: 'The rough and unequal texture throughout the paper is the main cause of the calotype failing in details before the Daguerreotype . . . and this is the very life of it. They look like the imperfect work of man . . . and not the much diminished perfect work of God.' Had the medium been capable of better definition, pictures of quite a different, and inferior, sort might have resulted; the sort of pictures which became increasingly common from the 1860s onwards. As it was, Hill and Adamson, fortunate in both their medium and material, created a unique portrait gallery of resolute individuals, exemplary citizens who came to epitomize independence and character to succeeding generations. The Hill and Adamson portraits meant at least as much in the 1930s as they did in the 1840s. They are photography's most reliable antidote to materialist values.

Adamson died. Hill turned his attention to painting. Photography evolved. In particular photographers began to look for technical improvements which might help them catch the moment in detail. Early processes were remarkably insensitive. In 1839 daguerreotype exposures could take between fifteen and thirty minutes, as Fox Talbot noted in a letter of 21 May 1852: 'Ld Brougham assured me once that he sat for his Daguerreotype portrait half an hour in the sun and never suffered so much in his life.' Daguerreotype times quickly reduced to between ten seconds and

16  DAVID OCTAVIUS HILL and ROBERT ADAMSON 'John Stevens, R.S.A.', with his sculpture *The Last of the Romans*. One of the fifty-two 'calotype portrait sketches, arranged by D.O. Hill and executed by R. Adamson', exhibited at the Royal Scottish Academy in 1845.

one minute, considerably in advance of the exposures of a minute or two required for paper negatives. By the early fifties, though, exposure times were down to a matter of seconds. On 31 May 1852 Fox Talbot wrote to Dillwyn Llewelyn: 'Pray accept the enclosed specimen which was taken the other day in 3 seconds by Henneman or his assistant. He sometimes succeeds in one second.' All this became possible thanks to publication in 1851 of Frederick Scott Archer's wet collodion process, in which negatives were made from a solution of guncotton dissolved in ether and applied to glass plates. An age of instantaneous photography was at hand.

Instantaneous photographs, miraculously, caught fleeting expressions and transient effects of light. Incidental details, once excluded, could now be registered – although still with some difficulty – and photographers were intrigued by this new capacity in their medium. In the summer of 1854 Dillwyn Llewelyn spoke of himself setting out determinedly to attack the 'restless waves'. He succeeded, and was awarded a silver medal at the Exposition Universelle in Paris in 1855 for a group of four photographs entitled 'Motion'. These had been exhibited in London in 1854, where they were described in this way by a reviewer:

17   JOHN DILLWYN LLEWELYN 'The Juno Blowing Off Her Steam, Tenby Harbour'.

18 JOHN DILLWYN LLEWELYN 'Clouds over St Catherine's, Tenby' c. 1853. One of four images submitted under the title 'Motion' to the Exposition Universelle in Paris in 1855. The set, which also included the picture opposite, was awarded a silver medal.

Mr Llewelyn, for example, has sent four instantaneous pictures, in one of which the seashore has been taken, with carts and persons moving upon it. Waves are caught with foam on them, and fixed while they are rolling; and the feintest trace of indecision in some walking figures shows that they could scarcely have completed one footstep before the picture was complete. Another picture represents the sea beating itself into foam against a rock, with flying clouds. Another represents a steamboat at a pier, and has fixed instantaneously the floating smoke and steam.

These remarkable images of vapour and breaking waves survive. Yet even after many generations of instantaneous photography they still look unusual, largely because they allot such an inferior place to man. Dillwyn Llewelyn, intent on clouds and drifting steam, reduces human involvement to a minimum. Figures in the distance blend with their settings. The pictures, with their display of large open spaces, sea and sky, have distinctly fatalistic implications, and are as disconcerting in their way as the inadvertent

documentary of the early forties. Instantaneity continued to preoccupy photographers, but thereafter they chose to keep it under control, to present man out of doors rather as a spectator than as a transient.

If photographers set store by instantaneity, it was not, certainly, to show Man as an ant-like creature insignificant among scudding clouds and breaking waves. In part the instant was pursued because it was attainable, photography's destiny. At the same time contemporary illustration had pointed the way. David Roberts's views of the East, lithographed and published between 1842 and 1855, were inaccurate when compared with photographs of the same sites by Teynard and Du Camp. Yet they were incontestably superior in several respects. Roberts's Egypt was a land of far horizons and wide spaces. It was also a land with atmosphere and weather – normally very fine weather, with crisp light under elegantly clouded skies. In this respect the artist's lithographs are as suggestive as they are informative. Detail is alleviated by atmosphere.

Despite a rush of technical improvements in the early 1850s, photography became sensitive to transient effects of light and movement only by degrees. Impressions of immediacy were difficult to win, and photographers were forced to improvise to gain anything of the naturalism achieved in lithographs. Francis Frith, an English topographical photographer, showed what could be done. He, too, travelled to the East, several times between 1856 and 1859, and he took pictures of many of the sites which had attracted Teynard and Du Camp. His work is difficult to sift. He took pictures of different sizes: 16 in. × 20 in. (41 cm. × 51 cm.), 8 in. × 10 in. (20 cm. × 25 cm.), and smaller stereoscopic pictures on a twin-lens camera. His publishing was done by several companies, and eventually by himself. James S. Virtue published his first book of sixty original photographs called *Egypt and Palestine Photographed and Described*. This was made up of pictures taken in 1857. Virtue also published *Egypt, Sinai and Jerusalem*, which contained twenty large photographic views taken mainly in 1858. Somewhat later William Mackenzie published a handsome four-volume survey of Frith's travels: *Sinai and Palestine*; *Egypt, Sinai and Palestine*; *Upper Egypt and Ethiopia*; *Lower Egypt and Thebes*. Frith was nothing if not enterprising; in 1862 Smith, Elder and Co. published *Egypt, Nubia and Ethiopia*, illustrated with 100 of his stereoscopic photographs.

At first sight Frith might seem a photographer in the tradition of Teynard and Du Camp. Certainly his pictures lose nothing by comparison with theirs. Yet Frith was more of a traveller and a narrator than a scholar. Above all he set out to show his audience what it felt like to be in these remote and exotic regions. Monuments which Teynard deplored because they were

picturesque attracted Frith for that very reason. His favourite subject was a roofless temple, known as 'Pharaoh's Bed', by the riverside on the Island of Philae. Teynard thought it was a late, and therefore decadent, building and that its placing was *excessivement pittoresque*. This is Frith's description, given alongside the picture in his first book:

Philae is the most beautiful thing in Egypt; and the temple, absurdly called Pharaoh's Bed, is the most beautiful thing upon the island. I flatter myself, too, somewhat upon the quality of my photograph – light transparent shadows, sweet half-tones, oh discriminating Public! It is true that the temple outdoes the tower of Babel, not only 'reaching unto the heavens', but robbing the picture of well-nigh all the sky – that feature so essential to the picturesque in landscape. But what could I do? I *must* give that scrap of water, and the Nile boat (a favourite anchorage for dahibiehs, this nook), and I could not falsify the height of the bank, as I see most artists have done, to suit the proportions of my picture.

Frith's subject, over and over again, is less ancient architecture objectively appraised than himself abroad, an average Englishman discovering fine views and coping with the problems of travel, with the 'impalpable fetid dust', with 'heaps of filth and rubbish', and with 'the Brandy-Sheikh', his nerve-wracking guide on the Nile cataracts.

Frith's photographs match his commentaries. They present Philae, Karnak and the Pyramids more as places encountered on a visit than as eternal monuments. Guards, guides and European travellers rest among fallen statues or lounge on the sand. His Egypt is an Egypt of habitable spaces rather than of flattened fragments. Mrs Poole, who introduced *Egypt, Sinai and Jerusalem*, singled out two landscape pictures for especial praise (Mount Serbal and the so-called Mount Horeb): 'The manner in which the forms are given and the successful rendering of the distance in both, at once seize the eye, which is not unused in art to flat, sketchy mountains, and, in photography, to the absence of aerial perspective.' In Frith's photographs the frames become thresholds opening onto continuous spaces. It is possible, at last, to imagine a path into these stony landscapes, across foregrounds of boulders and debris and on into the distance. To some degree Frith photographed in this way in the late fifties because his medium allowed him to do so – the collodion process and the smooth, clear surfaces of albumen printing, pioneered at this time, permitted far more precise renderings than ever before. But it is also true that Frith worked with a new emphasis; above all he wanted to give the feel of things, to show just what it was like to be there, on just those roads, among just those rocks.

Others followed in Frith's footsteps, and with Frith's intentions. In 1862 an English topographical photographer, Francis Bedford, toured the Near

19

35

East with the Prince of Wales. A two-volume book with 172 pictures resulted: *Photographic Pictures of Egypt, the Holy Land and Syria.* Bedford's East, even more than Frith's, is caught in passing. Frith numbered his negatives and noted the year; Bedford added specifics, days and months. Although nuances of weather and atmosphere make only a rudimentary showing in Bedford's pictures, everything else implies immediacy and transience: detailed foregrounds make his exotic sites seem near to hand and casual figures, often arranged as though in conversation, suggest intimacies of daily life. Bedford's procedure was to qualify everything remote and exotic. He interpolates such routine and familiar details as make us feel at home.

However, by 1860 photographers had a new and infallible aid to immediacy: the stereoscope. In 1849 Sir David Brewster had experimented with stereoscopic inspection of photographs. His book on the subject was

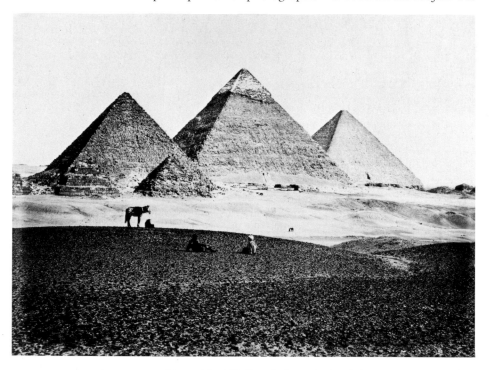

19 FRANCIS FRITH 'Pyramids of El Geezeh from the South West' One of a series of twenty photographic views from *Egypt, Sinai and Jerusalem*, with a description by Mrs Poole and Reginald Lane Poole (London 1860: from pictures taken in 1858).

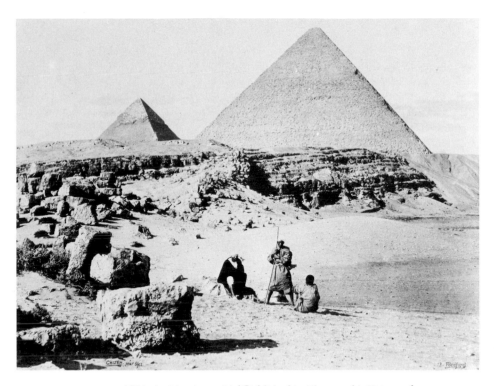

20  FRANCIS BEDFORD 'Ghizeh. March 5, 1862' Published in *Photographic Pictures of Egypt, The Holy Land and Syria . . . taken during the tour in the East, in which, by command, Mr Bedford accompanied His Royal Highness the Prince of Wales* (London 1863).

published in 1856. By then the process was established, and it was in vogue soon after. Pioneered in Europe, the process caught on in America and stayed in vogue until the end of the century. Twin-view stereoscopic pictures were seized on as 'wonders'. Here, at last, was the plain, unvarnished truth in three dimensions. Vicarious travel became a possibility for anyone who could afford a dollar or two for a stereoscopic viewer and between $1.50 and $6 (6s and £1 5s) for a dozen stereo cards (1860 prices). Organizations such as the London Stereoscopic Company and Langenheim Brothers in America quickly had thousands of views on their lists.

Stereoscopic photography had a number of consequences. In the first place it revealed that illusion itself was sufficient to make a picture interesting, and saleable. The process relieved photographers of the need to think hard about synthesis; stereographic space was sufficiently intricate and rewarding in its own right. Nevertheless, stereography, along with the refinements brought by collodion and albumen, helped establish a new

aesthetic in photography. Du Camp, in the early fifties, had composed with flat, wedge-shaped elements in shallow spaces. Frith in his later days in Egypt scarcely troubled at all with such planar arrangements. Instead his fastidiousness found its subject in finely calculated spatial constructions, such as the three columns of a ruined Christian church on the Island of Saye in Ethiopia, which he photographed as elegant markers setting out depth by degrees in a wasteland.

A second major consequence of stereography was a withdrawal into High Art. Stereographic pictures found an enormous, and not very discriminating, market. In the British photographic press in the late fifties there was mention of 'stereoscopic trash' and 'proof of a vitiated art taste'. An anonymous reviewer of the Fifth Annual Photographic Exhibition in London in May 1858 regretted the recent decline: 'To see that noble instrument prostituted as it is by those sentimental "Weddings", "Christenings", "Crinoline" and "Ghosts", is enough to disgust anyone of refined taste. We are sorry to see that recently some photographers have published slides which are, to say the least, questionable in point of view of delicacy.' Critical strictures did not turn the tide, however, and the sixties were great years for 'stereoscopic trash'. A leading producer, in England, was Michael Burr of Birmingham, who registered picture after picture at the Stationers' Office under such headings as 'The Troubles of Single Life' and 'My Country Cousin'. At the same time Julia Margaret Cameron, an English photographer closely connected with such artists and writers as G.F. Watts, Dante Gabriel Rossetti and Lord Tennyson, was also registering photographs – sometimes on the same day as good-humour man Burr.

Julia Margaret Cameron wanted nothing to do with transience and immediacy, and still less to do with popular sentiment and anecdote. 'A lady amateur' assessed her career in 1886 (Mrs Cameron had died in 1879):

She had a notion that she was going to revolutionise photography and make money. To some extent she did the first, if to be discussed a twelve month or more in every photographic circle means a revolution: but the second she never succeeded in doing. Her aspirations seemed to be that people should come to her as an artist who did not belong to the ordinary photographic rank and file. She was, in fact, a Whistler of photography.

Her procedures were described in 1865, not very sympathetically, by A.H. Wall, a critic, in the *Photographic News*. He thought her idea of artistic photography a curious one which could 'be described as consisting in the main of a piece of light or dark drapery pulled about the figure or over the head of some person in modern costume, which was concealed by much tucking in here and pulling out there, and in the photographing thereof with

21 JULIA MARGARET CAMERON 'Portrait Head of a Woman' (Mrs Duckworth) *c*. 1867. Published originally by the Autotype Company and signed by the artist.

a lens turned out of focus.' To A.H. Wall, and to others in the photographic world, her pictures were disconcerting. They were unreal, they transgressed against photographic naturalism.

What exactly did Julia Margaret Cameron have in mind? This is an extract from one of her letters written in the course of a voyage to Ceylon in 1875:

I need not tell you that amidst all this bustling world of 380 people, my husband sits in majesty like a being from another sphere, his white hair shining like the foam of the sea and his white hands holding on each side his golden chain. . . . O what good it does to one's soul to go forth! How it heals all the little frets and insect-stings of life, to feel the pulse of the large world and to count all men as one's brethren and to merge one's individual self in the thoughts of the mighty whole.

This was the spirit in which she made her photographs. Soft focus smoothed away the 'little frets' of life and her subjects, handsome and distinguished contemporaries, constituted a noble pantheon.

She lived in a thoroughly materialist age, and set herself to qualify that materialism – or to suggest a possible realm beyond the prosaic world. She shows her contemporaries as saintly and melancholy figures, in thrall to personal visions of some intensity. Like Hill and Adamson before her she found a form for inwardness. Her work also resembles that of Rembrandt; many of her figures emerge dramatically from darkness, with very little of dress or background in evidence. Her subjects are removed from mundane actuality, from the circumstances of their merely physical lives, and projected into a spirit world of her own devising – a legendary place not unlike the heroic Arthurian world created by her friend and neighbour Lord Tennyson.

Despite contemporary misgivings her work has often been singled out, placed as a major achievement in the history of photography. The art-photographers of the 1890s, for instance, claimed her as an ancestor through her use of soft focus and insistence on the idea of the thing rather than the servile tracing of its surface appearance. Dr Peter Emerson, an influential and intemperate pioneer of art photography in the mid-1880s, allowed that hers was just about the only worthwhile example of photography before his own. Comparisons with Rembrandt are another matter, however. Mrs Cameron's is a wholly transformational mode; her subjects are transported, carried away by a powerful imagination. Rembrandt's subjects, as exotically imagined in jewels and brocades and capes, fail to live up to the level implied by their trappings. His is an ironic art, to do with impermanent man decomposing in his finery. It would be another fifty years before August Sander, a great German photographer, produced anything comparable to the ironic portraiture of Rembrandt.

Julia Margaret Cameron tried to counter photographic instantaneity. Her French contemporaries, by contrast, put it to use – no one more so than Gaspard-Félix Tournachon, or Nadar as he was known after 1849. Nadar had begun to work as a journalist in Paris by 1840. He kept Bohemian company, wrote for a left-wing publication, *Le Corsaire-Satan*, and featured in a police dossier as 'one of those dangerous characters who spread highly subversive doctrines in the Latin Quarter . . . He is under close observation.' He also turned to caricature in the mid-forties, and in 1848 enrolled in the Polish Legion, an expeditionary force of 500 which marched from Paris to the rescue of Poland. Turned back at the German frontier, he enrolled as a secret service agent in 1849 and reported from Berlin, Stettin and Danzig. He then visited England, spent time in a debtors' prison in Clichy, and worked for various literary periodicals. In 1854 he published the *Panthéon Nadar*, a lithographed sheet of 300 caricatures of his Parisian literary contemporaries. He used photographs as a basis for some of these portraits, and shortly after this established a photographic studio.

The bulk of Nadar's outstanding photographs, mostly portraits, were taken between 1854 and 1870. They are of such distinguished contemporaries as Daumier, Manet, Courbet, Millet, Corot, Doré, Guys and Baudelaire. His subjects alone would make his work interesting, just as his life story might be worth recounting even had he been an indifferent artist. But Nadar's portraits are exceptional. In 1856 he expressed himself on the subject in the course of a lawsuit with his brother over the use of the name Nadar; he spoke of 'the moral grasp' of the subject – that instant understanding which puts you in touch with the model, helps you to sum him up, guides you to his habits, his ideas and his character and enables you to produce, not an indifferent reproduction, a matter of routine or accident . . . but a really convincing and sympathetic likeness, an intimate portrait.' Nadar's speciality was 'character'. His subjects often glance at the camera frowning or smiling, as they might glance at acquaintances in a conversation. Even when obviously posed they contrive to look alert, as though their attention has been or is about to be caught. In this respect they differ markedly from Mrs Cameron's pantheon of beautiful dreamers. His Parisian notables appear as activists, taken in passing.

Nadar's work is rivalled by that of another Parisian contemporary, Étienne Carjat, who photographed within the same social order, and was also a writer, caricaturist and editor. Their portraits are full of a quick spirit not evident in any previous photography. Intelligence, the lively, outgoing spirit which inhabits these portraits by Nadar and Carjat, ceased to concern photographers.

15

22 GASPARD-FÉLIX
TOURNACHON (NADAR)
'Jules Champfleury'
c. 1865. Published by
Goupil et Cie,
126 Boulevard Magenta,
Paris.

To a certain extent the medium itself allowed this sort of picture-making. Photography, by the sixties, was sufficiently responsive to catch quickness of expression in a glance or a frown. At the same time Nadar and Carjat were photographing among people who prided themselves on their singularity and vigour: people unlikely to be satisfied by a prosaic style in portraiture. This much can be gauged from the journals of Edmond and Jules de Goncourt, which span this period and refer to Nadar as well as to most of his subjects. The de Goncourts present their contemporaries, literary people and artists for the most part, as robust and impulsive. They also saw themselves and their friends as an embattled minority, outsiders in a bourgeois society of newspaper-readers and businessmen. By contrast, the eighteenth century seemed to them a golden age for men of letters, and it was in this way that they imagined themselves. Nadar and Carjat, seen solely within the history of photography, appear to be quite distinctive. But seen within the larger history of French portraiture their work becomes much more explicable. It belongs, in fact, to a tradition well established in the late eighteenth century

and continuously in evidence thereafter. Their precursors include the sculptor Houdon, who made speaking likenesses of such alert contemporaries as Voltaire, Rousseau, Diderot, d'Alembert, Franklin and Jefferson. In many of David's painted portraits there is a comparable emphasis on alertness caught in an instant. Even after the Revolutionary period the tradition continued in Ingres's many portrait drawings and paintings, and Ingres's career overlapped that of Nadar. The photographers, like their precursors, were court artists to an intelligentsia, and they made use of those portrait modes to which the French intelligentsia was accustomed. Their innovation was to add character to vivacity: Nadar's subjects invariably look alert, but they also show themselves as creatures of mood, tetchy, sullen, genial, affable.

Portraits of a similar sort were made at that time by Manet and, in particular, by Degas. Degas's sitters present themselves casually to the artist's gaze. He shows them as though he has momentarily caught their attention. They do no more than pause to have their pictures made, and in some cases make no effort at all – Manet, for instance, sprawled on a couch listening to his wife playing a piano, in a painting by Degas from around 1865. But photographers never went that far in the direction of instantaneity. They chose to preserve a measure of decorum, and left it to painters to reflect on photography's more extreme possibilities.

What emerges from the evidence of Nadar and Carjat in portraiture and Frith and Bedford in topography is a movement on the part of photographers to align their art with previously established traditions. Bedford ended up with something like the informal, atmospheric art of Roberts and the lithographers of the 1840s. Nadar achieved an intimate naturalism which had been a central element in French portraiture since the late eighteenth century.

There were, however, more selfconscious and well-advertised attempts to make photography a medium for art. Perhaps the best-known artist-photographer apart from Julia Margaret Cameron is Oscar Rejlander, a Swedish photographer who worked in England. Rejlander's famous picture is 'Two Ways of Life', a large composite photograph shown at the Manchester Art Treasures Exhibition in 1857. 'Two Ways of Life', modelled on Raphael's *Disputà* and arranged as a tableau against a distinguished architectural background, is a moralizing picture: two youths set out on life's adventure and one lends an ear to siren calls from naked beauties to his right while his companion sets out towards a life of sobriety, dignity and piety. A sage mediates in the centre of this complex allegory. In 1854 William Holman Hunt had exhibited *The Awakening Conscience*, concerning an onset

of guilt on the part of a kept woman, and Dante Gabriel Rossetti was at work on *Found*, which showed a fallen country girl chanced on in the city by a childhood sweetheart. Rejlander had this sort of modern moral subject in mind. He was also working in an era of Great Exhibitions. The prestige of nations was at stake, and Rejlander was exhibiting on behalf of his adopted country. In 1858 he explained that his picture 'was to be competitive with what might be expected from abroad.'

Rejlander was attacked, mainly on grounds of obscenity. He justified the picture, not on any moral basis but as an exemplar 'to show the plasticity of photography'. He lectured on his picture to the Photographic Society in London in 1858. At the end of the meeting Roger Fenton, Vice-Chairman and founder-member of the Society, gave his views; he thought the picture 'too ambitious a beginning'. He went on to qualify his judgment:

I will refer you to small pictures. I will refer you particularly to a picture by Mr Grundy of Birmingham, of the Wilkie or Teniers kind. It is a picture of a Fisherman – a single figure, in which the lines have all been artistically arranged, the pose of the figure, and the chiaroscuro have all been studied – there is everything in it but colour, and even that is suggested – there is expression also, though doubtless expression of a low order.

Grundy had published a series of *English Views* in 1857, small-scale stereoscopic pictures of country scenes, characters and occupations.

Fenton, a student of the painter Paul Delaroche in Paris in the early forties and a very experienced photographer by 1858, clearly had misgivings about photographic hankerings after High Art. Despite his misgivings some British photographers persisted along the lines indicated by Rejlander. The most stubborn of his successors was Henry Peach Robinson, noticed in the late fifties, celebrated in the sixties and active through to the end of the century. Undeterred by Rejlander's relative failure, Robinson set out to work with photography as though it was a limitless medium. In 1860 he thought of art as providing 'thoughtful work for earnest men', and in anticipation of Mrs Cameron regretted the banality of exhibition photographs: 'the old "Portrait of a gentleman", or "Landscape without Figures" so continually recurring in our exhibitions.' He had resounding ideas: 'a subject must be imagined, and imagination is art.' This notion was both Robinson's strength and weakness. He set great store by imagination, with his medium as little more than a means to an end. His history as an artist is the history of his engagement with these two terms. Imagination, he quickly discovered, could not be given free rein. In the end photography was written back into his formula for art, revalued as a reflection of that nature which had imposed itself on imagination in the first place.

He began by thinking of himself as a Pre-Raphaelite. In an article, 'Composition NOT Patchwork', in the *British Journal of Photography* (2 July 1860) he explained his practice of making composite pictures from several negatives: 'As to ridicule, we must of course, bear it; but we can take some comfort from the progress of pre-Raphaelitism, for many years justly laughed at for its crudities and bad drawing, as my attempts are laughed at for their "cruel cutting outlines", etc.' He used an additive process of picture-making which had worked for Millais and Holman Hunt, and saw no reason why it should not work for him. Nevertheless Robinson moved steadily away from Pre-Raphaelite precepts. His first ambitious picture, from 1858, was of a deathbed scene, called 'Fading Away'. It was criticized over inconsistencies in lighting and modelling, and because his actors failed to express the gravity of the situation. He never again tried to represent such a complex and dramatic event. In 1861 'The Lady of Shalott', based on Tennyson's poem of the same name, brought similar complaints. Robinson withdrew from action photography, and after 1861 made some of his most imposing pictures in a new mode.

His vision of a great art in photography had placed him in a difficult position. He worked with a medium ideally suited to the recording of fragments and moments, yet his conviction about the meaning of art ran directly counter to the natural capacity of photography. How could he use a camera and remain true to his convictions that art should in some way be grand, harmonious and complete? His answer was to concentrate on those moments when time appeared to stand still, or at least when the active rhythms of the day were least in evidence, in the early morning, in the evening, in a shadowed room or under the moon's light. He became a photographer of ambience, and a symbolist artist interested in general meanings rather than specifics of action and drama. In 1862 his major, and much admired, photograph was 'Bringing Home the May', a celebration of springtime.

It is harmonious in sentiment; the landscape is an unquestionable spring landscape: the children and damsels – there is too much of life about them to be perpetually called 'figures' – are in the spring of life; the whole picture is pervaded by the feeling of springtime. There is harmony in the action, purpose, occupation, and pose in each figure, which perfectly connects them as a whole, although divided into separate groups; and there is a feeling of gladness and freshness expressed in every part of the picture. It is harmonious as a composition, harmonious in gradation of tones; there is perfect gradation in the sunlit and well pronounced foreground objects, and gradation in the distant hazy woods. (*Photographic News*, 7 November 1862)

Robinson succeeded in reconciling a contradiction in art and photography;

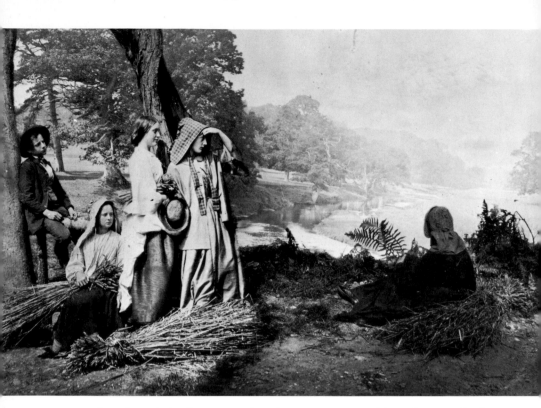

he acknowledged stillness and his feeling that art should stand against the flux of the world, and did so in photography, where the transitory nature of things was most clearly in evidence. He followed this in 1864 with another poetical composite, 'Autumn', and in 1868 advised his readers to 'turn to nature, look on objects indoors and out of doors, carefully analyse any object or group of objects that appears to have a pleasing effect, and he will find, in some degree, that the cause of the pleasure he experiences in looking upon them begins to dawn upon his mind.' In other words: imagination is to be guided by observation. Robinson maturing becomes, like many other photographers, a passive artist, whereas he set out convinced of the primacy of his own imagination. Because of his ambition he was the first artist-photographer to confront this problem of passivity in any sustained way. How was it possible to be an artist, with everything that entailed, and to use a camera, with all that entailed by way of being at the mercy of events? You watched and waited and appearances might give up their meaning. Appearances, as it were, took the initiative and imposed themselves. This is one of the reasons why the subsequent history of photography is not a

23　HENRY PEACH ROBINSON
'Autumn' Large-scale composite
photograph made from a
number of negatives.

24　ADOLPHE BRAUN 'Still Life
with Deer and Wildfowl'
*c*. 1865. A carbon print on tissue
paper from wet collodion on
glass negative.

miniature history of painting. Photographers are not in control as other
artists are, and if they do try to impose themselves they work against the
grain of the medium.

Relations between photography and painting were as close as they would
ever be in the thirty years or so of Robinson's career. It was a period of
bourgeois art patronage in which painters and photographers aimed to
please the same fashion-conscious audience. For instance, in the early sixties
some of the most opulent photographs made in Britain were Roger Fenton's
still lifes of fruit and flowers. There was nothing else like them in British
photography, and they can easily be seen as a baffling initiative on Fenton's
part. But Fenton was simply updating, following a pointer from Paris where
still lifes were in vogue, proliferating like rodents at the Salon, according to
the critic Castagnary in 1863. Fenton's equivalent in France was Adolphe
Braun, a composer of sumptuous still life photographs of shot game and
hunting tackle – modern versions of a favourite eighteenth-century genre
practised by Jean-Baptiste Oudry, painter of the royal hunts at the court of
Louis XV.

# Documentary Meanings

*Roger Fenton in the Crimea; America at war; Western exploration*

JULIA MARGARET CAMERON, Oscar Rejlander, H.P. Robinson and Adolphe Braun were photographers with ambitions as artists. They were a minority. Many of their contemporaries treated photography as nothing more than a convenient means of record-making. Paradoxically the pictures of this second group have often been more esteemed than those of the artist-photographers. Roger Fenton's photographs of the Crimean War are better known and more highly thought of than his noble still lifes of 1861–62. In the United States the most revered of all pioneer photographers are workaday topographers, members of Western survey teams in the sixties and seventies.

Why should Fenton, for instance, be remembered for his Crimean pictures, and for an earlier batch of photographs which he took on a tour of Russia in 1852? To a certain extent the Crimean photographs are nothing more than incidentals to an absorbing adventure story which began with Fenton's arrival at Balaclava on 8 March 1855. He stayed in the Crimea until late June, photographing for Agnews of Exchange Street, Manchester, and wrote a number of detailed letters which read like a prologue to memoirs of the First World War. Much of what Fenton reported on was horrifying. Balaclava Harbour was a cesspool filled with putrefying sheep's entrails, dead horses and beef bones. The valley round the port was parched and stripped of vegetation. On an expedition to Kertch, his one trip away from the siege of Sebastopol, Fenton witnessed looting, drunkenness and disorder among the allied troops. Three of his friends were killed and his brother-in-law wounded in an attack on the Redan quarries. Casualties were vast among French, British and Turkish troops sent in to attack elaborate strongpoints. Rumours abounded, and bad management. Fenton, ill at times and plagued by logistical problems and interruptions, lived through a nightmare. Yet, as in Flanders, the dream had its bright moments. Vivid spring flowers grew on the hilltops and Fenton dined on shoulder of mutton and pancakes with quince preserve.

These letters, with their abrupt shifts from horror to idyll, should have a place in any literature of war. They also have a bearing on Fenton's photography. He saw and described beautiful countryside as it was ravaged by a marauding army. He enjoyed a 'swell dinner' with the nobility, and

25 WILLIAM HENRY JACKSON 'Running Antelope – Hunc papa Dakotas' Published in W.H. Jackson's album, *Portraits of American Indians* (1877).

Hunc papa Dakotas                    Running Antelope

heard news of death by cholera. His times were seriously out of joint, and his pictures are disconcerting, as though to match. Fenton took very few pictures of anything which might be described as action, but he did photograph around the harbour, where his eye was caught by abrupt dislocations: heaps of shells and guns crowd up to tangles of rigging, and ships in the distant port look like oversized models on a pond.

What Fenton hinted at was fully realized by his successor in the Crimea, James Robertson – Superintendent and Chief Engraver of the Imperial Mint at Constantinople, who arrived at the war in time to record the fall of Sebastopol. Robertson photographed the interiors of the captured Malakoff and Redan forts, shattered by artillery fire. Guns, masonry, split timber and wattle lie everywhere in disorder. Photography at last had found the sort of incoherent, fragmentary subject which it was best suited to express. In normal times picture-making entailed composition, but war was abnormal, a time when events failed to add up.

Fenton, however, had more than chaos and destruction in mind. He was a reporter and his job, a new one in photography, involved him in new problems. Predecessors had shown just how places looked; Fenton had the

26 JAMES ROBERTSON and FELICE BEATO 'The Redan: Interior of Fortifications at Sebastopol after Evacuation by the Russians' September or October 1855.

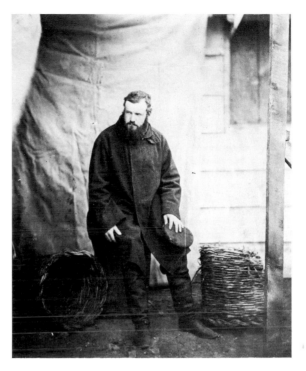

27 ROGER FENTON 'Captain Turner, Coldstream Guards' 1855. From an album of Crimean portraits in the collection of the Victoria and Albert Museum, London.

additional problem of showing what went on. Hence his attention to the port area. The journalist William Howard Russell, writing for *The Times*, had drawn attention to serious logistical shortcomings in the conduct of the war. For Russell there were two theatres of war, of which the most important was backstage. Fenton set out to show what this backstage looked like: harbour, ships, quayside, tramlines, stores, hutments. He tried for comprehensive views, to show what elements were involved in the workings of the port, and how they stood in relation to each other. These analytical pictures, cross-sections of a sort, he supplemented with close-ups which gave life to those items noted in miniature in his surveys. To some extent Fenton had prepared himself for the Crimea during his Russian trip of 1852, in the course of which he developed an analytical mode for architectural photography. In this he worked with oblique views which combined elevations with perspectives through architectural space. But the bulk of Fenton's Crimean pictures are portraits: Field-Marshals, Lieutenant-Generals, and down through the ranks of officers. These are not exemplary photographs of military men. One or two of his protagonists have a martial air to them, but many seem discreet and tentative, like private citizens got up in uniform against their better

28  TIMOTHY H. O'SULLIVAN 'Pontoon Wagon and Boat, 50th New York Engineers, Rappahannock Station, Virginia' March 1864.

judgment. They look like kin to a Colonel de Ballie, whom Fenton reported on in a letter of 28 March: 'a young man about my own age, who was busy putting a padlock on a fowl house he had just constructed, grumbling away all the time at the Crimea, at the army, and at his own particular hardships. He made me a very liberal offer of his commission, medals and other advantages, if I would only get him safe back to Pall Mall.' The war, in fact, was carried out with very little conviction, and it is on this that Fenton's portraits have a bearing. They are symptomatic pictures, and historical documents.

The same is true of much which has passed on to the registers in photographic history. It is especially true of American photography at the time of the Civil War of 1861–65. The war was extensively photographed, at least by Northerners, and the principal coordinator of the enterprise was Mathew Brady, America's most enterprising portrait photographer and founder of the 'Daguerrean Miniature Gallery' in 1844. Brady recorded the war from the battle of Bull Run onwards. In 1862 he organized a group of ten photographers to cover the various battle fronts. Brady's men were there or thereabouts at the major engagements: Mechanicsville, Fair Oaks, the Seven Days Battles, Sharpsburg, Fredericksburg, Chancellorsville, Gettysburg, the Wilderness, Cold Harbor.

29   MATHEW BRADY COLLECTION 'Yorktown, Virginia' May 1862.

Like Fenton, Brady's staff photographed the main protagonists, generals and their associates. They worked, too, on the battlefields, and one of the best-known pictures of the war is O'Sullivan's view of dead men on the field at Gettysburg. Casualties recur, fallen by batteries and fences, sunk in the mud of trenches, and arranged for burial. Mostly, though, photographers worked some way behind the lines, taking pictures of camp life, cookhouses, sutlers' stores, winter quarters, forges and wharves. They recorded the achievements of engineers, builders of railroads and bridges. As the fronts moved on they photographed fortifications, endlessly: block houses, rifle pits, breastworks and abatis. Finally they recorded ruins in the South: a shattered Fort Sumter, Charleston roofless, and Richmond like a ruined stage set.

Clearly Brady's photographers expected their audience to be interested in just how things were done: how the dead were buried, how bridges were built, positions fortified, guns placed. The Civil War appears, especially on the evidence of O'Sullivan's pictures, to have been a war of ingenious

30   GEORGE N. BARNARD 'Ruins of the Railroad Depot, Charleston, South Carolina' The last of sixty-one illustrations in *Photographic Views of Sherman's Campaign* (New York 1866).

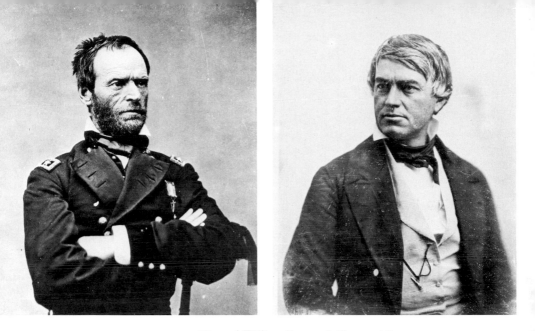

31 MATHEW BRADY COLLECTION 'General William Tecumseh Sherman' (in mourning for President Lincoln), 1865.

32 ALBERT S. SOUTHWORTH AND JOSIAH J. HAWES 'Cassius Marcellus Clay' A daguerreotype from the late 1840s.

artificers. At the same time they were also resolute destroyers, battling through woods stripped bare by gunfire. Again and again such photographers as O'Sullivan and George N. Barnard, whose *Photographic Views of Sherman's Campaign* was published in 1866, emphasize desolation on deserted battle sites. Nowhere else is war presented so unflinchingly, with so stern a face. The news is all of a war unstintingly pursued – a test of nerve for both antagonists and onlookers.

Fenton's Crimea is no such affair. His view is distinctly unmartial: litter on the quayside, bonhomie in camp, and a quiet day at the mortar battery. The Civil War, by contrast, is altogether more coherent, irrespective of photographer – O'Sullivan, Barnard or Alexander Gardner (another Brady assistant, who went independent in 1863 and eventually published his famous *Photographic Sketchbook of the War* in 1866). Their pictures tell of resolution everywhere: wholesale destruction, purposeful building, energetic soldiery and stern leadership. The pictures ask us, as they asked Americans in the 1860s, to look unwaveringly at the desolation and to recognize its justness. Perhaps the most interesting photographs in this respect are those of such commanders as General George H. Thomas ('The Rock of Chickamauga'),

Major-General Phillip Henry Sheridan and, grimmest of all, General Sherman, whose shattering progress through Georgia to the sea was recorded by Barnard in 1865.

What both the portraits and the pictures of the conflict point to is an ethos of sternness. By the 1860s Americans in public roles or involved in the unfolding of history knew just how to present themselves. They were agents of destiny, and destiny manifested itself in what was most personal, in the lineaments of a face and the set of a body. In 1851 prize-winning American daguerreotype portraits at the Great Exhibition in London were commended thus by the jury: 'America stands alone for stern development of character; her works, with few exceptions, reject all accessories, present a faithful transcript of subject, and yield to none in excellence of execution.' Brady was among the prize-winners. Where European portraits often showed supporting details, which defined their subjects in social terms, Americans consistently chose plain settings which emphasized the expressive powers inherent in face and stance. Writers might sometimes present themselves with some suavity, but men of affairs presented themselves, apparently, as they were, ready to the point of roughness. In Europe different groups imagined themselves differently. In America the keynote was gravity of mien. Brady's soldiers provide fine examples of this gravity, but it occurs everywhere, in the distinguished Boston studio of the daguerreotypists 32 Southworth and Hawes as well as in a mass of less noted studios throughout the country.

However, the sternest of the stern lived further west. Iron Black Bird, 25 Running Antelope, The One Who Catches the Enemy and many others had their pictures taken by U.S. Geological Survey photographers in the late sixties and early seventies. In 1877, 600 *Portraits of American Indians* were published in a volume of which only a very few copies seem to have been produced. These portraits, among the most impressive in the whole history of photography, were largely made by W.H. Jackson, who had taken pictures of Indians in the Omaha area since 1868, and who became official photographer on F.V. Hayden's Geological Survey in 1870. Hayden introduced the volume of 1877 in this way:

Those who have never attempted to secure photographs and measurements or other details of the physique of Indians, in short, any reliable statistics of individuals or bands, can hardly realise the obstacles to overcome. The American Indian is extremely superstitious, and every attempt to take his picture is rendered difficult if not entirely frustrated by his deeply-rooted belief that the process places some portion of himself in the power of the white man, and such control may be used to his injury. No prescribed regulations for the taking of photographs, therefore, are likely

33 CARLETON E. WATKINS 'The Vernal Fall' No. 16 of twenty-eight illustrations in *The Yosemite Book* (New York 1868).

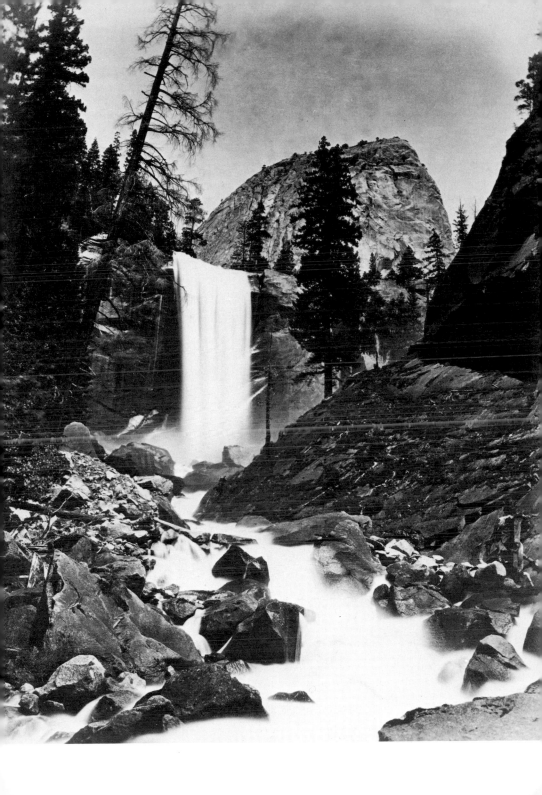

to be fully carried out. As a rule, front and profile views have been secured whenever practicable. Usually it is only when an Indian is subjected to confinement that those measurements of his person which are suitable for anthropological purposes can be secured. In most cases the Indian will not allow his person to be handled at all, nor submit to any inconvenience whatever.

These pictures are important in several senses. People unprepared 'to submit to any inconvenience whatever' are rare enough to attract attention on that ground alone. Beyond this, Jackson's Indians project themselves as a unique people, inhabiting a peculiar social and psychological space. Western portrait traditions generally stress character, and present the other as knowable. Running Antelope and his compatriots allow little of this sort of familiarity. They hold themselves apart and deny onlookers the consolations of intimacy. They contradict European beliefs in the pre-eminence of inwardness, and embody another way of being, one in which presence appears to matter more than soul.

Yet at the same time they appear to be at home in the culture of Sherman and the Civil War heroes. Running Antelope is as imposing and implacable as any general – a fitting opponent, in fact. Later, from the 1890s onward, Indians would be envisaged by the photographer Edward Curtis as domestic and religious peoples, cultivating and worshipping according to ideal, time-honoured patterns of life. Around 1870, though, Americans were less sentimental, more inclined to confront challenges. Hence these pictures of the Indian as warrior.

Hence, too, an extraordinary body of landscape photography dating mainly from the 1870s. This was the work of landscapists in California, and of survey photographers sent out to chart the West. In 1859 C.L. Weed was taking stereographs in Yosemite, California, and continued to do so through the sixties. In 1861 Carleton E. Watkins began to photograph in Yosemite Valley, a two-day journey south-east of San Francisco. Watkins used a giant camera, which took plates of 18 in. × 21 in. (46 cm. × 53 cm.). The Yosemite Valley was a gorge in the granite peak of the Sierra Nevada Mountains, situated in the County of Mariposa at the headwater of the Merced River. It was ceded to the State of California in 1864 as a place for public recreation. The area was surveyed in 1867, and more photographs were taken. In 1868 *The Yosemite Book* was prepared by State Geologist J.D. Whitney and published by Julius Bien in New York, with fifty-four photographic illustrations, mainly by Watkins.

Watkins's pictures, and those of the Englishman Eadweard Muybridge, who was his competitor in California from the late sixties onward, show Yosemite as a giant land of still water, timber and rock, a land on an inhuman

scale with no traces of habitation whatever. Whitney, the surveyor, referred to the area as the American Alps and thought it had possibilities for health and recreation. His captions and Watkins's pictures tell a somewhat different story. Yosemite was more than a beauty spot; it was big and bracing, a natural monument to the achievement of the American people. Whitney measured and commented on the immensity of cliffs and waterfalls, and in a brutal aside dealt with the original inhabitants: 'Like the rest of the so-called "diggers" in California, they are a miserable, degraded and fast disappearing set of beings who must die out before the progress of the white man's civilization, and for whom there is neither hope nor chance.' Yosemite was a consummation, nature's way of acknowledging a bold enterprise.

Meanwhile, elsewhere in the West more survey work was afoot. T.H. O'Sullivan, the most famous of Brady's men in the Civil War, joined Clarence King's Fortieth Parallel Survey and worked with it as a survey photographer through to 1875. W.H. Jackson remained with F.V. Hayden's survey party until 1878. A.J. Russell, a painter and photographer of railroads during the Civil War, photographed for the Union Pacific Railroad in the late sixties and briefly for a survey team in 1869. Muybridge and A.A. Hart took pictures for the Central Pacific Railroad.

Their photographs were published and republished in portfolios, bound volumes and stereo sets, sometimes merely with captions, sometimes with long explanatory texts. These texts imply an audience interested in whys and wherefores about the West. The engineers explain, opposite an O'Sullivan picture of a lake in Conejos Canon in Colorado, just how and why the beavers have dammed that particular pond. Alongside another, very well-known, picture of ancient ruins in the Cañon de Chelle in New Mexico they give more details relating to the site, its buildings and the overhanging rock 'here about 800' [c. 250 m.] high, and, as will be noticed, . . . strikingly furrowed longitudinally by the action of the driving storms, and vertically by the dripping from above.' Western landscapes could, the surveyors imply, be scrutinized and understood in practical terms. Beavers and Indians had shown how this rough and gigantic terrain could be coped with.

But not all of the survey pictures are of this sort. Many show the West, in the manner of the Yosemite pictures, as a daunting land of marvels. Rocks abound: sheer curtain walls fringed daintily with trees, rocks like skulls in Wyoming, and like viscera in Nevada, pinnacles, buttresses, spires and domes. This West of O'Sullivan, Jackson and Russell might invite a visit, but it scarcely looks ready for settlement. The idea at the back of this photography was that of Catastrophism, a geological theory which held that the world was shaped by periodic and large-scale upheavals. Clarence King,

one of the Survey leaders, argued, in a lecture at Yale in 1877, that the 'experience of sudden, unusual telluric energy . . . [left] a terrible impression upon the very substance of human memory.' King thought that 'if catastrophes extirpated all life at oft repeated intervals from the time of its earliest introduction, then creation must necessarily have been oft repeated.' The Catastrophists rejected Darwin's evolutionary theories, and proposed that Man, established after the last upheaval, was shaped by God's handiwork manifest in the landscape. American landscape bore distinct traces of the last catastrophe and was, therefore, of special interest. Perhaps the best-known exponent of this theory, Louis Agassiz, also reasoned that the 'relations and proportions which exist throughout the animal and vegetable world have an intellectual and ideal connection . . .'

Photographers have rarely had such an explicit theoretical basis for their work. Nevertheless this relates to no more than one outstanding feature of the exploration pictures. What they have in common, whether of beaver dams, ancient remains or Catastrophist rocks, and what separates them from European photographs of primeval landscape, is a particular kind of look: dispassionate and somehow placeless. The surveyors chose high vantage points and uninterrupted lines of vision, and what they show appears at a distance, accessible to sight alone. If their pictures have foregrounds they are marginal, or they begin at some distance away as though the camera registered its views at a remove from the earth. European landscapists, such as George Washington Wilson, Francis Bedford and William England, who were all active in these years, tended, by contrast, to mediate distant views by means of foreground detailing, seated figures and the like. American landscapes allow no such ease of access; they remain unapproachable, things seen across a gap, or even across a ravine as O'Sullivan's picture of the Cañon de Chelle suggests. In other words the surveyors present landscape as image, a seen configuration which rarely comes to hand. Perhaps in the face of such vast and unfamiliar places there was no alternative, no well-worn track or resting place which might make a viewer feel at home.

Perhaps, though, the truth is more intricate than that. Not only do exploration pictures show distant landscapes: they are also systematized, to a point of flag-like simplicity. Varnished waters abut precise shorelines where firs make fretted bands under bleached walls of rock. Whatever the ingredients − rock, scree, timber, water, sky − survey photographers took care to picture them distinctly. They favoured sharp spatial breaks, of the kind which put shadowed cliffs against pale mountain ranges. The result is a kind of picture which is simultaneously natural and artificial, descriptive and abstracted. Landscape is fitted into a clear pictorial formula.

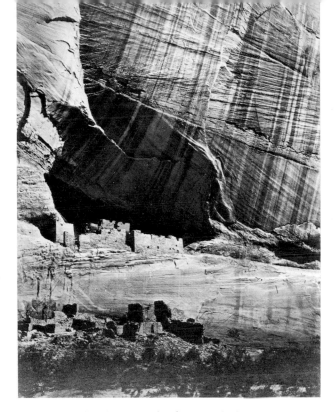

34 TIMOTHY H. O'SULLIVAN
'Ancient Ruins in the Gañon
de Chelle, New Mexico
(Territory)' 1873. No. 11 in a
set of twenty-five pictures,
*Geographical Explorations and
Surveys West of the 100th
Meridian, 1871–2–3–4*, by the
War Department and Corps
of Engineers, under the
command of Lieutenant
George Wheeler, published
by Julius Bien (New York
1874).

In this respect survey photographs resemble American landscape paintings of that time, where a similar duality is evident. The pictures of Fitz Hugh Lane, John Frederick Kensett and Sanford Robinson Gifford, all working in the sixties, appear to be thoroughly naturalistic, full of intricate verdure, fissured rocks and rippled water. Yet at the same time they are heavily, and ostensibly, dependent on pictorial formulae. Lane, Kensett, Gifford and the others had a formula for everything: clouds, meadows, mountains, woodland, wavelets. They also relied on a zoning system, making sharp distinctions between earth, sky, wood and water. Thus their pictures, naturalistic at a distance, quickly reveal themselves as fabrications, dependent on a set of pictorial conventions. This, of course, is basic to all painting. At that time, though, it was unusually obvious, part of a painting's meaning. Photographers, in their equally schematic assemblages of saw-toothed timber lines and pale mountainsides, also drew attention to what was conventional in their medium. It, too, had pictorial formulae for the depiction of natural elements and the surveyors ensured, by means of clear tonal and spatial breaks, that these should not be overlooked. Thus the West was, if still untamed, at least imposed on, itemized and brought to order.

## Small Worlds

*Thomson in China; Emerson in the Fens; Curtis among the North American Indians; Ponting in the Great White South*

PHOTOGRAPHY'S NEXT PHASE seems, at first sight, to be much more complex than anything which had gone before. Cameras became smaller and more manageable. Wet plates gave way to more convenient dry plates in the 1880s, and roll film was eventually introduced. The more photography became accessible to the masses, the more serious photographers began to think of themselves as artists. They made exhibition prints and used photolithographic and photo-etching techniques to reproduce their pictures for publication. Others specialized in documentary work, and travelled further and further afield to acquire material for publishers who were beginning, in the 1870s, to use high-quality photomechanical printing processes which guaranteed accuracy and permanence. Photographic clubs were formed, all over the world. Gifted amateurs took a hand.

Notwithstanding such diversity there are evident consistencies in the photography of the late nineteenth century. Photographers, artists and documentarians alike, increasingly became ideologues, promoters of particular world views and critics of prevailing values. Working with illustrated books and sets of pictures they created and peopled enclaves of their own: simple, attractive and manoeuvrable alternative worlds. Initially these pictorial microcosms were no more than functional introductions to complex societies, but in the later 1880s they began to develop critical and Utopian biases. The first photographer to have a whole society as his subject was John Thomson, a Scottish traveller and geographer. He began in a straightforward way with a report on *The Antiquities of Cambodia*, published in Edinburgh in 1867. Like his predecessors in India and Egypt he was in search of marvels, magnificent ruined cities in particular. That accomplished, he turned his attention to China, and for five years, during the late sixties and early seventies, he travelled and photographed there. The result was his ambitious *Illustrations of China and its People*, published in four volumes in 1873 by Sampson Low, Marston, Low and Searle. This, with its 200 photographs and extensive letterpress descriptions, gives a detailed and well-organized account of Chinese life. Its immediate model was the Reverend Justus Doolittle's *Social Life of the Chinese*, subtitled *A Daguerreotype of Daily Life in China*, and published by Sampson Low, Son and Marston in 1868.

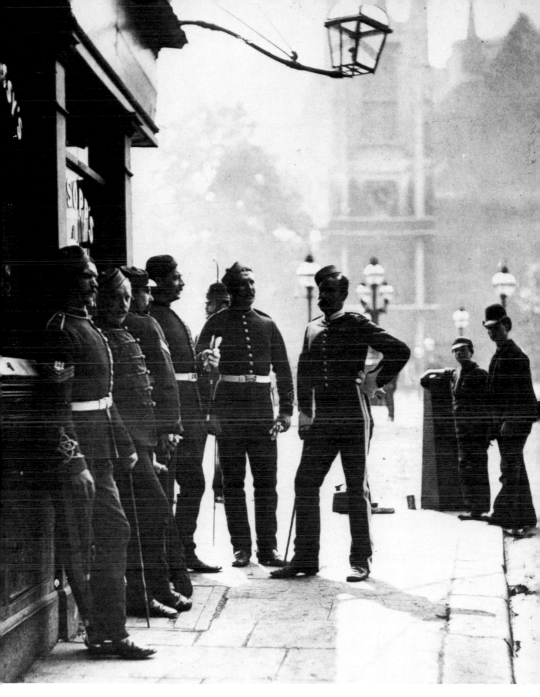

35   JOHN THOMSON 'Recruiting Sergeants at Westminster' From the second part
of *Street Life in London*, March 1876. Printed by the Woodburytype process.

Justus Doolittle, fourteen years a missionary in Fuhchau, concerned himself largely with Chinese ceremonial and spiritual practices. Thomson, however, was an altogether more purposeful reporter, although he, like Doolittle, was interested in, and reported on, opium-smoking, torture and public executions – all of which were signs of a heathen and backward land in immediate need of guidance. The suspicious Chinese confirmed their backwardness by repeated assaults on Thomson and his camera, which they viewed as a death-dealing instrument.

Thomson broke new ground in publishing. This is how he introduced his book:

It is a novel experiment to attempt to illustrate a book of travels with photographs, a few years back so perishable, and so difficult to reproduce. But the art is now so far advanced, that we can multiply the copies with the same facility, and print them with the same materials as in the case of woodcuts or engravings. I feel somewhat sanguine about the success of the undertaking, and I hope to see the process which I have thus applied adopted by other travellers; for the faithfulness of such pictures affords the nearest approach that can be made towards placing the reader actually before the scene which is represented.

He wrote about, and photographed, coalmining processes, which were primitive and badly managed. He described, in detail, the manufacture of gunpowder and caper teas, and merchants' methods of 'schroffing' or testing dollars for purity of metal. He looked into domestic and military arrangements, internal security, and armaments production. He photographed government officials and traders, Mongolian labourers, peasants and Tartar soldiery. Labourers and tribal specimens he vignetted five to a page; governors appear in solitary state.

Thomson, a Fellow of the Royal Geographical Society, was surprisingly uninterested in landscape. His attention was held mainly by manufacturing and by social arrangements. His book, in fact, is no disinterested survey. It is rather more of a prospectus, designed to be of use to traders and to settlers. Travelling along the Yangtze he was continually on the alert for steamboat routes and settlement sites. The Chinese governors are introduced as just the sort of people with whom European entrepreneurs might have to negotiate, just as they might have to deal with the labouring and artisan classes, assessed by Thomson. He was agitated by the sight of such untapped human and mineral resources and produced what is, in effect, a colonizers' handbook. His China, with its westernizing governors, tea blenders and careful merchants, is shown to be manageable by practical men. It is certainly not a missionary's land of such impalpables as animal worship, Confucian wisdom, poetry and landscape art.

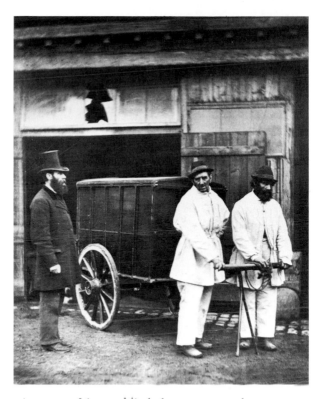

36   JOHN THOMSON 'Public Disinfectors' From the second part of *Street Life in London*, March 1876. Printed by the Woodburytype process.

Thomson's next excursion was into one of the world's darker corners, and the result was *Street Life in London*, published in eleven parts in 1876–77 by Sampson Low, Marston, Searle and Rivington. Thomson, and a writer called Adolphe Smith, explored outcast London, and brought back pictures of 'Black Jack', 'Cast Iron Billy' and 'Hookey Alf', of swagmen, boardmen, beggars and independent boot-blacks. The *Court Circular* thought Thomson's pictures (three to a section, and printed in lustrous sepia by the new Woodburytype process) 'capital specimens'. A medical paper, the *Lancet*, declared them likely to be of interest to 'the sanitarian, the citizen and the philanthropist'. In fact, Thomson and Smith were late explorers of the wilds of London which had fascinated travellers and storytellers, and their middle-class audience, through the 1870s. Their justification for *Street Life* was that the subject was vast and in a constant state of change, and that photography gave their testimony 'unquestionable accuracy'. Predecessors, such as the writer James Greenwood, had been charged with sensationalism and exaggeration. Thomson and Smith also wanted to draw attention to poverty at a time of expanding national wealth.

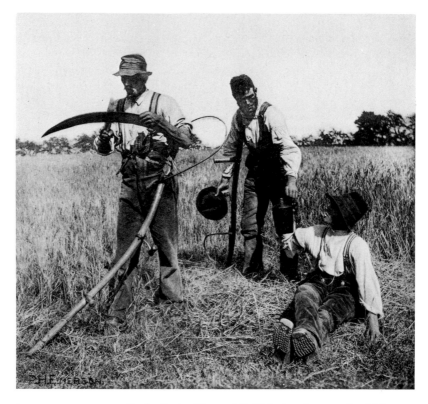

37   PETER H. EMERSON 'In the Barley Harvest' Published as the seventh of thirty-two photogravure illustrations in *Pictures of East Anglian Life* (London 1888).

Working-class areas in London, especially in the East End, were impoverished, unvisited and dangerous. Moreover, the labouring population seemed to be on a downward slope, almost on the point of evolving into a sub-human species, argumentative, wily, and incapable of either heavy or skilled labour, for which sturdy provincial immigrants were usually engaged. Darwin's evolutionary theory suggested the possibility of such a mutation, and Thomson's audience was anxious for news.

Thomson's feeling for social hierarchy, evident in his China survey, also shows itself here. He and Smith ranged widely through the lower depths, reporting on street people, such as boardmen and beggars, who had 'gone to the wall', and also on the industrious poor who were likely to struggle through by dint of saving and hard work. Where a personality is involved, a natural aristocrat of the back alleys like 'Tickets' or the Temperance Sweep (making a go of it having once reached 'that extreme stage of intoxication

which rendered medical assistance indispensable'), Thomson makes portraits. 'Tickets' is a thoughtful artist musing in his studio. Further down the scale merely representative types, flower-sellers for example, are posed as specimens. Two public disinfectors, ex-roadmenders towing a cart, hold themselves with tin-soldier rigidity, as operatives under top-hatted supervision. Thomson worked with an idea of social gradation in mind. Even in the gutter there were natural aristocrats, aspiring bourgeois and loyal foot-soldiers. Which is to say that his vast and rapidly varying subject is circumscribed, presented as an entertaining miniature community with its own language and hierarchy.

Thomson edited and arranged in the interests of efficiency and improvement. His principal successor as a maker of photographic books, Peter Henry Emerson, looked rather for respite, for an alternative reality, opposed to and better than the one which prevailed in England in the 1880s. He acted on behalf of a vanishing lifestyle in which Thomson's industrious values played no part whatever. His favoured site was an archaic East Anglia, and his bogeymen were Thomson's 'cockney' degenerates, and their affluent relatives, who threatened to overrun England. London was a prime source of wickedness, a 'fog-bound city' where the inhabitants 'stalked like ghosts over the snow beneath the yellow mephitic fog'.

Emerson was an artist of consequence, and the first photographer to struggle in public and in full consciousness with the limitations of his medium. He started out modestly enough, following deferentially in the footsteps of painters, but he soon put received ideas to the test and over a period of around ten years, from the mid-eighties onward, recorded his findings in a series of articles, journals and documentary writings unequalled in the history of photography.

His fame is largely as a photographer of East Anglian life, and partly as an intellectual roustabout and contentious aesthetician, prone to terrorize the photographic community. He was born in Cuba in 1856, of an English mother and an American father. In his schooling, in England, and in his university days, at Cambridge, he seems to have won every sort of distinction. He trained to be, and qualified as, a doctor, but became interested in photography in 1882, and was a photographic celebrity by 1885. Between 1886 and 1895 he published eight sets of photographs in books and in portfolios.

Emerson's first major venture was *Life and Landscape in the Norfolk Broads* (1886), jointly written by Emerson and his friend the painter T.F. Goodall, with forty platinotypes printed by Valentine of Dundee. The book was published by Sampson Low, Marston, Searle and Rivington, publishers of

Thomson's *Street Life*. As the title suggests, the pictures are of peasant life and of landscape. Some feature peasants and sportsmen in apparently candid close-up as they harvest and hunt. Heavy-limbed countrymen trudge home from their labours. Sportsmen look alert on the marshes. Peasant cottages nestle in the gloaming. All told, Emerson gives a comprehensive picture of a way of life. He shows a land of mists, reflective waters and flat horizons peopled by fishermen, reed-cutters, small farmers and boatmen, in a book intended as a document and work of art.

Two main influences shaped *Life and Landscape*. Its pictures of folk life are based on those of the French artist Jules Bastien-Lepage, the foremost naturalist artist of the seventies and eighties, whose pictures were regularly seen and admired in London. Emerson wrote in favour of them, and in one or two instances made direct imitations in photographs. This was a formative influence which he went on to reject. Bastien-Lepage concentrated on peasant life and labour, as J.-F. Millet had done earlier in the century. His was a simple, sober art, to do with people who lived close to nature. He reported dispassionately, and showed his subjects in context, as did his English followers, who centred themselves on the Cornish fishing port of Newlyn after 1880. By virtue of working intently out of doors the Newlyn painters hoped to achieve truthfulness. They were also in search of fundamentals, of an authentic, natural way of life to set against metropolitan artifice.

In the second place, Emerson and Goodall drew on a tradition of regionalist reporting, overlooked in all accounts of their work. From the 1840s at least, Norfolk had been envisaged as a primitive paradise, teeming with game, vivid with fragrant flowers, and the home of the last free men in England – fishers and hunters who lived on the fruits of the land and waters, and recognized no superiors. The laureate of this English Arcady was George Christopher Davies, whose *Norfolk Broads and Rivers, or The Water-Ways, Lagoons, and Decoys of East Anglia* was published in 1883, with photolithographic illustrations by T. and R. Annan of Glasgow, from Davies's photographs. Davies travelled by boat through the fen country, and his journal is both guide and adventure story. Emerson's books follow much the same pattern. He took Davies's writing as a model, just as he did the painting of Bastien-Lepage.

Norfolk's meaning was crucial to Emerson's enterprise. It was not simply a beautiful spot. To its devotees Norfolk seemed like the last enclave of ancient life in England. Yet its time-honoured ways were under pressure. Drainage schemes encroached on the marshes and threatened their wildlife and all who depended on it. Harsh game laws, enacted for the sake of visiting anglers and landowners, bore down on the livelihood of native hunters. The coming of

38   PETER H. EMERSON 'A Winter's Sunrise' The first of sixteen photo-etchings in
*Marsh Leaves* (London 1895).

the railways reduced river traffic and closed the boatyards. Tourism brought
degenerate townspeople into this last sanctuary. Davies was alert to the
implications of progress, but not much troubled. Emerson was disturbed, to
the point of violence, and his writing in particular is that of a desperate man
aware that his best efforts can do nothing to stem the tide.

An immediate problem which faced both Emerson and Davies was that of
the disparity between what they saw and sensed and what photography
allowed them to record. Both spent their days in paradise: 'On its western
margin there are wooded glades quivering with sunlight and shadow; green
park-land and fruitful fields; cattle standing knee-deep in shallow bays under
the shade of ancient trees . . .': Davies, on Wroxham Broad. The beauty of
the place was infinite and heartbreaking. Emerson, in love with the
landscape, overlooked nothing, from winter's mists to summer's fullness.
Yet such opulence was beyond the scope of photography and, eventually
realizing this, Emerson had to content himself with exquisite miniature
pictures of frozen earth, mists and far horizons – winter landscape, which
suited photography's monochromatic limitations. His last illustrated book,
*Marsh Leaves* (1895), contains sixteen of photography's most reticent
pictures, tiny photo-etchings of a remote grey world punctuated by thorn
trees and wasted reeds. These resemble nothing so much as souvenirs, fragile
mementos impressed on paper.

To do full justice to such opulence and variety as he found in the Norfolk Broads Emerson had to rely on words, which eventually made up for everything the camera had promised and failed to deliver. Emerson was no ordinary writer, although he could be longwinded and apocalyptic when goaded by modern enormities. Guided by naturalistic precepts he wrote, when in control of himself, as a recorder, describing landscape and transcribing local speech. In his introduction to *Wild Life on a Tidal Water* (1890) he emphasized that all his descriptions were '*written on the spot*, and with as much care and thought as a good landscape painter bestows on his work.' His descriptions are precise and evocative, and his transcripts from local speech extraordinarily vigorous. At times he seems to suppress himself altogether, and to act simply as a camera eye (and ear).

At other times his reporting is anything but objective. He felt acutely for landscape as a living thing, stirred by the springtime, purified by fire, flayed by the wind, smothered and killed by winter. Some of his descriptions of this animated world read like word pictures of agile expressionist landscapes. Naturalist objectivity was at odds with a powerful subjective sense likely to dramatize anything which came its way. Why, in this case, did Emerson trouble to photograph at all? Because the camera, with its sparing depictions, placed some control on an imagination which threatened to run wild. His documentary scruples over reported speech fulfilled much the same function.

Gradually he lost faith in his and the age's remedies. At first he put his trust in art and culture. In *Wild Life on a Tidal Water* he still believed in the priority of culture: '. . . we must never forget that it is through artists of all kinds that we learn to love nature, to them we owe all our appreciation of nature . . .' By the time he came to write *On English Lagoons* he thought otherwise: '. . . the more one sees of natural effects the more is one persuaded that Nature sings oftener in harmony than many a painter would have us believe . . .'

Yet if Nature was the supreme artist and beneficial influence, what was Emerson to make of his findings in East Anglia? Like Bastien-Lepage and his successors he had begun by believing in the dignity of peasant peoples who lived in close contact with the natural world. His peasants, however, rarely acted the part. They were certainly at one with nature, but behaved more like foxes or wolves than enlightened beings. Their conversations with Emerson were mainly of hunting, of great hauls with hooks and nets, swivel-guns and cripple-stoppers. Rare birds went the same bloodstained way as the rest. Sometimes his hunters behaved outrageously: one, described in *Wild Life on a Tidal Water*, watched indifferently as a boatload of tourists drowned in a treacherous estuary. They were a pitiless lot, who gainsaid most of what

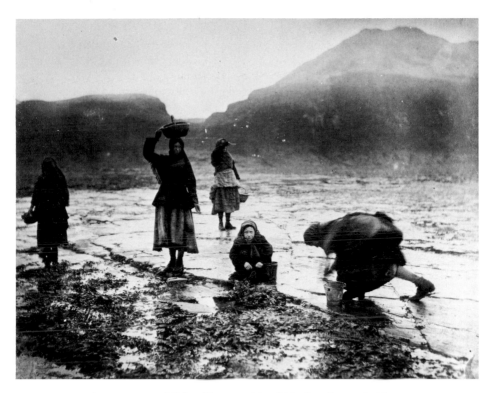

39 FRANK MEADOW SUTCLIFFE 'Flither [limpet] pickers' No date, but probably
from the 1880s when a taste for seacoast imagery was developing in Britain.

might be expected of them. In the end Emerson emerges as a stoic, accepting
the brutality of the fen people and content to register landscape's effects on
himself.

Emerson's fen country, especially as he first imagined it, was an archaic
dream land, designed to keep metropolitan England at bay, to drown out the
sounds of barrel-organs and beer saloons. It had many successors, including a
Germany of medieval townscapes and ancient oaks discovered by
photographers in the troubled 1920s, and a France of wine-growers and
sturdy peasants revealed by Henri Cartier-Bresson, André Kertész and
Brassaï in later years of crisis.

Emerson's quest was paralleled, though less systematically, by F.M.
Sutcliffe, a portrait photographer working in the town of Whitby on the
Yorkshire coast. Sutcliffe made his living through portraiture, but his main
interest was in genre, of the kind practised by Emerson in his early days and
by the naturalist painters who worked in Brittany and on the Cornish coast.

71

He photographed seacoast counterparts to Emerson's heavy-limbed peasants. Sutcliffe's personnel, fishermen and their womenfolk, converse on doorsteps or on the quayside, arrange their catches and scour the rocks for bait.

Like Emerson, Sutcliffe was disturbed by the passing of old ways. His town, once famous for fishing and boatbuilding, was coming to rely increasingly on the tourist trade, and with that its old animation vanished. Garish sounds of barrel-organs and hurdy-gurdies replaced the noise of the shipyards; sailing boats were replaced by steamers, and rowing boats by motor launches. In the surrounding countryside things were little better, as such itinerant tradesmen as tinkers, scissors-grinders, peddlars, pot-hawkers and mole-catchers died out and were not replaced. In the town old cobbled streets were cemented over and pantiles gave way to regulation slates. Sutcliffe wrote about these modern shortcomings at length, especially in his later days, and during his most creative years, in the 1880s and 90s, set himself to record this vanishing world.

## Colour plates

Monochrome photographs from the nineteenth century come in various shades of brown and orange. Most albumen prints are in a resonant umber, and their tonal range is narrow by comparison with that evident in monochrome prints from this century. Atget's vase from Versailles has something of the unified tonality of early photography.

The Autochrome process, marketed by the Lumière brothers from 1907, made possible pictures which were even more fused and unified, free from glaring lights and oppressive shadows. Lartigue's autochromes show the world at ease, beautifully blended. John Havinden, with bulk and texture for his subject, uses colour to confirm the existence of matter, but during the 1930s photography's tasks were mainly social and reformist, for which urgent black-and-white was an apt medium.

When a new generation of photographers turned to colour they were already at home in monochrome. As a result most colour photography during the 1960s and after is highly deliberated and often very witty: Harry Callahan and Manuel Alvarez Bravo displace colour – a wall doubles as a sky or holds the colour of an absent tree. A dingy pool in Memphis gives up its bright hue to a lapping hound photographed by William Eggleston. Helen Levitt works with a different sort of system, placing vivid pairings of white and red over a subdued ground of grey and pink. Joel Meyerowitz, by contrast, uses colour to show continuous space, and to represent the world as large and unbounded. His photography is rich with palpable impressions of light. Thus Meyerowitz remakes and amplifies the photography of Stieglitz and Weston. Colour has given new access to photography's established modes.

1 EUGÈNE ATGET 'Marble Vase by Jean Cornu, Versailles' Numbered 5046–1904 in the collection of the Victoria and Albert Museum, London.

III   HELEN LEVITT 'Cockerels: New York City' Dye transfer print. Published in
*Aperture* magazine in 1975.

◁ II   WILLIAM EGGLESTON 'Algiers, Louisiana' Originally published in *William
Eggleston's Guide* (New York 1976).

IV  JOHN HAVINDEN 'Beach landscape' Taken from a Dufaycolour negative of
c. 1935.

V  MANUEL ALVAREZ BRAVO 'Verde' (Green) 1966.

VII  HARRY CALLAHAN 'Ireland, 1979' Originally published in *Harry Callahan: color* (New York 1980).

◁ VI  JOEL MEYEROWITZ 'Provincetown, 1976' Originally published as Plate 18 in *Cape Light: color photographs* by Joel Meyerowitz (Boston 1978).

VIII JACQUES HENRI LARTIGUE 'Bibi au Restaurant d'Eden Roc, Cap d'Antibes'
Autochrome. 1920.

Unlike Emerson, he remained faithful to his early models; he was a naturalist throughout. Yet there is another aspect of his photography which prefigures some of what was to follow in the twentieth century. Often he arranged his mariners and quayside idlers as they might look deep in conversation. Many of his countrymen appear as solitary workers, ploughing a lonely furrow. His seacoast children muse to themselves or are engrossed by their play. His landscapes are, as often as not, misty nocturnes, more evocative than descriptive, invitations to dream about the shrouded town and the sea. Equivalent photographs inland showed tracks and rivers curving into the distance. Sutcliffe's subject is privacy. He either shows people immersed in personal or collective preoccupations, or invites his audience to do likewise in front of such suggestive voids as the open road.

It was probably for this reason that Sutcliffe became one of the first established photographers to be interested in snapshots. Lightweight cameras were promoted by the Kodak Company in England in the late nineties and Sutcliffe was invited to use one. He admitted that it allowed him to keep pace with his hectic times, and that it was more convenient than anything he had used before. At the same time lightweight cameras made possible a more intimate photography, which both underlined the singularity of private lives and put a premium on an artist's attentiveness. Lightweight ('detective') cameras allowed photographers, in the regulated conditions of a mass society, to declare that they had lived through and been alert to unique moments.

Meanwhile in the United States of America Edward S. Curtis was considering what was eventually to be one of photography's major enterprises. In 1896 he had begun a survey of Indian Life in North America. Needing financial assistance, he eventually turned to J. Pierpont Morgan and in 1907 published the first of the twenty volumes which finally made up *The North American Indian*. The project occupied Curtis until 1930. He began his survey with reports on Apaches, Jicarillas and Navahoes and ended with Eskimo tribes in Alaska. 'Progress' caught up with Curtis: at the outset he found successors to Jackson's aboriginal Indians, braves like Kills in Timber, an Ogalala from 1907 featured in Volume 3; by the end his Indians had adapted to white man's ways, and by 1927, nearly 40,000 negatives into the survey, Wilbur Peebo, a Comanche chief, sat for Curtis in a collar and tie.

Like Sutcliffe's seacoast folk, the Indians were, or seemed to be disappearing. Curtis regretted this, but saw that it was inevitable. Nature, manifest in the work of the American people, willed it. He viewed the vanishing buffalo herds in the same way: 'If by care they could have been

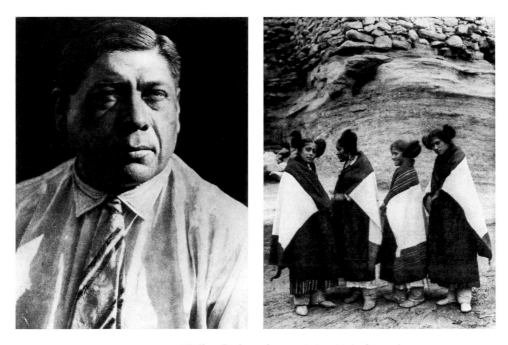

40  EDWARD CURTIS 'Wilbur Peebo – Comanche' Published as a photogravure in Vol. 19 (*Wichita, Southern Cheyenne, Oto, Comanche*; New York 1930) of *The North American Indian*.

41  EDWARD CURTIS 'Hano and Walpi Girls Wearing Atóö' Published as a photogravure in Vol. 12 (*The Hopi*; New York 1922) of *The North American Indian*.

utilized for twenty five years longer, they would have served like other things of primeval life, their natural purpose, and we could have viewed their end with only that regret with which we see the forest fall and the prairies' broad surface turned sod by sod from its natural beauty to the utility that Nature's own laws demand.'

Aware of a rapidity and inevitability in social change, Curtis set himself to record what was passing away. His books are endlessly informative, in both words and pictures, about people 'destined ultimately to become assimilated with the "superior" race'. He ranged widely, and gave detailed accounts of farming and fishing techniques, Indian politics, religion and art. In part he wanted to alter the conventional picture of Indian life, and to show that they were also skilled in the arts of peace.

Nonetheless, *The North American Indian* is a peculiar kind of documentary. Despite its mass of details on basket- and blanket-weaving, travois-making, food storage, and so on, it is as evocative as it is explicit. Introducing the first volume, Curtis said this about his intentions: 'While primarily a photographer, I do not see or think photographically; hence the story of Indian life will not be told in microscopic detail, but rather will be presented as a broad and luminous picture . . .' His photographs certainly bear this out; printed in photogravure, they show Indians, their lands, homes and artefacts, in a gentle, diffused light, as evocative as that which washes through Sutcliffe's Whitby.

It is an ideal light because his Indians are ideal people, even if some of them, like the Mohave, were sent out 'the wrong way' by the Creator. They are imagined by Curtis partly for their own sakes, and partly as an example to his

42　EDWARD CURTIS 'Apache Still Life' Published as a photogravure in Vol. I (*Apache, Jicarillas, Navaho*; New York 1907) of *The North American Indian*.

contemporaries who might, he implies, do well to learn from them. In addition to his major work he wrote and illustrated popular books, such as *Indian Days of Long Ago*, published in 1914 and introduced as a moralizing text: 'I have tried to show how their religious beliefs influence the character building of youth . . .' He emphasized this again and again, as a main part of his purpose and as a notable feature of Indian life. Moreover he supported this view of Indian affairs with portraits which accentuate soulfulness; his Piutes and Pawnees are as spiritual and grave-eyed as any of Mrs Cameron's Victorian notables. They are also portrayed in much the same way, as possessors of an inner light which shines forth from the darkness.

In the second place his Indians are a people devoted to the arts, as he noted in his introduction and repeatedly stressed in words and pictures: 'Likewise with their arts, which casual observers have sometimes denied the Indians; yet, to note a single example, the so-called "Digger" Indians, who have been characterised as in most respects the lowest type of all our tribes, are makers of delicately woven baskets, embellished with symbolic designs and so beautiful in form as to be works of art in themselves.' The tribes of the south-west, to which he first attended, were all skilled in handicrafts and his earliest pictures, in the books and in accompanying folios of gravures, feature many Navajo and Mohave still lifes of baskets, pots and blankets. Thus his plea, delivered indirectly under anthropological guise, was for a society devoted to religion and to the arts. That is: he dreamed of Utopia at a time when Lewis Hine, one of America's greatest documentarian photographers, was just beginning to reveal enormities of child labour and exploitation in the industrial North.

Curtis's tactic was to present a timeless world of long ago as an example to the present, a world as Arcadian and ideal as anything imagined by Emerson in his early days. Like Emerson, he too introduced himself as an authentic reporter taking notes on the spot: 'At the moment I am seated by a beautiful brook that bounds through the forests of Apacheland. Numberless birds are singing their songs of life and love. Within my reach lies a tree, felled only last night by a beaver, which even now darts out into the light, scans his surroundings and scampers back. A covey of mourning doves fly to the water's edge, slake their thirst in their dainty way, and flutter off.' This was a Nature altogether different from that which built the railroads, killed the buffalo and turned the prairies sod by sod. The two could hardly be reconciled, and Curtis acknowledges this in publications which are objective and evocative by turns, filled with detailed expositions of Indian practice and illustrated by moody pictures of spiritual tribesmen and tranquil evenings in the desert.

43 EDWARD CURTIS 'Ola-Noatak' No. 716 of 722 large photogravures published to accompany *The North American Indian*. This image is linked with Vol. 20 (New York 1930), on the Eskimos of Nunivak, King Island, Little Diomede Island and Cape Prince of Wales.

Curtis's concerns were shared by an Englishman, Herbert G. Ponting, best known as the official photographer on Scott's British Antarctic Expedition of 1910–13. From 1904 onwards Ponting had worked in Japan, taking pictures for the commercial firm of Underwood and Underwood. His first book, *Japanese Studies*, was collotyped by K. Ogawa in 1906, and then in 1910 Macmillan published his more detailed account, *In Lotus-Land Japan*.

Ponting, too, was involved in a search for Utopia, and he found something very like that in Japan, where religious practices governed daily life, and where art was respected and everywhere evident, in costume, pottery and even in the rice fields. Japan was also a notably successful society, whose forces had routed the Russians in 1904. They had lessons for a West which, Ponting implied, was crassly materialist and a bad influence, even then subverting Japanese design standards. Ponting deplored export ceramics, which catered 'for the most atrocious foreign taste'.

He pictured the Japanese as craftsmen, fishermen, artists and pilgrims, studious in their work, or at ease in gardens or by the water's edge. His photographs mimic the spare arrangements to be found in Japanese prints, and suggest a graceful tranquillity: he prefaced *In Lotus-Land Japan* with a quotation from Shelley:

> They came into a land
> In which it seemed always afternoon.

In Antarctica, where he entertained Scott's Polar explorers with his Japanese studies, Ponting found an even more ideal world, one entirely free from social disorder and 'atrocious foreign taste'. Antarctica, or *The Great White South*, as Ponting called it in the title of his book of 1921, was the ultimate destiny of nineteenth-century photography, a purified, virginal world foretold by Emerson's final pictures of the wintry fens. It allowed Ponting to work in a more sparing, abstract way than ever, with stern, straight horizons, mosaicked and patterned ice and cloudless skies. The frozen South, though pitiless, was a port after stormy seas and an aesthetic absolute, entirely indifferent to all of culture's shortcomings and intricacies. Ponting himself came to this elemental landscape after a hectic, questing life: 'six years' ranching and mining in Western America; a couple of voyages round the world; three years of travel in Japan; some months as war correspondent with the First Japanese Army during the war with Russia; and in the Philippines during the American war with Spain; and . . . several years of travel in a score of other lands.' This roving career through many lands, assuaged by such austerity and purity as he found in Japan and in the Great White South, offers itself as a parable of nineteenth-century life.

44   HERBERT G. PONTING, F.R.G.S. 'The Pines of Mio: "Bent and twisted by the winds that blow"' Published as a collotype in Ponting's *Japanese Studies* (Yokohama 1906).

# Truths Beyond Appearance

*Artist-photographers in Europe and the United States, c. 1900*

EMERSON, SUTCLIFFE, CURTIS AND PONTING are explicable photographers. They were, to a considerable degree, reporters, interested in and informative on peasant life, Indian ceremonial and Japanese domesticity. Some of their contemporaries, however, are less readily understood. Many of them were ambitious artist-photographers, keen debaters, critics and exhibitors. Many were members of photo societies such as the Photo-Club of Paris, founded in 1885, The Linked Ring, established in London in 1892, and the Photo-Secession, founded by Alfred Stieglitz in 1902. They made names for themselves, drew critical attention, and won prizes at international exhibitions.

Prior to 1890 declared artist-photographers were few in number; after that date they appear in quantity, all over Europe, and in the United States. In Britain James Craig Annan was a major innovator. After 1900 the best-known British photographer was Frederick H. Evans, a former bookseller who became known for his pictures of landscape and medieval architecture. For the most part these artist-cameramen were amateurs: Charles Job, a specialist in pastoral landscape, was a stockbroker; Alexander Keighley owned a woollen mill; Joseph Gale was an army officer, and Reginald Craigie a clerk in the Bank of England. These middle-class men of affairs were mainly landscape artists, who envisaged the British countryside in idyllic terms, inhabited – if at all – by pastoralists and sprites. They were questers after the sort of vision imagined by another Bank of England employee, Kenneth Grahame, in 'The Piper at the Gates of Dawn' in *The Wind in the Willows* (1908). Grahame described trances in a sacred land, during which all was transformed, beautiful and spiritual. The photographers dreamed likewise: dryads dance in the misty distance of Keighley's 'Fantasy' of 1913, and linger on the banks of any number of silent pools and tranquil rivers.

For most of these gifted amateurs photography allowed a way out, into an imagined Olde England or into other charmed worlds. In 1892 some of the most innovative art photographers in Britain, impatient with sharp-focus traditions, founded The Linked Ring. This was as bizarre as any of W.S. Gilbert's inventions; it featured a 'Controller of the Exchequer', and a 'High Executioner' and 'Deputy High Executioner' – in charge of annual

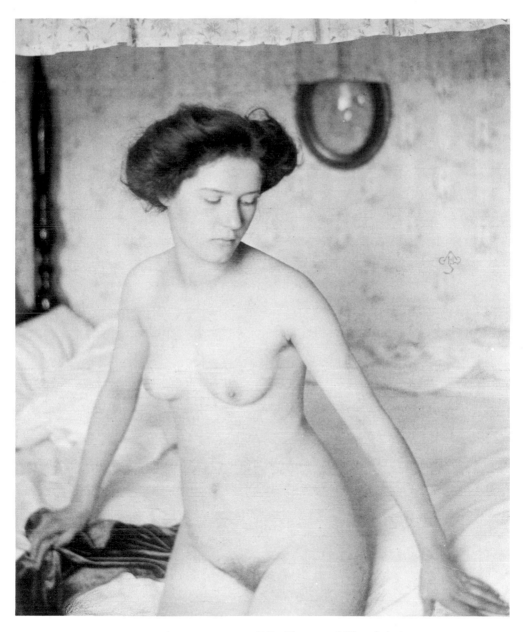

45    CLARENCE WHITE and ALFRED STIEGLITZ 'Miss Thompson' Waxed platinum
print, *c.* 1907.

46　FRANK EUGENE 'Stieglitz, Steichen and Kuehn Admiring the Work of Frank Eugene' Platinum print, 1907. Named by Stieglitz 'The Tutzing Trio'.

exhibitions. It was a gentlemen's club, which eventually admitted women in 1900, and it staged important international exhibitions, or salons, from 1893 until 1909. The Linked Ring was established as a rival to the now Royal Photographic Society, and among its founders were the veteran Henry Peach Robinson and Henry Herschel Hay Cameron, son of Julia Margaret.

Britain had no dominating equivalent to America's Alfred Stieglitz, eventual winner of over 150 medals and prizes in international exhibitions. Stieglitz had been a rising star since 1887 when Emerson first singled out one of his pictures in a Holiday Work Competition in *Amateur Photographer*. He was elected to The Linked Ring in 1894, and he edited *American Amateur Photographer* until 1896, when he founded *Camera Notes* for the Camera Club of New York. On resigning in 1902 he set up the American Photo-Secession and then began to publish *Camera Work*, which went through fifty issues until 1917 and became the most esteemed of all photographic publications.

Stieglitz's only rival in the United States was F. Holland Day, a prodigy from Boston, where he ran a publishing company. Day emerged in 1896, and quickly became a rival to Stieglitz as a photographic organizer – his major

47　FREDERICK HOLLAND DAY 'The Vision' From the 'Orpheus' series. Platinum print, 1907.

promotion was an exhibition, *The New School of American Photography*, sponsored by the Royal Photographic Society in London in 1900. Like his British contemporaries he also pictured worlds apart, rocky landscapes mainly, peopled by classical deities – Orpheus especially. His most controversial project, carried out in 1896 and 1898, was a photographic series on the Passion of Christ, with Day himself, bearded and starved, playing the main part.

Among the photographers promoted by Stieglitz and Day were Rudolf Eickemeyer, Gertrude Käsebier, Joseph Keiley, Clarence White, Edward Steichen, Alvin Langdon Coburn, Frank Eugene, George Seeley and Anne Brigman. They were more forthright symbolists than their British counterparts. More often than not they chose to epitomize rather than to evoke Nature, often with nude figures of fauns and nereids, piping and sporting among rocks and on seashores. Frank Eugene, trained as a painter in Munich from 1886, photographed a Pan figure piping in a dark wood in 1897 – the sort of pagan subject favoured at the time by such Northern painters as Arnold Böcklin. Clarence White, perhaps taking his cue from Day's 'Orpheus' pictures of 1907, photographed another musical faun in a dark nook in the same year. Anne Brigman, a relative latecomer who worked mostly in California after 1903, made picture after picture of nereids and dryads in expressive poses by trees, rocks and water over such titles as 'Dawn' and 'Soul of the Blasted Pine'.

France's outstanding artist–photographer throughout this period was Robert Demachy, a member of a banking family and active as a photographer from 1880 onwards. Demachy was interested in printing techniques, especially the gum-bichromate process, which he used after 1894; this was a species of low-relief printing which could easily be tinted. The result is that his pictures look scarcely at all like conventional photographs and more like photographically based lithographs. The same is true of pictures by his contemporaries René le Bègue and Constant Puyo. The French were well known for their interest in 'artificial' techniques.

Demachy had the widest range of any photographer working at the turn of the century. Where his American counterparts 'seem like sincere artists whose pictures reflect on and express their beliefs, Demachy appears as a picture-maker able to work in any number of modes. He took pictures behind the scenes at the ballet, and his prints look like variants of Degas drawings. His tree-lined landscapes and misty rivers might have been seen by Monet, and he was an able naturalist in Brittany and in the alleyways of old towns. Demachy's was a thoroughly disinterested art; his nudes, in particular, have an impersonality matched in no other photographs at that

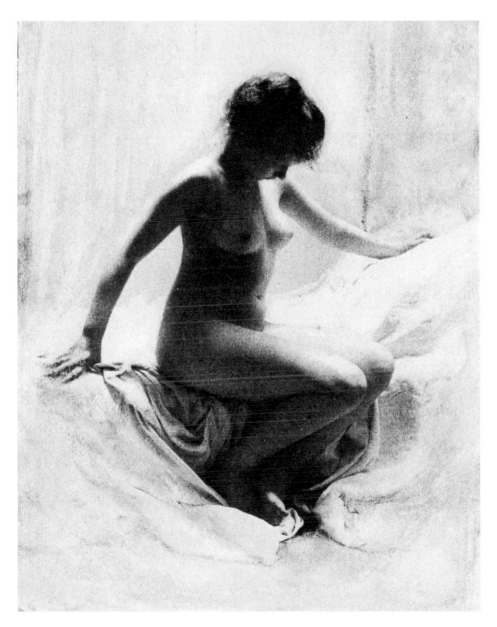

48   ROBERT DEMACHY 'Académie' Grey pigment gum–bichromate print, 1900.

time. His models act their parts coolly, as embodiments of Fatigue, Languor or Youth. They might have stepped straight out of an Ingres painting, whereas their American counterparts hold themselves as though involved in some fraught, naked encounter.

The Photo-Club of Paris, to which Demachy belonged, had staged one of Europe's first and largest exhibitions of artistic photography, at the Galerie Durand-Ruel in 1894. This show, which included 505 pictures by 154 artists, was chosen by a jury dominated by painters. The first of these jury-selected international exhibitions had taken place in Vienna in 1891, and Hamburg had followed suit in 1893 with an enormous exhibition of amateur photography. Photographers from both centres were respected on the international scene. Vienna produced the gum-printers Heinrich Kuehn, Hugo Henneberg and Hans Watzek, who experimented with multi-coloured prints from the mid-nineties. Kuehn's pictures, mainly of relatives, friends and children, are unusually discreet and intimate. Henneberg and Watzek were landscapists – Henneberg in a funereal style which recalls Böcklin's *Isle of the Dead*. Watzek, an unusually careful worker, produced only sixty-five pictures in twelve years.

What were these art photographs like, and what did they mean? In the first place, much of what was made between 1890 and 1910 is hard to tell apart. A representative exhibition print of this period would be of a misty landscape, punctuated by a setting sun and a line of trees – rhythmic poplars, perhaps – mirrored in reed-flecked waters. Pictures of this sort were introduced as 'landscape arrangements', with such titles as 'The Pool', 'Fleeting and Far' and 'A Garden of Dreams', and they look very much alike, irrespective of author and place of origin. German pools were sometimes darker and the English countryside more dreamy, but the basics of the idiom were international. This is the first paradox of artistic photography: a near-anonymous international style in the hands of prickly, selfconscious individuals.

A second contradictory feature of an era in which photographic art went public as never before, through books, magazines, catalogues and incessant exhibitions, is a pervasive sense of intimacy. Time and again photographers drew their subject matter from family circles and from close friends. To look through any collection of art photography is to be put in touch with a charmed society of painters, writers, dreamers and exquisite children, all graceful in ethereal light. This, of course, had been prefigured by Julia Margaret Cameron and by Hill and Adamson, who were admired in this era, but the new intimacy was much more fragile and delicate than anything which had gone before. Heinrich Kuehn's pictures look like pages from a

49  HEINRICH KUEHN 'Der Malschirm' (The Artist's Umbrella) Hand-printed photogravure, 1910.

gracious family album, peopled by exceptionally handsome children, dignified elders and elegant womenfolk, wind-blown in summer meadows. Kuehn was rivalled in this respect only by the American Clarence White, a book-keeper of slender means with a grocery company until 1904 – and thereafter a professional photographer and teacher. White, bedevilled by cares and vexation according to Stieglitz (who was a friend and eventually an antagonist), imagined an even more refined world than that of Kuehn. His protagonists, elegant children and grave young ladies, act with the utmost decorum in cultivated nature. He was the most Japanese of all the artist-photographers and a virtuoso arranger of simple shapes.

These delicate creatures of the light, summer girls and shining children, told of – or at least held out hopes of – a perfected civilization. Nothing of the workaday world clung to them. They were at one with nature, at their ease in flowery meadows or strolling among the trees. They were not simply personifications of ideal Youth and Beauty, although they were that too.

Delicately, they refer to family life and to procreation; but theirs is a family life purified of coarse sensual drives, hallowed by association with the guiltless flowers. At the same time, easy and unaffected in nature and in our presence, they point to a luminous future world in which mankind will be candid and unembarrassed. In this respect Kuehn's children and White's maidens are close relations to the slender nudes of Steichen and Demachy, who wear their nakedness with ease and likewise foretell a candid future. A member of The Linked Ring, writing in 1896, counted it as one of the achievements of the society to have fostered 'the Study and Exhibition of the Delineation of the undraped Figure'. Nor, he added, had there been 'a single Protest'. In truth the nudes of the artist-photographers are clothed in chastity and, with one or two exceptions, thoroughly unalluring. The odd artist out was Frank Eugene, the German-schooled American who was a fetishist among the aesthetes. Where White, Kuehn and most of the others aimed at a pale-toned, seamless integrity, Eugene preferred to set ripe figures against wispy, half-obliterated backgrounds. Nonetheless, his personnel also belong to a world apart, that of the studio, Bohemia and medieval romance.

The principal outsiders in the charmed family circles of artist-photographers were other artists and photographers. Stieglitz looks out intently in photographs by Käsebier, Steichen, Kuehn and Eugene. Eugene photographed the painters von Uhde, Geiger and Heyligers. Steichen photographed almost everyone, including Rodin, of whom he made many studies which show the sculptor in meditation, as an old man of the mountains. Both Eugene and Steichen were painters as well as photographers, and they were familiar with the best-known artists of their time. Moreover, art had a special value. It was not simply a practice around 1900, more like a hallowed calling. Artists were Nature's spokesmen, at a time when Nature, Truth and Beauty were understood to be closely intertwined. Artists – and Rodin was the supreme example of this – revealed what was inherently beautiful and forceful in Nature and in Mankind, for the two were inextricably associated. Their liking for centaurs, fauns, wood and water nymphs was no accident of taste: all of these mythical creatures, near relations to Man, lived in close and harmonious contact with Nature and served as convenient metaphors in the art, photographic and otherwise, of the late nineteenth century.

These were the sort of Truths with which artists, well attuned to Nature and to Beauty, had to deal. This is why an artist such as Stieglitz regarded himself so seriously, and why Frank Eugene captioned one of his portraits of Steiglitz 'Photographer and Truthseeker'. This sense of a high calling also accounts for the incessant wrangling which is such a distinguishing feature of

50　EDWARD STEICHEN 'Little Round Mirror' Gum-bichromate over platinum print, Paris, 1902, from a negative of 1901.

51　FRANK EUGENE 'Nude – A Study' Platinum print, 1898.

photographic affairs around 1900. There were certainly some dilettantes involved in photography at that time, but the principal figures were absolutely in earnest. For the most part they seem even more earnest than their contemporaries in painting and sculpture; for they were, in terms of the larger art world, an excluded sect, often relegated to the industrial sections of major exhibitions and forced to contend with jury selection by painters and sculptors. Hence the foundation of so many photographic magazines at this period, of which Stieglitz's immaculate *Camera Work* is deservedly the most famous. Hence, too, the ethos of parochialism and intransigence evident in photography ever since.

Closely connected with the intimate mode came a new interest in snapshot photography, in unique configurations caught in passing. A pioneer and

52   JAMES CRAIG ANNAN 'A Franciscan, Venice' Hand-printed photogravure. The negative was made in 1894, and the picture published in *Camera Work* in October 1904.

53   JAMES CRAIG ANNAN 'Stirling   ▷
Castle' Photogravure, first exhibited in 1904 and published in *Camera Work* in July 1907.

leading exponent of this was James Craig Annan. He was the son of Thomas Annan, who was a noted documentarian in Glasgow in the 1870s and head of the firm which photo-engraved Davies's fenland pictures in 1883. The young J.C. Annan and his father had gone to Vienna in 1883 to study the photogravure process with its inventor, Karl Klíč. By 1892 he was taking his own photographs, and soon after he began to publish and exhibit them as gravures. Annan, a diffident artist, was much admired by Alfred Stieglitz and his pictures appeared in five issues of *Camera Work*. Stieglitz himself took instantaneous pictures in the early nineties.

Annan had a relatively long career as a productive art photographer. Having begun around 1890, he was still at work in the 1920s, and some of his most intriguing pictures date from a journey to Spain in 1913. Annan's output varies: in the early nineties he was sometimes a naturalist in the style of Bastien-Lepage and Emerson. He stands out, however, as a connoisseur of transience. Where Emerson's naturalistic peasants hold themselves in dour facsimiles of action, Annan's varied cast of peasants and passers-by stride out and even glance fleetingly towards the camera. His pictures are conspicuously the work of instants.

Annan, however, was not simply a technician or an analyst of movement. His instants are not those of Eadweard Muybridge, who photographed motion in the eighties in order to discern just how horses moved their legs at a gallop or gulls their wings in flight. Nor was Annan a narrator singling out significant moments in a story from which all the rest could be imagined. Nothing of any great consequence looks likely to arise from his photographic notations: his protagonists hurry by immersed in their own affairs – two White Friars, for instance, step out on a sunlit day in Italy in 1894, and in another photograph, made on the same tour, a dark Franciscan hastens by a corner towards the waterside. These are, to a certain degree, genre pictures of representative Italian types, but they soon gave way to a purer type of instantaneity. Around 1903, for example, Annan photographed Stirling Castle on its imposing Scottish crag. In the foreground a white horse moves tentatively into the shadow of a farm building. A major monument has thus become no more than a setting for a transient incident: a moment which caught Annan's eye. In the same way, in 1894, Italy, land of culture and piety, became a mere backdrop for scurrying monks and, in 1913, ancient Spain was seen as a site peopled by casual

peasantry and passers-by. In other words Annan worked ironically, qualifying generalized meanings with transient notations – even in venerable Burgos, he noticed, bullocks had to tread warily on the cobblestones.

Nonetheless, snapshot photography as practised by Annan and Stieglitz did not only involve ironic references to accidents and momentary observation in the presence of large ideas. In 1897 Stieglitz discussed the hand camera and its importance and made no reference to irony whatever. Instead he emphasized how deliberately he set out to take instantaneous pictures:

In order to obtain pictures by means of the hand camera it is well to choose your subject, regardless of figures, and carefully study the lines and lighting. After having determined upon these, watch the passing figures and await the moment in which everything is in balance; that is, satisfies the eye. This often means hours of patient waiting. My picture, 'Fifth Avenue, Winter', is the result of a three hours' stand during a fierce snow-storm on February 22nd, 1893, awaiting the proper moment. My patience was duly rewarded.

To judge from his snapshot pictures, Stieglitz was watching for moments when the casual life of the street harmonized, when random elements came to terms with a pre-existing pattern of lines and marks given by sidewalks and buildings. In other words, pictures existed in nature, but only an artist, sensitive to natural harmonies, could identify them. The rest of Stieglitz's article, published in the *American Annual of Photography*, is made up of an attack on 'enthusiastic Button Pressers' who imagined that pictures resulted as a matter of course when a plate was exposed.

Both Annan and Stieglitz emphasize that they, as artists, have a special relationship with the world of appearances. Annan shows himself to be susceptible to the extraordinary, to moments when commonplace material shows itself in an unusual light. The horse at Stirling and the monks in Venice present themselves thus for an instant only, and only to his eyes. His is a different sort of privileged vision from that of Stieglitz, which is keyed in to those intrinsic harmonies only manifest, he implies, to a patient and sensitive artist.

Annan was working with reference to symbolism. His momentary revelations are continually set against scenes which invoke general meanings: Italy, antiquity, grandeur, peasant life. Stieglitz, at that time, was a symbolist through and through. In this respect they were at one with the aesthetic tendencies of their times. Artists and theorists, taking their cue from poets, and especially from Baudelaire, had begun to think, in the eighties, in terms of *correspondances* or affinities between particular states of mind and corresponding conditions of inanimate nature. Mankind answered to certain evocative arrangements of words or materials, or 'objective correlatives' as

they came to be known. Artists who held to this view objected, above all, to what was called 'photographic seeing', which meant the kind of clinical exactitude evident in daguerreotypes. Thus photographers, already excluded by force of habit from the major institutions of art, had to cope with an additional prejudice.

In a symbolist environment Naturalism was out of favour. Art's subject was what lay behind, or was implicit in, appearance. To get at the essence of things commonplace experience had to be refined. Artists continued to refer to Nature, but they no longer concerned themselves with particular landscapes at particular times of day; instead they set out to find visual equivalents for such generalities as Spring, Evening or The Sea. The most influential of all these artists was the French painter Pierre Puvis de Chavannes, although he denied symbolist intentions on his part: 'I have tried always to say as much as possible in the fewest possible words.' His best-known picture was *The Poor Fisherman* of 1881, described by one critic as 'an extraordinary symbol of human poverty' and by another as 'more than a painting . . . a poem of life'. His pictures went under such titles as *Summer, Hope, Orpheus* and *Charity*, and in 1903 Stieglitz, in the first issue of *Camera Work*, illustrated his symbolist depiction of *Winter* (1892–93).

Symbolist aesthetics, despite the degree to which they were itemized, listed and explained in the 1890s, gave rise to difficulties. Was there, for instance, anything like an objective order or proportional system underlying appearance? Photographers often suggested that this was the case, in pictures systematically dappled by foliage and sectioned by tree-trunks and branches. This idea established itself and became a formula responsible for many neat abstract arrangements of light and shade. It brought all sorts of subjects within photography's range. Initially photographers restricted themselves to a cautious exploration of landscape, but after 1900 they turned more and more to industrial and urban subjects. Alvin Langdon Coburn, an American relative of Day, was a pioneer in this respect. Coburn, who had gone to England first of all in 1899, photographed in London after 1904 and presented an orderly view of a misty city framed and sectioned by masts and spars on the riverside. His workaday London is as beautiful as any refined landscape and as sparsely populated. It is a city purified and reduced to a few simple harmonious elements in the symbolist manner. His English successors, Ward Muir, Walter Benington and Malcolm Arbuthnot, envisaged London in similar terms; not as the sprawling chaos hinted at by Thomson and Smith in the late seventies, but as a provider of orderly arrangements in which Man made up the numbers, fitted into and provided a foil to underlying harmonies.

On the other hand, if photographers took up the purely evocative option in symbolism, and worked with suggestive voids into which an audience could project memories of seasons past, the external world could seem dissolved away, its substance denied. As a result many substantial artist-photographers had qualms about symbolism. More accurately, the medium itself had qualms, for with its inherent objectivity it was especially equipped to pick up everything which was unique or accidental about a scene. Hence those studied snapshot pictures by Annan in which all generalities are qualified, in which the world leads its own hasty life in opposition to the artist's search for essentials.

Another response to the symbolist problem was that of Frederick H. Evans. Evans began his project of photographing cathedrals in 1898, when he retired from bookselling at the age of forty-five. He was a photographic composer, attentive to subtle rhythms and repetitions in his subjects. This is evident in his landscape pictures, where he rhymes stone walls and roads with bands of trees and rocky outcrops. His landscapes are as spare and elegant as any taken at that time, and more subtle than most: in 'On Sussex Downs' he shows a swelling line of dark trees cutting over a horizon into a pale sky, while in the dark lower zone of the picture a white road recedes into the distance, echoing and reversing the line and tone of the trees. The subtly structured 'On Sussex Downs' is characteristic of his landscape pictures, where he composes as though with abstract elements – with a road as a white diagonal mark, and a line of trees as its counterpart. Surprisingly, in view of the abstracting tendencies in his own art, Evans was not greatly enthusiastic about Post-Impressionism when it reached London in 1910. It lacked that beauty of which Evans was a devotee.

Evans's idea of beauty was ideal and ethereal, and although it could reveal itself out of doors it showed most clearly in the great cathedrals and abbeys of France and England. These buildings were already rich in implications of sacred geometry, but this was not what held Evans's attention. Of his earlier pictures he said that he wanted 'to suggest the space, the vastness, the grandeur, the leading on from element to element, that so fascinates one going through a cathedral.' He was searching for a kind of perfection which was both intricate and ordered, and he found it most readily along the columned aisles and naves of large churches where dim light opened out the darkness little by little.

One critic, Roland Rood, reproached Evans in a review in the *American Amateur Photographer*, March 1906. His pictures, Rood judged, were the result of 'deadly exact calculation' and of 'spherical thought, ever circling around the centre'. Evans's cathedrals are, in fact, microcosms, embodiments

54 FREDERICK EVANS 'On Sussex Downs' Platinotype, c. 1900.

of a world moving between darkness and light. Sun streams into a dark
world, bringing order and clarity. At the same time Evans was always careful
to allow for a maximum of intervening tones. His light waxes and wanes by
imperceptible degrees across clusters of columns, 'leading on from element
to element' in ways which evoke interminable and recurring natural
patterns. One of his very famous pictures is of stone stairs at Wells Cathedral,
which he called 'A Sea of Steps'. This picture, like all of his ecclesiastical
work, intimates a lulling, contemplative rhythm through shadow into light
and back again.

Out of doors he found counterparts in the cathedral-like spaces of pine
woods, discreetly lit and remote from the agitation of ordinary life. It was
this sort of turbulence that Evans consciously opposed, and spoke about in a
lecture to the Royal Photographic Society in 1900: 'The sense of withdrawal,

an apartness from the rush of life surging up to the very doors of the wonderful building, is so refreshing and recreating to the spirit as surely to be worth any effort of attaining.'

Evans was, and was known as, a purist. Unlike Demachy and Eugene he made no alteration to his negatives, and never tired of saying so. Thus his pictures, produced as fine platinum prints, could be taken to be reliable and truthful, containing nothing from the artist's 'inner consciousness'. By this Evans meant that he was dealing with actuality. Whatever was ideal, perfect and harmonious about his pictures was not of his imagining; rather, it was in the nature of things to be so – although, as with Stieglitz, it took an artist's patience and sensitivity to make this plain.

Outside their own milieux the artist-photographers were never very influential. In Britain the refining process involved in symbolism resulted in a formulaic pictorialism which quickly lost touch with the urgencies and convictions of such pioneers as Evans. In America Stieglitz continued to be a force and an inspiration to a new generation of photographers, which included Paul Strand, Ansel Adams and Edward Weston. But Stieglitz, too, changed with the times to become a different sort of artist in the 1920s. Nevertheless, much of what had concerned the artist-photographers concerned their successors. Annan's privileged moments foretold snapshot photo-journalism in the 1930s. He was the first ironist in photography, the first to make pictures which referred to the difference between personal experience and collective or general meaning – this would once more become a pressing issue in the 1930s. Evans's search for pure, perfected images would also be taken up again by other photographers in other places, and chiefly by Edward Weston in the United States. But photographers would never again work under the guidance of such a coherent and authoritative ideology as that which dominated this era. Increasingly after 1900 the ties between Art, Nature, Truth and Beauty were loosened. The future became something which might be willed, constructed or engineered and photographers became constructivists, critics or commentators, according to their circumstances.

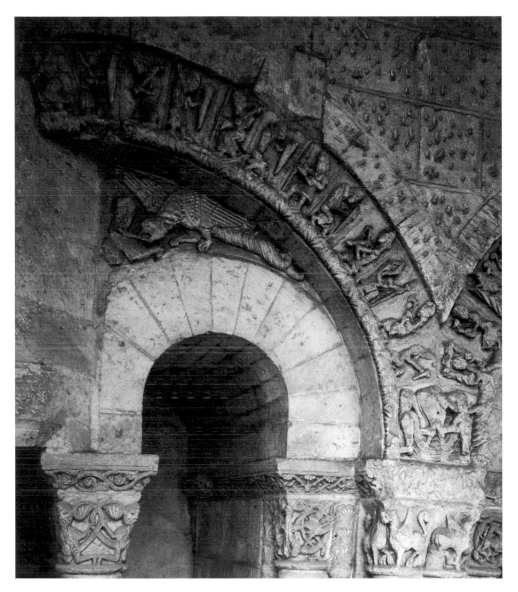

55   FREDERICK EVANS 'Angers: Prefecture. Sculptured arches of 11th–12th
Century' Platinotype, *c.* 1900.

## Looking to the Future

*New photography for new societies — and some reactions, mainly in Europe between the wars*

STIEGLITZ, WRITING IN 1897, scorned most of what had been done with 'detective' cameras. Serious photographers, he noted, thought them only 'good for the purposes of the globe-trotter, who wished to jot down photographic notes as he passed along his journey.' Yet hand cameras were inevitable, and Stieglitz set out to use his in a controlled way. Few others shared his concern, and most were content 'to jot down photographic notes' of whatever took their attention. These notes eventually became raw material for a major photographic art of the twentieth century — that of the book-arranger and the photo-essayist. At first, though, the note-takers worked privately, for their own amusement or for that of their friends.

The most prolific jotter of the Stieglitz era was an Italian, Count Giuseppe Primoli, a bold and witty photographer of high and low life in Italy and France between 1888 and 1905. Primoli, dubbed 'king of the instantaneous picture' by his contemporaries, used a lightweight Kinegraphe and photographed all walks of life at all sorts of social events. Because of his noble connections — he was a nephew to Princess Mathilde and related to the Bonaparte family — and because of his notoriety he gained access everywhere, and took pictures of popes and kings, and of the nobility, hunting, riding and idling in the Roman countryside. In 1889 he had a plan, according to Edmond de Goncourt, to photograph the Shah of Persia on a night commode, and he snapped Degas buttoning his trousers outside a public lavatory. His pictures are those of a nimble sightseer with an eye for the curious, the bizarre and the informal. He noted the most relaxed sort of street life outside temples and churches in Rome, and took pictures behind the scenes as other photographers strove to compose their subjects. In 1890 he photographed Buffalo Bill and Annie Oakley in Rome, and, like his successors in the 1930s, he took deflationary, informal pictures of, for example, a doorman engrossed in a newspaper under a 5 lire entrance sign. In his diary he noted that he had a literary sensibility, and that to have any effect on him characters had to be mediated through books, and nature through art. Through his photographs he imagined life as a series of curiosities, anecdotes or entertaining moments, looked at largely from the wings. Edmond de Goncourt reported in 1895 that Primoli made transparencies

56   TINA MODOTTI 'Tehuantepec Woman' *c.* 1928.

57 GIUSEPPE PRIMOLI 'Balancing Act' Rome, c. 1895.

58 PAUL MARTIN '"A Loving Couple" on the Sands' Yarmouth, 1892. Taken with a 'Facile' hand camera while the photographer was on holiday. ▷

from his photographs and that these were projected in the dining-room at the Princess Mathilde's. He was a successor to those bright spirits photographed by Nadar and an impious predecessor to the photo-journalists of the 1930s.

England's Primoli was Paul Martin, a wood-engraver, amateur cameraman and recorder of folk-life in the 1890s. From 1892 Martin used a relatively lightweight 'Facile' camera which allowed him to photograph undetected on the streets of London and at the coastal resorts of southern England. Like John Thomson he photographed the working people of London, porters and street traders especially, and at the sea coast he found picturesque fishermen in the style of Sutcliffe. His innovation was to catch these time-honoured characters in action, in the midst of transactions and conversations. They have come, in later decades, to epitomize the quaint ways of a bustling Olde England. In 1935 many of Martin's candid snapshots were used in Noel Carrington and Jocelyn Rae's *This Man's Father*, where they had a dual role: they both showed how streamlined modern times had become by comparison, and they also indicated that ordinary life went on vibrantly as before. Photographs have been increasingly used in this way, in

support of one or another view of a national identity; and in the 1930s the British, threatened from abroad, were looking for evidence of a robust national spirit – which Martin's rough and ready street folk provided. Nevertheless, in the 1890s he used his pictures, like Primoli, as transparencies, in sets and sequences which he introduced and discussed. That is: his pictures were raw material, a basis for anecdote and analysis, whereas the artist-photographers who were his contemporaries made pictures which were complete in themselves.

What exactly was Martin's subject? Although he won prizes and mentions as a pictorial photographer, he scarcely ever suggests an underlying order or harmony in appearance. Nor is his storytelling consequential. His holidaymakers merely test the water or roll in the sand, as his hawkers inspect their wares or look out for trade. His society proceeds at its own pace, intent on its own affairs, and he looks on, a spectator engaged by the surface of events. His work, distanced and discreet, implies that society, or what people do in the normal course of events, is interesting enough in itself. Naturalist precursors, such as Emerson, suggest that their common folk are exemplary, poignant or heroic, in ways which apply to none of Martin's personnel.

59   GEORGE HENDRIK
BREITNER 'Cruquisweg'
Amsterdam, *c.* 1900.

Martin, in his modest way, signals a new sort of interest in society: one which understands it as a mainly human affair, independent of nature. The seashore is of less interest to him than its inhabitants, their dress and their behaviour. This was a view of things endorsed and expanded by the Dutch painter-photographer George Hendrik Breitner, who took pictures in support of his painting around 1900. Breitner appears as a snapshot painter depicting fragments of Amsterdam as they appear to him, with little apparent interest in making compositions of them. His streets hurry past, arbitrarily cut by the picture edge, and his subjects are anonymous pedestrians and workers. Breitner denies any hint of harmonious order in appearance. What he does stress, again and again and particularly in his photographs, is the fact of construction: his Amsterdam is a city in transition, opened out, excavated, clothed in scaffolding and a site for barges, trams and carts. His people are activists and constructors, builders of a city. Breitner refers to the whole by means of selected details: anonymous pedestrians who are as corpuscles in the great body of the city; cargo boats which fuel the organism; tramways which are its nervous system. In a few photographs in the early 1890s Stieglitz had made similar references to New York: his picture 'The Terminal' (1892), of a team of horses towing a Harlem tram, is just such a significant detail implying a greater, organized whole. But Stieglitz's interest was usually in the spirit of things, and he generalized other details of this sort – a steaming railroad engine at an intersection in 1902 he captioned 'The Hand of Man'.

After the war of 1914–18 Breitner's way is met with more and more. Photography entered a new phase – that of the 'New Photography' – and

appeared to concern itself with society rather than with nature. Belief in a right order inherent in nature waned somewhat, but did not disappear. Mankind, wilfully constructing and arranging, approached the centre of the stage. Some artists, especially in Russia and Germany, imagined a new society built to new plans: a society in which artists and engineers would play leading roles. A new generation of photographers saw themselves as publicists and designers of this new order which was about to come into being. Others, now mostly overlooked or relegated to the sidelines of modernist photo-histories, clung to old values and asserted continuity with the past and the priority of nature.

Photography's reputation increased, especially in Germany, where Moholy-Nagy noted, in a phrase which virtually became a motto, 'The illiterates of the future will be the people who know nothing of photography rather than those who are ignorant of the art of writing.' Photography was to contribute to a universal visual language, at a point in the near future when

60   ALFRED STIEGLITZ 'The Terminal (New York)' 1892. This was published by Stieglitz as a photogravure in *Camera Work* in October 1911.

cameras were to become as commonplace and as readily used as typewriters. Franz Roh, who introduced the New Photography of the twentieth century in the foreword to the illustrated book *Photo-Eye*, which he edited with the typographer Jan Tschichold on the occasion of the Stuttgart Werkbund *Film und Foto* exhibition in 1929, denounced what had gone before as imitative of painting, clichéd and sentimental. Roh had none of Stieglitz's reservations about 'detective' cameras. He did not believe that ease of operation would necessarily lead to dullness and laziness. Indeed he looked forward to a Utopian age in which Everyman might become an artist and become widely understood, 'making use of the international language of outer environment that fundamentally neither changes after centuries nor after countries . . .' In fact, the artist-photographers of 1900 had believed something similar, although their 'international language' was more abstract and refined. Nor did the earlier photographers see themselves as deeply implicated in the construction of a new society.

Much depended on, or seemed to depend on, the work of the New Photographers. They felt called on, and were sometimes forced to, justify themselves in large terms: nowhere more so than in Russia, where photographic ideologies were argued vehemently on the pages of *Sovjetskoje Foto* and *Novy Lef*. The principal innovator in Russia was Alexander Rodchenko, a photomontagist since 1921 and a painter before that. Rodchenko was introduced by the poet Osip Brik, writing in *Sovjetskoje Foto* in 1926, as a searcher after new photographic rules and as an enemy of painterly photography. In *Novy Lef* Rodchenko wrote (1928) against belief in established truths and on behalf of a turning, shifting world and a multiform, dialectical humanity to which snapshot photography in particular could do justice. He put these beliefs into practice at that time in photo-articles in which he arranged close-ups and high- and low-viewpoint pictures on such contemporary subjects as radio broadcasting and the printing press.

Rodchenko came under attack in Russia as a plagiarist, as an imitator of foreign photography – especially that of Moholy-Nagy in Germany. In reply he pointed out that there was a common project which transcended national boundaries. He also emphasized his faith in picture-taking from unusual angles, which showed familiar things in a new light. His opponents argued for traditional viewpoints, and noted that low-viewpoint pictures which made lattice-work radio towers appear as collapsible bread-baskets were distortions. He was increasingly criticized for his attention to form rather than content. By the mid-thirties he used eccentric viewpoints less and less. Even so he remained true to his earlier vision of a shifting, evolving

61   ALEXANDER RODCHENKO 'On the Baltic/White Sea Canal' From an issue of *USSR in Construction*, No. XII, December 1933, on the building of the canal.

world. His photographs of the thirties are composed along diagonals, which echo the movements of such dynamic protagonists as circus performers, swimmers and athletes.

Man Ray, an American photographer and painter who worked in Paris from 1921 onwards, also thought that much depended on his art, and he too wrote of his pictures as having a large social role. He explained himself in a brief statement, 'The Age of Light', published in 1934 as a foreword to *Photographs by Man Ray 1920 Paris 1934*. He was faced with the need to justify such individualistic work as his own in an era preoccupied with 'the problem of the perpetuation of a race or class and the destruction of its enemies'. His own pictures, of strikingly lit close-ups and fragments, glowing nudes, dreaming faces and images of shadows and light traces, had to do, he claimed, with the lyrical expression of a common desire. His own particular emotions and desires, lyrically expressed in photographs, contributed to the discovery of universal qualities in mankind, and challenged the divisiveness inherent in ideas of race and class. Man Ray was a Surrealist and a believer in the fundamental rectitude of the emotions, as against the constraining and belittling power of social convention.

In the United States itself photographers also worked for the betterment of society, although unsupported by such a powerful ideology as that of the Surrealists. They instructed their contemporaries, guided them towards a balanced, ordered aesthetic, by drawing attention to traditional architecture. Charles Sheeler was a pioneer in this respect. He had trained as a painter, visited Paris in 1909, and then found employment as an architectural photographer in Philadelphia. He lived in Bucks County until 1919. There he painted and photographed such vernacular buildings as barns and farmhouses, in a near-abstract style which broke sharply with the soft-focus procedures which were the norm in photography between 1900 and 1920.

Sheeler was the first American artist to turn to architecture in a search for source-forms. In a lucid appreciation of 1938 Constance Rourke praised Sheeler as the discoverer of 'forms that were basic in American creative experience'. Vernacular buildings expressed native taste uncorrupted, and could be taken as a guide by the architects and designers of the future.

Others followed the path indicated by Sheeler, most notably the American painter Edward Hopper, who began to pay serious attention to local architecture in 1923. In 1928 the photographer Ben Judah Lubschez began work on a survey of the *Plantations of the Carolina Low Country*, eventually completed in 1938 by Frances Benjamin Johnson, and published with a cautionary introduction on the need to keep the past in mind, especially a past which built according to immediate need and local

62   CHARLES SHEELER 'Interior' 1917.

conditions. In 1933 Walker Evans, later to win fame with *American Photographs* (mainly architectural) in 1938, surveyed Victorian buildings in the Boston area for the Museum of Modern Art. In 1935 Aaron Siskind set out to document Colonial architecture in Bucks County, Pennsylvania, just as he had documented Carpenter Gothic on Martha's Vineyard the year before. Thus American artists returned to primary sources in American culture.

However, most of the New Photographers of the twenties were from Germany, where camera design was far in advance of the rest of Europe and publishers and printers exceptionally active. There are well-known names from this era: Dr Paul Wolff, for instance, who from 1925 onwards showed just what sort of anecdotal reportage was possible with Oscar Barnack's new lightweight Leica camera. But many considerable talents remain almost unknown, for they worked on architectural projects, contributed to archives or concentrated on such specialist topics as plant and nature photography – in which field Hermann Fischer is one of the great, and unacknowledged, masters.

In some respects the New Photographers were innovators. Certainly they experimented with new processes and styles. László Moholy-Nagy, Edmund Kesting, Theo Ballmer and, in France, Man Ray made photograms, using objects, light-sensitive paper and no camera. Franz Roh, writing in *Photo-Eye*, described the process and noted that the results were difficult to gauge in advance, and were often surprising. To make a photogram was virtually to throw a dice, to put oneself at the disposal of chance. Yet the published results were usually neat silhouette-pictures of such compact objects as eggs, gloves, beads and watch springs, picked out against dark backgrounds. Many photograms, with their transparent overlays, look like simplified versions of Cubist etchings, which they also resemble in their range of subject matter. Braque, for example, illustrates commonplace objects which easily come to hand: dice, bottles, cards, cigarette papers. His compositions are metaphors which connect his own art with the sort of arrangements and manoeuvres anyone might make with routine items on a café table. The photogrammists refer to experimental workshops and cutting-rooms rather than to café tables, but their interest too is in what is manipulable and close to hand. Like the artist-photographers of 1900 they idealize and abstract. Unlike them they turn away from nature and deal with what is man-made, with readily available studio props and with the bits and pieces of a clockwork world. They emphasize control, calculation and construction in the face of a process which converts the commonplace, in Roh's words, into 'a lustrous strange world'. The New Photographers, as a rule, sought out

116

63   MAN RAY Photogram, No. 86 in *Photographs by Man Ray 1920 Paris 1934*
(Hartford, Conn. 1934).

64   ALBERT RENGER-PATZSCH 'A Teazel' Illustration No. 46 in *Das nieverlorene
Paradies*, a book on plant life in Germany by Max Metzger and Ludwig Oefer
(Berlin 1934).

images which hint at control; they also referred, as if obsessed by opposites,
to subjectivism, spirit and nature, to forces not easily gauged and
manipulated.

One of the most striking photographic enterprises of the age was Karl
Blossfeldt's *Urformen der Kunst* ('Prototypes of Art'), published in 1928 by
the Verlag Ernst Wasmuth in Berlin. This was a book of greatly magnified
plant pictures which Blossfeldt, who had trained as a sculptor in an
ironworks in the 1880s, had begun to take around 1900. Blossfeldt kept his
sculptor's sensibility, just as he remembered his grounding in Art Nouveau,
with the result that his work looks anachronistic in the context of the
streamlined New Photography of the late twenties. Nevertheless,
Blossfeldt's source-forms were particularly apposite in 1928. They were
natural in that they featured chestnut and maple shoots, ferns, larkspur and
the blooms of saxifrage. But they were also presented as nature's own
wrought-ironwork, and hinted at a close correlation between art and nature,
between the work of man and development in the organic world. They

65   HUGO ERFURTH 'Alfred Flechtheim (1878–1937)'

suggested that society might be sustained in harmony with nature, and Karl Nierendorf, in his introduction to the book, emphasized that his contemporaries were seeking just such an accommodation, 'an active and direct relationship with Nature'.

On the other hand the critic Walter Benjamin thought that Blossfeldt's images of burgeoning plant life were of another order: 'These have developed from one of the deepest, most unfathomable forms of creation – from the mutation in which the element of genius has always resided – the collective creative power of Nature. This fertile mutation is diametrically opposed to human invention . . .' Although much of the New Photography had human invention as its subject, and was correspondingly plain and well organized, plant pictures of the late twenties and early thirties, of which Blossfeldt's are prime examples, were far more expressive than objective – as though contemporaries found relief from the more prosaic values of their time in the vivacious, and sometimes sinister, growths of which nature was capable. Nature's workshop, at this time, was peopled by as many magicians as artificers; out of it came picture after picture of plants conceived as lurid baubles, coiling and looming large in disconcerting close-up against dark grounds. They are addressed to the imagination, with all its taste for ambiguity and waywardness, and constitute a dark side to a New Photography which generally favoured the clear light of day.

Close-ups of plant heads, seeds, flowers, tendrils and buds expressed organicism, and told of a powerful, even threatening, life force in nature. Some portrait photographs of the same era made comparable claims on behalf of mankind. Helmar Lerski, in particular, presented a set of imposing portraits in *Köpfe des Alltags*, published in 1931. Lerski envisaged a number of German workers, most of whom were either unemployed or unskilled, as grimly heroic and possessed (as Curt Glaser notes in his introduction to the book) of 'a wealth of expression and unsuspected psychological depths'. Thus the commonest of the common people, sweepers, washerwomen and housemaids, were imagined as members of a sombre and ancient race.

Lerski projected a picture of an elemental mankind. His contemporary Hugo Erfurth, who worked first in Dresden and then in Cologne after 1934, sought a similar kind of gravity in the faces of Germany's leading artists, writers and politicians. From 1923 onwards he set out to assemble portraits of the leading people of his time. He varied his address; some of his celebrities stare masterfully into the lens, others look soulfully away; all seem to have been tempered by experience. Something of the aura of 1900 clings to them. They have inwardness, which might be expected, for Erfurth had learned his trade in the 1890s. But they also have a purely physical weight, of a kind with

Berchtesgaden, Rothenburg and Dinkelsbuhl. He proposed a natural, essential homeland, quite distinct from modern views of society as transitional and manipulable. Gerhart Hauptmann, who introduced the book, thought that Hielscher's pictures gave access to the silent music of the great German spirit, a spirit imperilled by modern constructions, skyscrapers and the like.

Hielscher's *Deutschland* might be taken for the last gasp of an outmoded romanticism. Things changed in the later twenties, but often the change was more apparent than real, as was the case with Albert Renger-Patzsch's *Die Welt ist schön*, a collection of 100 photographs published by Kurt Wolff in 1928. In this book Renger-Patzsch shows the workaday world in an especially crisp and orderly light. He also associates it, and its pit heaps, lathes and switchgear, with burgeoning plant life and with the animal kingdom. On the cover he juxtaposed a tree-like pylon and an agave, as systematic as any pylon. Nature and culture, he suggests, are scarcely distinguishable.

68   ROBERT PETSCHOW 'A Crossing of the Single Track Sandau-Schonhausen Railway Line and the Main Berlin–Hanover Line' Illustrated in Section 3 ('The Machine Age') of Eugen Diesel's *Das Land der Deutschen* (Leipzig 1931).

69   GERMAINE KRULL 'View from the Transporter Bridge in Marseille' Published ▷ in *Marseille* (Paris 1935).

Renger-Patzsch was the first photographer to apply the new precisionist aesthetic across the board, from the animal kingdom to factory sites. Despite his interest in nature he did differ from Hielscher and Blossfeldt, largely in terms of emphasis. He pictured nature as fathomable, and as relatively mechanistic. In particular he valued stillness, choosing to see the world untroubled by the thickness and turbulence of atmosphere. In his book he scarcely ever showed anything which told directly of movement. In two cases the tide circles on the shore, and from time to time his skies are faintly patterned by clouds; in the main, though, his world is caught in a dead calm of ice, still water and bleached sky. He fixes appearance and evokes a poised stillness. Action is not recorded, but it is everywhere implicit: in, for instance, the alert eye of a coiled serpent, in the gaze of an animal, or in the half-blown top of a seed head. And the same applies elsewhere, especially in the architectural and industrial pictures for which he is famous. On his work-sites no one pulls the levers, turns the handles or stokes the boilers; no smoke comes from the chimneys and the cranes stand idle. His works, however, are empty rather than abandoned; in a crisp light they stand ready for use. His is a world in the morning, before the wheels start to turn.

The preferred vantage point of the New Photographers who were Renger-Patzsch's contemporaries and successors was on high, in upper windows, in scaffolding, or in the girders of a bridge. This allowed them to make pictures which resembled blueprints, plans or maps. Their dominant perspectives were those of planners and engineers, specialists in layout. They also took close-ups, which provided detailed information, and showed that matter was within reach and thus manoeuvrable.

Apart from the Eiffel Tower, their favourite vantage point was the Transporter Bridge in Marseille, an iron structure built in 1905 and brought to contemporary attention in 1927 by Sigfried Giedion as a forerunner of modern building styles. The architect and designer Herbert Bayer photographed there in 1928, and in 1929 so too did his Bauhaus colleague Moholy-Nagy. Germaine Krull, a Polish-born photo-journalist who had trained in Munich and worked in Paris after 1924, also took pictures from the bridge, several of which appear in her illustrated book of 1935, *Marseille*. Florence Henri, a painter, advertising photographer and, in 1927, student at the Bauhaus, took pictures among the same girders in 1930. The advantage of this bridge was that it allowed a view onto the moorings in the harbour and onto the quayside. The port appeared as in a diagram – a diagram, moreover, where very little seemed out of place. Marseille from the bridge is shipshape, stowed and ready for action.

It is also consistent that at sea level the New Photographers should have

focused on tugboats, agents of the harbour's order. One takes pride of place, for example, on the cover of Krull's *Marseille*. Others, photographed by Andreas Feininger and Robert Petschow, steam through the pages of Roh and Tschichold's *Photo-Eye*.

The most thorough of all the diagrammatic photographers was Robert Petschow, two of whose pictures appear in *Photo-Eye* (where they are attributed to Gunther Petschow). In the twenties he surveyed Germany from the air, from balloons and Zeppelin airships, and 481 of his photographs were used to illustrate Eugen Diesel's *Das Land der Deutschen* in 1931. What 68 Petschow reveals again and again, in views over forest, field and quarry, is a striking orderliness. Traces of ragged nature survive in the mountains, but almost everywhere else the land appears to lie under a schematic, man-made overlay. Canals cut across the winding courses of rivers. Railway lines loop precisely over neatly tailored field systems. Sheaves of corn dot the grain fields at regular intervals. Neat strings of barges thread their way along the rivers. Petschow's evidence is of a country comprehensively worked, to a point where unreconstructed nature only survives in isolated sections, and then only by courtesy of the inhabitants.

In the same years the architectural photographer Walter Hege, a former pupil of Hugo Erfurth in Dresden, was working on a survey of the Acropolis. He had published studies of Naumberg and Bamberg Cathedrals in 1924 and 1926. *Die Akropolis*, published by the Deutscher Kunstverlag, came out in 1930. Hege visualized the Parthenon virtually as a modern monument, as a purist arrangement of shining columns and lintels standing proud of the irregularities of scumbled earth and sky. Hielscher's architectural gravures are consistently heavy in tone, over earth, sky and building. Hege's images, printed on coated paper, distinguish sharply between sunlit buildings and their surroundings, and emphasize the perfection of what is man-made, against the litter and irregularity of natural forms.

The major artist among the New Photographers was Moholy-Nagy. Like the others he made close-up and cross-section pictures, which refer to an organized, industrialized, cultured whole. Where Petschow, for instance, seems to have no obvious reservations about the ubiquity of an organizing culture, Moholy-Nagy appears to have had misgivings. His favourite sites are streets, crossings and meeting points seen from high windows. From above, these chequerboard settings look neat and impersonal, punctuated only by casual strollers and passing cyclists. Stieglitz used such passers-by to complete his compositions. Moholy-Nagy uses them as assertive incidentals; even at a distance they are expressive, individuals who keep their character,

slouching, stepping out, gesturing expansively. And, very often, their expressiveness is enhanced by a long splash of shadow as they cut into raking sunshine. That is: his individuals, though they live in a system, are not submerged. His references are not narrowly to industry, to electricity, to the city, or to individualism. Instead he takes several conditions into account at once, as when he shows intractable individuals moving in their own way over the grid. Sometimes he demonstrates that this grid is also a prison: in one of his best-known pictures, taken at Ascona in 1926, shadows thrown by a metal grill threaten to ensnare a hapless doll.

The doll is a metaphor of sorts. It invokes, by a process of substitution, certain unsettling ideas on modern society. Elsewhere Moholy-Nagy uses fragments which stand for greater wholes: vigorous pedestrians who represent their fellows, ordered streets which are part of the city at large. He shows such significant elements together and thus makes a wide, discursive range of references to the modern condition. Renger-Patzsch also used such tropes, mainly those in which fragments stand for wholes: pulley wheels, insulators, oil pipes, chimney stacks, pieces of the industrial system. But he never works discursively, setting one detail against another as Moholy-Nagy did. In fact very few photographers did more than work with significant details held in isolation, to be enlivened by an adjoining text or context. Rodchenko in montaged title pages for some of Mayakowski's poetry in 1926 juxtaposed ancient and modern, town and country, but most photographers looked only for impressive details which might do credit to such large ideas as electrification, industrialization, technology, the nation and the people. Herbert Bayer told of summer, sun and the outdoors in a picture of tanned legs scuffing sand on a beach. Max Burchartz, an advertising designer in Essen and also an exhibitor at Stuttgart in 1929, found a form for youth and beauty in a detail of an eye and freckled face meticulously framed. Tina Modotti, Italian companion of Edward Weston in Mexico in the twenties and one of photography's heroines, found symbols for the people, their dignity and their struggles in images of dusty hands resting from labour and the imperious faces of Indian women. Following her expulsion from Mexico in 1930 she too lived in Germany, where her pictures were used by a left-wing magazine, *Der Arbeiter-Fotograf*. The New Photographers, irrespective of political viewpoint, relied on such significant details. With the exception of Moholy-Nagy, none of them looked likely to develop the complex photographic language which some of their contemporaries thought about to come into being.

When Franz Roh considered photography for *Photo-Eye* in 1929 he tried to single out the elements of a language which would, he imagined, soon

56

70   LÁSZLÓ MOHOLY-NAGY 'Stockholm' 1930. A similar picture was published in *Querschnitt*, No. 5, p. 328 (1932).

become universal. He identified photograms, reality photos (fragments and close-ups mainly), photomontages, and photos with etching, painting and typography. He assumed that photographs would be used in combinations, and that out of these combinations new meanings and insights would arise.

By 1934 Walter Benjamin, an influential German critic and sometime writer on photography, thought that recent photography had been a failure and that earlier promises had not been realized: 'What do we see? It has become more and more subtle, more and more modern, and the result is that it is now incapable of photographing a tenement or a rubbish heap without transfiguring it . . . It has succeeded in turning abject poverty itself, by handling it in a modish, technically perfect way, into an object of enjoyment.' Certainly the New Photographers had sought for sanitizing effects and, with a taste for cleanliness, streamlining and smooth papery arrangements, had expunged the reek of quayside and workplace.

Benjamin's more serious objection, quickly sketched in on the same occasion (a lecture delivered in Paris to the Institute for the Study of Fascism), was that photography had not taken a route indicated by such photomontagists as John Heartfield, George Grosz and Hannah Höch in the early twenties. He associated photomontage with the processes deployed in Brecht's epic theatre, which, disjointed and artificial, worked against naturalistic illusionism, and thus against any idea of an independent and unalterable natural order of things. It proposed instead that social life was experimental, a construction which might be taken apart and modified. Its audiences were to be surprised, stimulated and urged to see just how provisional and man-made society was. Photomontage in the early twenties was an art of such radical discontinuity, with images from various representational modes yoked together in pictures. Thus pictorial illusion was interrupted, opened to question, and the picture became a means of disclosing rather than of merely reproducing the conditions of social life. But the moment of photomontage came and went before it could be grasped by photographers, few of whom were radical critics of society anyway. There were also powerful ideological forces arrayed against Benjamin and against all those who envisaged photography as a language. Chief of these was the idea (which had survived with some changes of emphasis from the preceding era) that photographic purism gave access to source-forms, to that pure underlying geometry which the Americans found in vernacular architecture and the Germans in the natural world magnified and refined. Such practices promised to deliver ultimate truths, whilst the hectic impurities of the photographic languages envisaged by Benjamin and Roh merely opened a way to debate, play and relative truths.

128

71   JOHN HEARTFIELD and GEORGE GROSZ 'Dada-merika' 1919.

# European Society and American Nature

*August Sander, Eugène Atget, Alfred Stieglitz, Paul Strand and Edward Weston – two classifiers and three exponents of photographic seeing*

THE ARTISTS CONSIDERED HERE are from radically different cultures. August Sander and Eugène Atget have society as their subject. Atget watches culture forming and disintegrating – although no historians and critics agree on what exactly he did or why exactly he is important. Sander envisaged an evolutionary pattern at work in modern society.

Alfred Stieglitz, Edward Weston and Paul Strand have an entirely different subject. They look to nature, in which – according to nineteenth-century views – natural laws are to be found. They look for truths which lie outside a society for which they have little but contempt. Strand is at ease with nature, an absorbed and reverent scrutinist. Weston is somewhat different, a more anxious devotee who continually emphasizes an emotional basis in his art. If sufficiently attuned, in a state of photographic grace, he responds fitly to nature. There is something in him of a Protestant wondering if he is among the elect. He, like Wordsworth before him, does his wondering in front of nature.

The greatest reputation to emerge from the 1920s was that of August Sander, a portraitist and industrial photographer. Sander, born in 1876, began to work as a commercial photographer in the late nineties and he was a frequent medal-winner in exhibitions before the Great War. After the war he continued to live in the Cologne area, and came to know several progressive artists there. At this time he was working on his major project *Man of the Twentieth Century*, which he had begun to consider as early as 1910. In 1929 Kurt Wolff published his book *Antlitz der Zeit* (*Face of Our Time*), which he intended as an introduction to a much larger publication of 540 photographs to be produced twelve at a time in forty-five portfolios. *Man of the Twentieth Century* did not materialize, and in 1934 the German Ministry of Culture ordered that the printing blocks for *Face of Our Time* should be destroyed and all available copies seized. Meanwhile Sander was working on a series of books under the general heading *German Land, German People*, of which five were published. Thereafter he took landscape photographs in the Rhineland. He survived the war, but 40,000 of his negatives were destroyed in a fire in 1946. Two of his pictures were used in the great *Family of Man*

72 AUGUST SANDER 'Boxers' (Hein Heese and Paul Röderstein) Cologne, 1928. Illustration No. 13 in *Antlitz der Zeit* (*Face of Our Time*).

exhibition in 1955, although at that time his severe portrait style looked anachronistic. Since then his reputation has grown to the extent that he is now thought of as one of the great masters of twentieth-century photography. He died in 1964.

The bulk of his surviving photographs are portraits, and several of them are well established in the canon of photographic masterworks. Probably his best known is of three young countrymen photographed on a country track whilst going to a dance in the Westerwald area in 1914. It is as intriguing as anything by him. The three youths wear dark suits crumpled at the ankles, white collars and flat-crowned hats, and carry walking-sticks. They seem to have paused, but only momentarily, to present themselves to the camera. Although each is similarly dressed, each is a quite distinct character. The leader of the group looks back severely at Sander and his camera. At his right hand stands someone who might be a more urbane brother, thoroughly at ease in expression and gesture. The third, a little detached from the other two, is altogether more raffish. Everything sets him apart: a curl of hair under the brim of an angled hat, a cigarette, a crumpled jacket. The picture is immensely suggestive – a starting point for a novel rather than a sociological illustration.

But this was not just a solitary instance or lucky photograph. Sander, realizing that understanding comes as a result of discernment, often set like against like, less to make a pattern than to accentuate difference. Immediately after the three countrymen in *Face of Our Time* he introduces two farm girls, got up in their identical best. They too invite comparison, for they also differ slightly but significantly in demeanour. Individually they might simply be taken as stolid peasant girls. Seen one in the company of the other they emerge as distinct personalities, each with a separate destiny. Several pages later two boxers present themselves, Hein Heese and Paul Röderstein, photographed in Cologne in 1928, and again the difference in personality could hardly be more marked, between a genial bruiser whose smile matches his bootlaces and the punctilious athlete by his side.

Sander, however, was more than an astute portraitist. Around 1910 he introduced himself in an advertising brochure as taking 'natural portraits that show the subjects in an environment corresponding to their own individuality'. But that was before he had begun to work on *Man of the Twentieth Century*. In his essay of 1931 'A Short History of Photography', Walter Benjamin considered Sander's book of 1929 and judged it to be 'an atlas of instruction' or training manual in front of which contemporaries should sharpen their 'physiognomic awareness' to deal with increasingly dangerous times. He said little more, apart from emphasizing that anyone

not on the alert would come to grief. Alfred Döblin, the novelist and author of *Berlin Alexanderplatz*, who wrote an introduction to *Face of Our Time*, was more forthcoming. The book provided him with evidence of social tensions involving classes and generations. Döblin looks at a photograph of a schoolgirl fashionably dressed and remarks on how quickly the young are growing up. He refers to a portrait of a Protestant pastor surrounded by his pupils and sees a lack of accord between teacher and taught. He notes a significant difference between a picture of a middle-class family group and one of four serious-looking students working to pay their way through college.

Döblin argues that Sander is a realist, that he looks beyond particulars at universals and ideas. Yet on coming to identify these ideas he finds little more than commonplace observations on the young maturing so early nowadays and on the fact of class division. He also remarks that environment and livelihood have their effects on people, and that peasants look weather-beaten in contrast to the softened faces of middle-class families. How could any of this alarm even a Nazi Ministry of Culture into destroying the plates and seizing stocks of the book?

But there was much that was subversive about *Face of Our Time*. Döblin drops a hint in passing when he asserts that people are shaped by 'the special ideology of their class' as well as by livelihood and environment. This was Sander's underlying subject. His people had ideas about themselves and he, in turn, had ideas about them. The country people who appear at the beginning of the book look stoically into Sander's lens, almost as though mesmerized. His middle-class subjects, sure of their own worth, pose with more grace and self-possession. Others, especially urban workers, look back guardedly and even uncooperatively, as though reluctant to compose themselves. Artists, writers and architects, at one with the modern age, stare out objectively.

Country people, artisans, urban workers, merchants, artists and writers show themselves to Sander in an orderly, consistent way, in poses appropriate to their station, trade or class. His survey is a classification but at the same time it is something else: a history of Germany in transition. This is where the trouble arose in 1934, because Sander's idea of history was controversial. In his introductory brochure to *Face of Our Time* he referred to *Man of the Twentieth Century* as a survey which would proceed 'from the earthbound man to the highest peak of civilization, and downward according to the most subtle classifications to the idiot.' In other words, his view of history was progressive and evolutionary. The peasant types, introduced at the beginning of *Face of Our Time*, belong to, and stand for, the

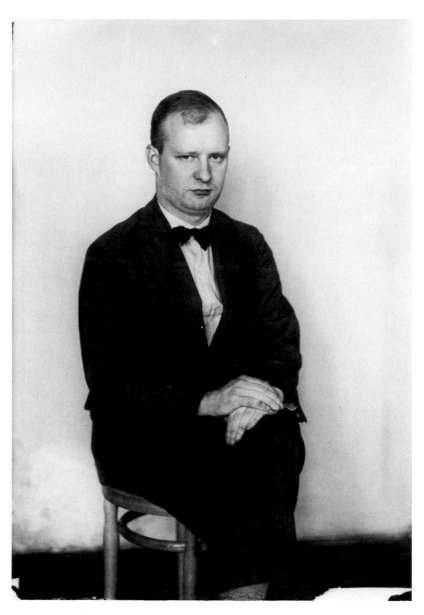

73    AUGUST SANDER 'Der Komponist P.H.' (The Composer Paul Hindemith)
Cologne, 1926. Illustration No. 52 in *Antlitz der Zeit* (*Face of Our Time*).

past – most of them were photographed in the years before the Great War. Others, especially his middle-class subjects, also associated themselves with the past through their choice of archaic poses which recall portrait styles of the nineteenth century. The only people thoroughly at home, self-possessed and unaffected, in front of Sander's camera are a painter (Jankel Adler), a composer (Paul Hindemith), a sculptress (unnamed) and an architect (Otto Poelzig). Most of their contemporaries, even though distinguished, show signs of unease – either that, or they overreact like the tenor Leonardo Aramesco, photographed in Cologne in 1928. In this way Sander suggests that 'the highest peak of civilization' is to be found among the intelligentsia, whom he also associates with socialism – for the only other people who seem to adapt themselves readily to this objective mode are several left-wingers and revolutionaries also included in the survey.

None of the implications of all this could have been well received in the nationalist ethos of 1934, to which Sander's evolutionary scheme was absolutely opposed. In 1934 Germany, now a National Socialist state, was once more surveyed, for the *Orbis Terrarum* series of Atlantis Verlag, by photographers of the new generation such as Walter Hege, Erna Lendvai-Dircksen and Albert Renger-Patzsch. It was substantially the same Germany as Kurt Hielscher had celebrated in 1924, but reinforced by Lendvai-Dircksen's portraits of peasants, gorgeously presented in traditional costume.

Sander is important for several reasons. Even if he had not composed *Face of Our Time* he would still be admired as an innovator, largely because of his double portraits and what they reveal. But it is *Face of Our Time*, the first properly discursive photo-book in the history of the medium, that really sets him apart. It is a complex work, combining a taxonomy, a history and a point of view, and resembles nothing else done at the time. Its principal successors are Walker Evans's *American Photographs* (1938) and Robert Frank's *The Americans* (1958/9), both of which have the same sort of nuanced intricacy. Other photo-books published in the twenties simply reiterate themes of modern life or romantic landscape, with no more than a small amount of comparative material to give a perspective on the main theme.

*Face of Our Time* took the shape it did largely because Sander was a persevering artist who had, by 1929, lived through and recorded some thirty years of German history. Where most photographers had a brief heyday, usually of a decade or so, Sander had kept abreast of his times – and not merely as a turncoat, switching in accordance with contemporary fashion. He had been a prize-winning art photographer in 1910. In the 1920s he was friendly with *avant-garde* painters twenty years younger than himself. He knew, and photographed, the radical Cologne painter Franz Seiwert –

editor, with Max Ernst and Alfred Baargeld, of the communist journal *Der Ventilator* in 1919. Gottfried Brockmann, another of the Cologne avant-gardists whose work was affected by the aftermath of the Great War, lived in the Sander household for two years. Sander knew others, such as the painters Otto Dix, Heinrich Hoerle and Jankel Adler, yet this did not mean that he was at all subject to their influence. If anything, the reverse may have been true, for the style of Sander's dispassionate portraits of 1910 became the portrait style of New Objectivist painters in the twenties. In fact, Sander spanned the generations and was of the same age as the artists who had instructed his *avant-garde* friends. Indeed he belonged to a generation many of whose painters had been scrupulous naturalists, who in their turn looked back to the restrained portraiture of Wilhelm Leibl and Wilhelm Trübner in the 1870s.

What Sander brought with him from the nineteenth century was an idea that portraiture ought to be decorous and formal, and that sitters should be seen in full or three-quarter length. In this respect he was unlike the New Photographers of the twenties who made use of eccentric angles and close-ups of staring, pitted faces. The advantage of Sander's kind of portraiture was that it allowed his sitters to reveal their varying ideas of decorum, whereas the new generation made use of a format which allowed none of this to emerge. Nor did Sander restrict himself to photography of any particular class. Thus in 1929 he found himself in possession of exactly the sort of diverse material which made possible his critical survey of the German people.

In *A Short History of Photography* Walter Benjamin foresaw dangerous times ahead, and thought that Sander's book might sharpen the wits of its audience. He had similar hopes for another body of photographs recently come to attention – the documentary pictures of Eugène Atget, collected by the American photographer Berenice Abbott and published in Paris and Leipzig in 1931. Benjamin valued Atget very highly, referring to him as 'an actor who, repelled by his profession, tore off his mask and then sought to strip reality of its camouflage.' Atget, he thought, had liberated the object from its aura, by which he meant that Atget's pictures were free of the kind of evocative atmosphere prized by traditional photographers: 'They are not lonely, but they lack atmosphere: the city in these pictures is empty in the manner of a flat which has not yet found a new occupant. They are the achievements of Surrealist photography which presages a salutary estrangement between man and his environment, thus clearing the ground for the politically-trained eye before which all intimacies serve the illumination of detail.' In other words, Atget dealt with what was out there,

74  EUGÈNE ATGET 'Fontaine de la Tête du Bœuf. Rue des Hospitalières, St Gervais' Numbered 2207–1903 in the collection of the Victoria and Albert Museum, London.

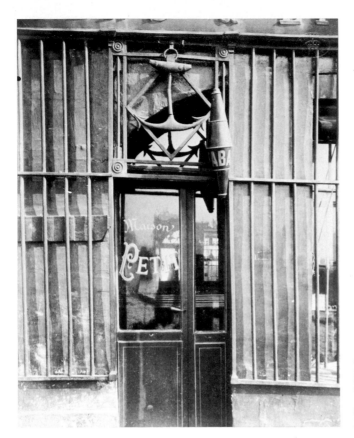

75 EUGÈNE ATGET 'Shop [sign], 38 Quai Bourbon, Paris' Numbered 2210– 1903 in the collection of the Victoria and Albert Museum, London.

rather than with his feelings; he invited his audience to inspect and to analyse rather than to dream.

In his lifetime Atget was thought of, if he was thought of at all, simply as a documentary photographer. He died in obscurity and poverty in 1927. Berenice Abbott supervised the publication of some of his pictures in 1931, and his reputation has grown ever since, to a point where he now has the status of a major artist.

Atget came to photography late in life. He was born in 1857. He is said to have been a sailor, and then an actor for fifteen years. By 1899 he decided to, or had to, make a change and thought that he might become a painter – but, needing to make a living, he became a photographer instead. On 12 November 1920 he summed up his career in a letter to Paul Léon, Director of Fine Arts at the Museum of Historical Monuments in Paris:

Over the past twenty years, through my work and on my own initiative, I have collected artistic documents of the fine sixteenth to nineteenth century architecture in all the ancient streets of old Paris in the form of photographic plates in format 18 cm. × 24 cm. [7 in. × 9½ in.]: old hotels, historical and curious houses, fine façades and doors, panellings, door-knockers, old fountains, period stairs (wood and wrought-iron), and interiors of all the churches in Paris (overall views and details), including Notre-Dame, St Gervais et Protais, St Severin, St Julien-le-Pauvre, St Étienne-du-Mont, St Nicholas-du-Chardonnet, etc. This huge artistic and documentary collection is now completed, and I can truthfully say that I possess the whole of old Paris.

In three letters to Paul Léon, Atget discussed prices and terms and listed the major museums and libraries to which he had sold print sets. In further letters in the same month Atget explained that his completed work was in two parts: *Arts in Old Paris*, recorded in 1053 images, and *Picturesque Paris*, in 1568 pictures. He explained that many of the buildings and items in *Picturesque Paris* were no longer in existence, and added that he had begun to work on two new projects: *Arts and Crafts in Old Paris* and *Art in Districts around Paris: Seine, Seine-et-Oise, Seine-et-Marne*.

Atget's other clients were the shopkeepers whose premises he photographed, and painters such as Utrillo, Dunoyer de Segonzac and Vlaminck. His trade plate on the door of 17bis rue Campagne-Première advertised 'Documents pour Artistes'. Another artist to whom Atget sold prints was Man Ray, who lived at No. 31 in the same street. Man Ray was impressed by Atget's pictures and publicized them in Surrealist circles; three were published in the journal *La Révolution Surréaliste* in 1926, and then eleven were exhibited in the modernist *Film und Foto* exhibition of 1929 in Stuttgart. Thus in the space of a decade Atget appears as an antiquarian and tradesman, then as an associate of Surrealists and Constructivists.

Some of his pictures readily fitted a Constructivist context, for in his travels through Paris he photographed any number of details, of shop windows, fairgrounds, metal signs and fountains. These were exactly the sort of suggestive fragments which caught the eye of such New Photographers as Moholy-Nagy and Germaine Krull. The pictures used in *Film und Foto* were of this sort: manikins and a corset display in shop windows, details of painted signs at fairgrounds, house façades and a tree.

But what had he to do with Surrealism? Why did his work interest Man Ray, and why did Benjamin refer to it as an achievement of Surrealist photography? In part because Atget transformed much of what he photographed. He brought dead matter dramatically to life; or, more accurately, noticed when it came to life. The manikins selected for the *Film*

*und Foto* exhibition mime vividly, as though in some prosaic re-enactment of Rodin's *Burghers of Calais*. Elsewhere pieces of applied sculpture, caryatids and gargoyles, squirm under their tasks, or look out interestedly at the life of the street around them. But Atget was at his best with the classical statuary to be found in princely parks and gardens in and around Paris, at Versailles, St Cloud and Sceaux. His are the photographs of a symphathizer who felt for a sculpted figure of Winter, wind-blown under a bowed fir tree in the unkempt park at Sceaux, where he also saw ruined figures of Apollo and Daphne fading into the greenery – in metamorphosis, as Daphne had been in the original story. At Versailles he saw a sculptural group in a pool cowering under a stormy sky, and captives disconsolate among autumn leaves around the fountain of France Triumphant. Everywhere his gods and goddesses rove the woods, as though Atget had tried to see them in their original wildness before they were reduced and codified by story and pattern book.

These old statues, come alive in the woods, provide clear evidence of Atget's abilities as an animator. They alone might have been sufficient to win him a place in the Surrealist pantheon. Yet he had other, equally substantial, claims, based on both his style and subject matter. As Benjamin pointed out, he avoided 'aura'. His pictures are sharply delineated and in them commonplace objects, such as cobblestones and roof tiles, appear as in a jeweller's cabinet. Commonplace material, which in the normal course of events would be scarcely worth a second glance, is preserved and made to matter. Just how it matters is another question – but the items in an Atget photograph are actual to an astonishing degree, treasured for themselves alone, revelations of their own particularity. Where many of his contemporaries studied phenomena for underlying meanings or essences, Atget seems to have looked through generalities to find original particulars. Something like this happened at Sceaux and Versailles, where the tabulated gods were restored to an original habitat and seen again as though in their wilder early days, before the legends were born.

Atget seems always to have worked towards the actual, and away from whatever was generalized and reductivist – and he appears to have done so as a matter of policy. He was an ironist acutely conscious of a gap between actuality and 'aura', between what is there to be seen and our notions of the same. This is the meaning of Man Ray's delight in Atget's choice of the aura-laden caption 'Versailles' for a picture of a prostitute at a doorway in that noble milieu. The same sense of irony permeates his pictures of the royal parks at Versailles. He photographed the same material from varying positions. He stood back and took the avenues, urns and shrubbery in a way which showed them to be part of a scheme. He then moved closer to reveal

74

140

that the elements in this pattern were marked and scarred by time and human hands – nymphs and fauns dance among thickets of graffiti on the monumental urns.

In Old Paris he found comparable discrepancies, in the shape of humble business carried on under ornate classical ornamentation. But he was not simply a satirist, mocking the pretensions implicit in fine titles. His concern was for culture itself, seen in the light of the raw material from which it was devised. If Sander's subject was the evolution of man over a thirty-year period, Atget's was the evolution of culture. The difference is that Atget was more ironic than progressive. The world on which he reported was rooted in base matter and likely to return there. His Old Paris was fabricated out of stone, wood, sand, plaster and tiles. Its builders and owners aspired to grandeur, and chose to live under titles and signs: Au Lion d'or, Au Soleil d'or, Au Griffon, A l'Enfant Jésus. These caught Atget's eye, as examples of a primitive sign system which preceded, and was more real than, language. They were things to which meanings were attached, and not abstractions.

Thus, just as at Sceaux he had restored the gods to an original habitat, so in the streets of Paris he identified the primitive antecedents of language. His sense of the rootedness of culture was pervasive, and shows itself in photographs of workshops, depots and yards, in which raw materials were worked to make the city and its furnishings. At the end of the scale he noted the junkyards and mean alleys in which the cycle completed itself.

In the 1920s Atget's handmade Paris was already a thing of the past. In his letters to Paul Léon he remarked that much of what he had photographed was no longer in existence. His world of handcarts and workshops was giving way to a streamlined age, in terms of which Old Paris looked more medieval than modern. Moreover, it was a world everywhere expressive, a physiognomy both tended and eroded, inherited after generations of use and abrasion. By contrast the sort of modernity celebrated by the New Photographers of the twenties appeared to be anaemic, insubstantial and unsympathetic, a landscape without a history. Atget's was a Surrealist terrain, dense with mystery and capable of stirring anyone who chose to look into it.

Atget was as paradoxical an artist as Sander. Both were survivors, and both came to prominence in an era whose major tendencies they opposed. Sander, schooled in the nineteenth century, respected the integrity of his sitters and emerged with a series of immensely revealing portraits. Atget, working more or less as an artisan with no reference to any of the traditions or institutions of established art, collected a complex *œuvre* which certainly had Constructivist aspects but which contradicted Constructivism in

76   ALFRED STIEGLITZ
'Equivalent' *c.* 1927.

77   ALFRED STIEGLITZ 'Later   ▷
Lake George: Weathervane on
Wooden Cottage' *c.* 1934.

several important respects. Where Moholy-Nagy, Germaine Krull and their associates pictured a newly-minted culture, Atget emphasized history; his cityscapes show infinite traces of use, repair and decay. Equally he emphasized contingency at every turn. The new generation of photographers in the twenties viewed the world from all angles, as though they were gods for whom everything was possible. Atget's, by contrast, was an art of standpoints. His Old Paris is a city of cobbled streets, passages and courtyards, particular places seen from such-and-such a spot close to hand. He respected place as Sander respected person, and thus avoided that homelessness which was characteristic of the new Utopian photography of the twenties.

Although Sander, Atget and their European contemporaries used varying styles and made different emphases, they had society as their common subject. In this they differed from their American counterparts: Alfred Stieglitz, in the later phases of his career, Paul Strand and Edward Weston, at the outset of theirs. American photography, despite many affinities with that

in Europe, appears to be altogether more subjective, the work of reclusive artists separated from society at large. Admittedly Stieglitz photographed New York City, but it was at long range and from an upper window. For a while, during 1915–16, Paul Strand took pictures on the street, but he quickly turned his attention to primal nature. Edward Weston's views of industrial plant, made from 1922 onwards, are as other-worldly as any of Frederick Evans's cathedral pictures.

Stieglitz had controlled The Little Galleries of the Photo-Secession at 291 Fifth Avenue, New York, since 1905. This venture, along with *Camera Work*, came to an end in 1917, and Stieglitz began to devote more of his attention to picture-taking. He established another gallery in 1925, and then An American Place at 509 Madison Avenue in 1929, but a considerable amount of his time was spent at Lake George in upper New York State. At Lake George (a resort area which had attracted landscape artists in the late nineteenth century) Stieglitz took some of his best-known pictures, including his 'Songs of the Sky' and 'Equivalents' – sets of cloud

78 ALFRED STIEGLITZ 'Dorothy Norman' 1935.

79 ALFRED STIEGLITZ 'Dorothy ▷ Norman' 1936.

photographs with which he had begun to experiment in 1921. He also made many portraits of his companions, Georgia O'Keeffe and Dorothy Norman.

Stieglitz's subject matter changed, and his style, but his ideas never did. Surveying his career in an article for Dorothy Norman's magazine *Twice-a-Year* in 1942, he reaffirmed his faith in nature: 'Underlying all is a natural law and on this natural law rests the hope of mankind.' The main danger confronting any artist conscious of natural law is pride, and clearly Stieglitz was on the alert to this quality in himself. In 1923 he wrote a short piece for a magazine, 'How I Came to Photograph Clouds'. One of his explanations was that he had been stung by a remark of the writer Waldo Frank to the effect that he was a hypnotist and, by implication, imposed himself on his subjects. The answer was to photograph what lay furthest from his control: 'Through clouds to put down my philosophy of life – to show that my photographs are not due to subject matter – not to special trees, or faces, or interiors, to special privileges – clouds were there for everyone – no tax as yet on them – free.' He noted that it took him a long time to get the pictures right – his ideas of natural law were as demanding in 1923 as they had been

in the 1890s. He also added that they were, in an important sense, mere photographs, vehicles for natural, unmediated images.

Other pictures from the Lake George years appear to have been taken 77 almost at random. He photographed poplar trees in summer time, grasses in front of lilac bushes, the flanks of a barn and of a chicken house, a window in winter time and a section of a porch with the lake in the distance. What they are of is relatively unimportant, for their subjects, like those of the cloud pictures, are harmony, rhythm, order and proportion. 'Songs of the Sky' and 'Equivalents' can be compared to pieces of music, in that each is differently keyed, patterned and accented. Theirs, though, is a sumptuous, romantic music, whereas the chicken shed plays a more jagged tune.

Despite their connection with Lake George, none of these photographs evokes a particular place. Like his German contemporaries, Stieglitz worked with fragments: a window and a section of wall, the corner of a house. He was not looking, as they had done, for significant details which might refer to a greater social whole. Instead he wanted images which harmonized and told of an order which transcended place and time. Any photograph which

simply described Lake George as a habitable place on a particular day would fail in this task, and thus Stieglitz avoided distance, depth and the integrity of objects – all of which were likely to draw attention to what was down-to-earth and timebound.

Where do the portraits belong in this career dedicated to truth and natural law? They are extraordinary portraits which make it easy to see why Waldo Frank thought of Stieglitz as a hypnotist or Svengali. His subjects were Georgia O'Keeffe in the twenties and Dorothy Norman in the thirties, and both appear in a large number of roles. They age overnight. They grow young. They are by turns thoughtful, opulent, austere, arrogant and forlorn. Although both perform for the camera, they do so with conviction; by contrast, their forerunners in the art photographs of 1900 seem tentative and unconvinced of their own distinction. Both women clearly believe in themselves, as Stieglitz believed in himself. But they differ from the Stieglitz who looks out with unremitting gravity from a mass of portraits over the decades. They are protean, variable characters without any of his own inflexibility. Through them Stieglitz acknowledged another way of being in the world, one constituted of mood and temperament, and somewhat removed from the constraining rule of natural law.

At first sight Edward Weston appears to be a photographer in the Stieglitz pattern. He too was capable of the kind of ecstasy which Stieglitz often felt in the presence of the natural world. He also took pictures of clouds (1936) and went into the back country, where he photographed fragments of rock and timber. And he associated with the kind of exultant personalities to whom Stieglitz was drawn. General Manuel Hernandez Galvan, portrayed by Weston in Mexico in 1924, embodies masculinity, just as Guadelupe Marin de Rivera is the very image of a heroine.

Born in 1886, Weston moved from Chicago to California when he was twenty and worked for some years as a portrait photographer and soft-focus pictorialist. The sharp-focus pictures for which he became known are the work of his mature years; they date from the early twenties onwards. He moved to Mexico in 1923 and began to build a reputation as a leading modernist photographer. In 1929 he and Edward Steichen organized the American section at the *Film und Foto* exhibition in Stuttgart. Back in California he photographed in the Mojave Desert and at Point Lobos on the coast. In 1932 he was involved, with Willard Van Dyke and Ansel Adams, in the formation of a society of purist photographers, called 'f.64'. In 1937 he was the first photographer to be awarded a Guggenheim Fellowship, which allowed him to travel extensively through the West. In 1941 he made another long trip, this time through the South and East, taking pictures for a

146

80 EDWARD WESTON
'Guadelupe Marin de Rivera'
1924.

special edition of Whitman's *Leaves of Grass*. During the forties he was
gradually incapacitated by Parkinson's disease, and he died in 1958. He
valued himself and his work very highly, and in general people have agreed
with that valuation.

Weston wrote a great deal about photography and about his life, in a
series of daybooks which cover the years 1922–34 and in articles for the
photographic press. He defined himself as a 'straight' photographer, who
looked for 'the very quintessence of the thing itself rather than a mood of
that thing'. He called his approach the 'direct' approach, and spoke of the
camera's 'innate honesty' which allowed him to look into 'the nature of
things' and to present them 'in terms of their basic reality'. In other words he
was as much concerned to get at Truth as any of his predecessors among the
art photographers of 1900, yet he disapproved of their means, and called
their successors 'photo-painters'.

Weston did not, as Stieglitz had done, cite natural law as his guiding
principle. He was not nearly so concerned with pictorial integration or
harmony as Stieglitz had been; his pictures tend to be of things, rocks, trees,

147

plants, bodies, set against backgrounds and not joined with them. All the same there was something out there in the world which had to be answered to. Whatever it was revealed itself to an artist prepared to watch carefully and patiently, and Weston's description of this process recalls an earlier account by Stieglitz. In an article of 1930, 'Photography – Not Pictorial', Weston described the moment: 'To pivot the camera slowly around watching the image change on the ground glass is a revelation, one becomes a discoverer, seeing a new world through the lens. And finally the complete idea is there, and completely revealed. *One must feel definitely, fully, before the exposure.*' Intuition guided Weston to 'the complete idea'. He explained that he never tried to plan in advance and started out with his mind 'as free from an image as the silver film' on which he was to record. Yet this did not mean that he was merely a passive beholder, waiting for right order to declare itself. The response, when it came, was his response, and thus his pictures are much more personal and expressive than those of Stieglitz. He is, in fact, exactly the sort of artist foretold by Annan's example in the 1890s: a sensitive observer who worked as though at the behest of nature yet without the constraints of natural law.

Weston was much less of a purist than his advocacy of 'straight' photography implies. This is not to suggest that he misrepresented himself, rather that the 'direct approach' was inherently unstable. He hoped that the beholder of photographs such as his would 'find the recreated image more real and comprehensible than the actual object.' Certainly his still-life close-ups of kelp, nautilus shells, peppers and roots taken around 1930 have tremendous plasticity and presence. They are larger than life but, isolated against dark backgrounds, twice as strange. Paradoxically the 'direct approach' resulted in ambiguity. Weston's subjects, set apart as sculpted specimens, are as suggestive as they are specific. Dark kelp, seen at close range, becomes sinister and expressive; a split artichoke gapes like an enormous mouth, and a nautilus shell rears like a sea monster. They are 'more real' in the sense that they are more alive; but the life they refer to is that of the imagination, seeking forms to match its needs.

The photographs of peppers, kelp and fungi hint at a turbulent, even demonic, imagination. If this were all, Weston's pictures would be no more than powerful curiosities. Yet even where he wrought his most expressive transformations he suggested a countervailing stability. His nautilus shells may curve like serpents, but they also take the light with a scrupulous exactitude which brings Evans's cathedrals to mind. They pass, by degrees, from brilliant highlighting into shadow – as do the peppers, across a darker tonal range. In this respect they are microcosms, enclosing time itself. Where

an Atget photograph, for instance, signals particulars of standpoint, time of day and history, Weston's still lifes, with their nuanced tonal transitions across shells and the gills of fungi, embody continuity – 'the leading on from element to element' which fascinated Frederick Evans. They offer a résumé of moments, an image of time as light rising and waning.

These metaphoric still lifes constitute only a small – if often quoted – part of Weston's work. He was also a distinguished landscapist, a celebrated photographer of nudes and, like many of his contemporaries, a recorder of American vernacular imagery, such as hand-painted noticeboards and signs. His Guggenheim book, *California and the West*, published in 1940 with sixty-four pictures and a text by his wife Charis Wilson, is a documentary survey which, at first sight, looks like many other reports on America done at that time – and the same applies to the forty-nine pictures published in *Leaves of Grass* by the Limited Editions Club in 1942.

Weston's America, however, is no congenial homeland. It looks, at times, like a deserted site from which the tide of civilization has already receded, leaving a debris of fallen timber and eroded relics: old cars, bleached stumps, mud flats and abandoned homesteads. Even when untainted, it remains forbidding, for Weston's tendency with landscape as with still-life items was to work objectively. That is: he envisaged a world raised up against him, as an object in the original sense of the word. His vistas end, as often as not, in a barrier of rock, or they feature hillsides and impenetrable thickets.

This original and challenging sense of objecthood permeates his art. He photographed little which was either comfortable or consoling. His skyscapes are whipped by the wind, and more turbulent than any of Stieglitz's cloud studies. His female nudes have a palpability and immediacy far in excess of anything sought by his predecessors; they embody nothing but themselves, not even the mystery of personality – for they seem self-absorbed, or engrossed in a purely physical existence.

In short, Weston's is an extremist art. He looked for whatever was most opulent and most complete. On the other hand he was also drawn to whatever was most alienating, to extremes of dessicated and abandoned landscape. He was an ironist, in a very fundamental sense, working always with regard for the twin poles of fullness and desiccation, life and death of the senses.

Edward Weston's work is paralleled, in many cases, by that of Ansel Adams, also a member of the Californian f.64 group and a long-time devotee of Western landscape. He too made pictures of dead trees, sand dunes and eroded rocks, and he wrote of purist photography as a means towards insight – into both nature and humanity. His faith in photographic seeing matches

that of Stieglitz and Weston, as indeed it matches that of Man Ray, who wrote in 1934: 'Open confidences are being made every day, and it remains for the eye to train itself to see them without prejudice or restraint.' Adams trained his eye in Yosemite in the 1920s and over the following decades made some of America's most famous landscape pictures, in which a mountainous America extends to far horizons. He envisaged a more peaceable world than Weston, one in which rock is mitigated by water, foliage, clouds, sun and moon. Traces of modern man sometimes show themselves in his pictures, but, set against large skies and vast spaces, they cease to matter.

Weston's near-contemporary Paul Strand was an equally substantial artist. Strand also sought to honour what was beautiful in the material world, and he too invoked the death of the senses in photographs of skulls and tombstones. Like Weston, and in the same years, he took close-up pictures of rocks, fungi and tree roots, and these also have metaphoric implications. Yet despite these affinities, and despite similarities of intention, his art differs in many fundamental respects from that of Weston.

Strand, born in 1890, was introduced to photography in 1907 by the great American documentarian Lewis Hine in classes at the Ethical Culture School in New York. In 1912 he became a commercial photographer, and in the next few years came to know Stieglitz who, in 1917, devoted the last number of *Camera Work* to Strand's pictures. During the twenties and thirties he was as much a film-maker as he was a still photographer. In 1921 he and Charles Sheeler filmed *Manahatta*, about New York City. For a while Strand worked as a freelance cameraman. In 1933 he was appointed chief of photography and cinematography in the Fine Art section of the Secretariat of Education in Mexico, and photographed and produced a film, *The Wave*, for the Mexican Government. After a journey to Moscow in 1935 he returned to the United States and worked for the Resettlement Administration of the U.S. Government. He was a photographer on Pare Lorentz's film *The Plow that Broke the Plains*, and then as President of Frontier Films he edited *Heart of Spain* and photographed *Native Land*. Thereafter he devoted most of his time to still photography, and from 1950 onwards published books on New England, France, Italy, the Hebrides, Egypt and Ghana. After 1951 he lived mainly in France, and he died in 1976.

Strand, like Stieglitz and Weston, expressed himself forcibly on the nature of 'true' photographic practice. He was deeply committed to Stieglitz and outraged by public indifference to *Camera Work*, as he was outraged by pictorial and soft-focus photography in the early twenties. He was equally at odds with a modern, mechanized America which he judged — in an article, 'Photography and the New God', published in *Broom* in 1922 — to be in thrall

81    ANSEL ADAMS 'White Branches, Mono Lake, California' 1950.

to 'a new Trinity: God the Machine, Materialistic Empiricism the Son, and Science the Holy Ghost'. Artists clearly had no place in this new order and were, he thought, looked on as 'a menace to a society built upon what has become the religious concept of possessiveness.' They, by contrast, were committed to 'the extension and projection of knowledge through the syntheses of intuitive spiritual activity, and its concomitant the *vita contemplativa.*' In a long career he adhered to this original diagnosis and programme.

He believed passionately in 'straight' photography. At the same time he claimed that the photographer should also be a creator looking for forms in which to clothe 'his feelings and ideas'. He spent little time trying to resolve this apparent contradiction between 'straight' photography and personal creativity, because in his own work there was no contradiction. His 'feelings and ideas' were at one with the objects of his contemplation. This is how he commended a photograph by Stieglitz in a lecture, 'The Art Motive in Photography', given to the Clarence H. White School of Photography in 1923: 'Notice how every object, every blade of grass, is felt and accounted for, the full acceptance and use of the thing in front of it.' He might almost have been evaluating his own pictures, which are scrupulous in their representation of depth, weight and substance.

Although an argumentative lecturer and writer, Strand the photographer was a quietist, absorbed in a respectful contemplation of commonplace objects. There was, however, nothing passive about the kind of contemplation which he proposed, and this is evident even in his earliest pictures. One of the photographs published in *Camera Work* in 1917 is of a white, slatted fence ranged across the foreground, with a house and barn in the distance. It is entirely characteristic of Strand that he should focus on something so functional and easily taken for granted as this, which is no more than a marker or dividing line. Yet, arranged thus, silhouetted against a dark ground, the regular slats of the fence show themselves to be variously weathered and broken. Within the pattern there are differences, and it was to such differences that Strand continually drew attention.

In 'The White Fence', with its systematic patterning and random breakages, Strand established the basis of his art. His aim was the redemption of cliché. His means varied, but in general he invested his subjects with some sort of perceptual difficulty which makes the act of seeing into an act of deliberate reconstruction. In his photographs forms overlap and lose themselves in shadow. He frequently omitted such coordinates as horizon lines. He chose standpoints from which space appeared to be unusually compressed, and only to be fathomed by changes in the scale of architectural

82   PAUL STRAND 'Toadstool
and Grasses' Maine, 1928.
Published originally in *Time
in New England* by Paul
Strand and Nancy Newhall
(New York 1950).

detailing. Discernment is always possible, but only after a while and only after reflection.

This was Strand's way from the beginning, although he gradually refined his means. One or two of his early pictures, published in *Camera Work*, feature overlapping pots and fragments of modern architecture, and are as hard to resolve as an early composition by Fernand Léger. His photographs soon became less abstract and more informative. In 1920 he photographed a New York townscape, 'Truckman's House', from a high window. The evidence of a row of roofs to one side of the picture shows that the ground recedes, but everything else is photographed from an angle which obscures the lie of the land. The result is a picture which appears to be part photograph, part collage. In New Mexico in the early thirties he found ambiguities in the white walls of adobe buildings. The church at Ranchos de Taos, which he photographed in 1931, could hardly be more ponderous and clearly articulated, but Strand saw it in a light and from an angle which make its exact shape a matter of surmise. It stands in the not so clear light

153

of day and on variable ground, which means that the picture must be scrutinized if the depth of a buttress is to be gauged or the exact shape of the choir established. In 1936 he composed with overlapping sections of boarded buildings in Canada and raised more problems of spacing and placing.

His *tour de force* in this vein is 'The Bicycle', taken at Luzzara in Italy in 1953. At first sight this might look like nothing more consequential than a view of a worn-down site in old Europe. A line of grey steps rises and turns around a white column. Dainty wallpaper, much rubbed, covers the far wall and staircase, and a bicycle stands propped against the column. With these few, plain elements Strand makes a picture worthy of De Hooch. Crucial evidence, as before, is withheld by screening, and the disposition of the space has to be gauged from such givens as the length of the cycle, the width of the steps and the scale of the wallpaper motif repeated from section to dimly-lit section.

His art, very much like that of De Hooch in the seventeenth century, is an art of gauging, one which needs to be deciphered scrupulously. Through it Strand acknowledged both the artifice involved in art and the priority of things as they are; as he said of Stieglitz, 'there is always a full acceptance of the thing in front of him, the objectivity which the photographer must control and can never evade.'

In addition, Strand was a portraitist. In 1916 he took candid portraits on the streets of New York, of low-life figures whom he envisaged as caricatures. Thereafter his subjects pose in full consciousness of the camera. They appear, that is, in their own terms, rather than as character studies. To a certain extent these later portraits are revelatory, for some of his sitters look beyond the camera and compose themselves as if for an audience. Most, however, pose as though the good opinion of posterity was of no account. They look back impassively, momentarily turned aside from necessary work, for they are mainly peasants and farm people. In fact, Strand's suggestion is of a primal race, untainted by city ways and by fashion. These dignified country folk embody the dignity and honesty by which Strand set such store.

He and Weston both disapproved of the societies in which they found themselves. Weston registered his distaste in an art which centred on extremes of sensuality and a closely connected austerity. Strand, in the outlying regions, pieced together details to make a picture of a natural life which might put civilization to shame.

83  PAUL STRAND 'The Bicycle' Luzzara, Italy, 1953. Published originally in *Un Paese* (Turin 1955).

## American Society

*On reformist documentary, up to Walker Evans's analyses of American culture in the 1930s*

PAUL STRAND, angered by a society involved in an 'unscrupulous struggle for the possession of natural resources, for the exploitation of all materials, human and otherwise', proposed that material might be valued differently – for its own sake, rather than as a 'natural resource'. He sought to instruct by example. Others, especially Strand's mentor Lewis Hine, took exploitation as their subject and worked to document ruination and hardship. But the first of these documentarians was Jacob Riis, who revealed appalling conditions in the slums of New York in the 1890s. He was followed by Lewis Hine, who enlisted in the struggle against child labour in the years 1907–18. In the early thirties Doris Ulmann documented the people of the backward Appalachians. Then, in the late thirties, American photographers set to work in earnest, mainly under the aegis of the Farm Security Administration of the U.S. Government, to chronicle life and hard times in the rural areas. The nature of this tradition is open to question, for many American documentary pictures are portraits – character studies which reveal little of social conditions. American photographers did set out to right particular wrongs, but above all they worked with regard for individual identity, under threat in an increasingly mechanized society.

Jacob Riis, a Danish immigrant who became a reporter for the New York *Tribune* and the Associated Press Bureau in 1877, was the first American reformer to use a camera. John Thomson's pictures of the London poor, taken in the 1870s, appear suave by comparison with Riis's brutal records of derelict New York. Riis, when a police reporter, photographed the Mulberry Street area on the East Side. This sector, badly run down, was peopled by recent immigrants who worked in local sweat-shops and lived in squalor. Riis agitated on their behalf in the columns of the *Tribune*, and then in 1890 published his famous exposé *How the Other Half Lives*, in which he introduced the people of the tenements and back alleys to a book-reading public.

*How the Other Half Lives* was shakily illustrated with halftones and drawings based on Riis's original photographs. These illustrations endorse Riis's findings. The photographs themselves have precedents. They look like nothing so much as battlefield photographs of the 1850s and 60s, for Riis, like

84  JACK DELANO 'Greene County, Georgia, Nov. 1941. W.H. Holmes, a renter on the Wray place, plowing sweet potatoes' Plate 20 in Arthur Raper's *Tenants of the Almighty* (New York 1943), where it is paired with a picture of Jim Brown, a negro farmer. An F.S.A. photograph.

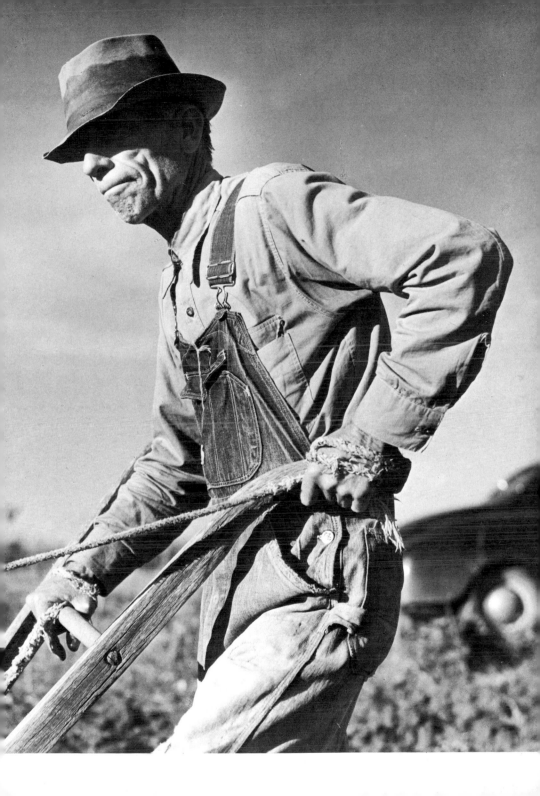

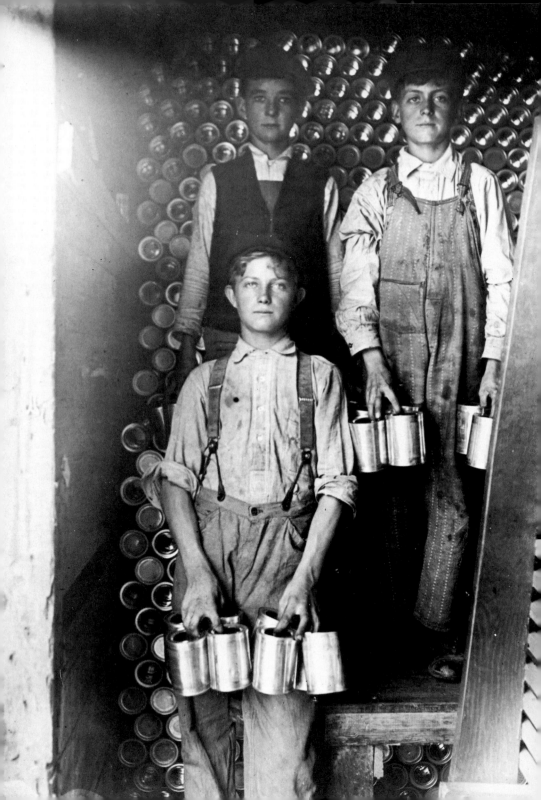

the war reporters, was confronted by scenes which defied reason. Moreover, most of his subjects were beaten down or almost at their wits' end, surprised in cheap lodging houses or narrow rooms, and in no position to give a good account of themselves. Nevertheless, his story is not entirely hopeless; he saw shining examples even in the worst conditions, 'like jewels in a swine's snout', and they crop up in the photographs in vivid faces of children smiling among the debris. However, his hopes for a better world are outlined in his text: pictures simply illustrate the immediate grounds for his complaint.

Lewis Hine saw exploitation differently. Riis photographed squalor and wrote about his hopes for American society. Hine, by contrast, made pictures which looked to the future as they disclosed present hardship. His children, at work in mills and factories, are victims of a heedless system; at the same time, in Hine's paradoxically beautiful pictures, they shine out as symbols of a better world.

Hine, born in 1874, began to take pictures around 1903 when he was teaching at the Ethical Culture School in New York. This had been established in 1877 as the Workingman's School by Felix Adler, the founder of Ethical Culture – a humanist religion which stressed the worth, dignity and creativity of man. Adler, serving on the Tenement House Commission in the 1880s, had particularly impressed Riis as a scourge of unscrupulous landlords. Between 1904 and 1921 Adler was the chairman of the National Child Labor Committee, for which Hine also worked.

Hine's first photographic task, connected with his teaching at the Ethical Culture School, was to make pictures of contemporary immigrants on their arrival at Ellis Island. He worked at this between 1904 and 1909, and took around 200 pictures in all. The purpose of this project was to reveal the new Americans as individuals, and to counter any idea that they were the worthless scourings of Europe. Hine continued to work with such redemptive purposes in mind.

In 1906 Hine became more involved than ever with reformist organizations. He began to work as a freelance for the National Child Labor Committee, founded in 1904 by socially concerned citizens to save children from exploitation. He came into contact with Arthur and Paul Kellogg, who ran the magazine *Charities and the Commons*. In 1907 Paul Kellogg asked him to contribute to the Pittsburgh Survey, a detailed sociological study which was to result in a six-volume report illustrated by Hine and by the painter Joseph Stella. In 1909 Paul Kellogg established a weekly magazine, *The Survey*, and Hine was invited to serve as a staff photographer. But most of his time in these years was given to the N.C.L.C., by which he was employed on a regular basis from 1908 onwards.

159

85 LEWIS HINE 'Indianapolis. August 1908. Boys Working in a Cannery. Unloading freight cars full of new tomato cans' An early example of Hine's labour pictures.

His survey of child labour took him far afield. In 1908 he reported on mining and glass works in West Virginia, and canneries in Indianapolis. In 1910 he recorded children at work stringing and snipping beans in Buffalo, tending machines in a cannery at Niagara, hulling strawberries and canning peas in Delaware, and picking shrimps in Biloxi, Mississippi. Wherever he went he photographed newsboys and messengers, from Waco, Texas, to Washington, D.C. These children worked long hours and mixed with poor company. Hine kept a detailed record of most of his encounters; at first these were countersigned by other witnesses, but the habit seems to have lapsed after a while. His reports range from life stories to such basic notes as these, made in South Carolina in February 1911: 'Nine of these children from 8 years old up go to school half a day, and shuck oysters for 4 hours before school and three hours after school on school days and on Saturday from 4 a.m. to early afternoon. Maggioni Canning Co.'

To some extent Hine reported on conditions. For instance he photographed the shacks used as accommodation for seasonal labourers working on the cranberry harvest in New Jersey in 1910: 'Wooden toilets near at hand, and bushes used as such, give forth very offensive odors. Turkeytown, near Pemberton, N.J. Witness E.J. Brown.' For the most part, though, he made portraits, and outlined his charges in captions and notes which were later reworked in articles, posters and pamphlets. Where the Ellis Island immigrants, newcomers in a strange land, show themselves anxious or reserved, Hine's exploited children address his camera with confidence. They have, or seem to have, stories to tell. They appear as speaking likenesses, testifying to their own condition; and in this respect they anticipate much of what follows in the 1930s, when virtually every documentary portrait comes supported by a plain statement, aphorism or complaint. The documentary photographers saved the idea of individual existence from oblivion in general categories and statistics, and ranged personal voices and country idioms against the dry prose of surveys and reports. The European tendency, by contrast, was analytical and objective. Europeans observed covertly and drew conclusions, for they were acting in a culture in which social distance was accepted as a matter of course.

Hine continued to work after the war, for *The Survey* and for the American Red Cross. He photographed again at Ellis Island in 1926, and then in 1930 recorded the construction of the Empire State Building. In 1932 he published *Men at Work*, subtitled *Photographic Studies of Modern Men and Machines*. This was dedicated to Frank Manny, principal of the Ethical Culture School, and introduced thus: 'This is a book of Men at Work; men of courage, skill, daring and imagination. Cities do not build themselves,

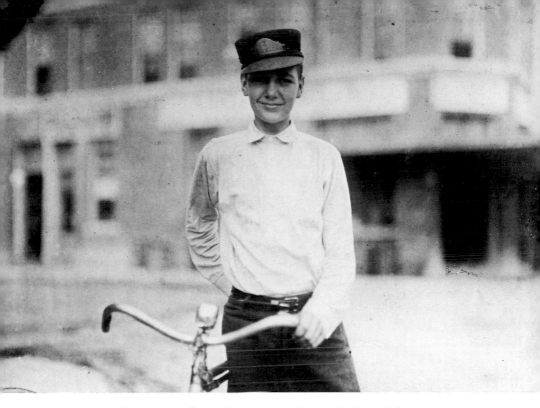

86   LEWIS HINE 'San Antonio, Texas, October 1913. Preston De Costa, Fifteen
Year Old Messenger, No. 3 for Bellevue Messenger Service'

machines cannot make machines, unless back of them all are the brains and
toil of men. We call this the Machine Age. But the more machines we use the
more do we need real men to make and direct them.' Just as he had sought to
reveal the real people involved in immigration, so he sought to show the real
face of labour.

Notwithstanding these intentions *Men at Work* is a generalizing survey.
'The riveter', 'the sky boy' and 'the hoister' might have stepped straight out
of a five-year plan. They symbolize industrial work, and portray workers as
stalwart heroes posed monumentally by monumental machines. In 1930
Hine was working in a collectivist ethos, and these were images appropriate
to that ethos. At the outset he had been examining a new subject, and he was
free from models and constraints. During the early thirties he was no more
than one of many artists set on honouring the common people and, in
particular, Man the Producer.

Despite his distinguished record Hine began to have difficulty in finding
work during the thirties. Roy Stryker, at the Farm Security Administration,

thought that his best days were behind him, and Florence Kellogg, art editor at *The Survey*, found his photographs unfashionable – Hine wrote to her defending his use of 'more pictorial personalities' and restating his belief in 'the human spirit'. To judge from *Men at Work* Hine's modern style was indeed outmoded, but only in the sense that it belonged to the immediate past. Hine had reshaped his art in terms of the mechanist aesthetic which prevailed in painting and design during the 1920s. By 1930 this aesthetic and everything it stood for – industrialization, standardization – were suspect. Strand had voiced his suspicions in 1920, but after the collapse of the stock market in 1929 and the onset of the Great Depression there were more doubts than ever. The machine was to blame, and thus Hine's attempts to present mitigating evidence in *Men at Work* were compromised from the start. More radical answers were required if the baleful influence of machine and factory was to be resisted.

The result was a shift to a form of pastoral documentary in the thirties, and the first major photographer in this new mode was Doris Ulmann, a wealthy and distinguished New York portraitist who photographed during the summer months in the South and in the Appalachians. Two books resulted: Julia Peterkin's *Roll, Jordan, Roll*, with eighty-nine copper photogravure pictures by Doris Ulmann, published in 1933, and *Handicrafts of the Southern Highlands*, by Allen H. Eaton, with fifty-eight illustrations from her photographs, published in 1937. Both books, like Edward Curtis's survey of North American Indians which was just then finishing, celebrate ancient folkways. *Roll, Jordan, Roll* eulogizes the life of rural blacks, and the photographs illustrate such seasonal and ceremonial business as cotton-picking, river fishing, ploughing and baptism: 'Better to be poor and black and contented with whatever God sends than to be "vast-rich and white and restless".' Peterkin and Ulmann pictured an idyll of the sort Emerson had originally set his heart on:

The Negroes hold fast to the old ways and beliefs acquired by their forefathers through years of experience. Free from the slavery of calendars and clocks, they depend on the sun to tell the time of day, and on seasons to mark the time of year. They do not build or run machines, they have no books or newspapers to read, no radios or moving pictures to entertain, but they have leisure to develop faculties of mind and heart to acquire the ancient wisdom of their race.

In other words they lived real lives, whereas society at large was constituted of what the writer Sherwood Anderson called 'half-born men', creatures shaped by experience of film and radio.

Like Curtis's Indians these Arcadians were skilled artisans and artists, and they were closely identified with particular spots: Isaac Davis, broom-maker

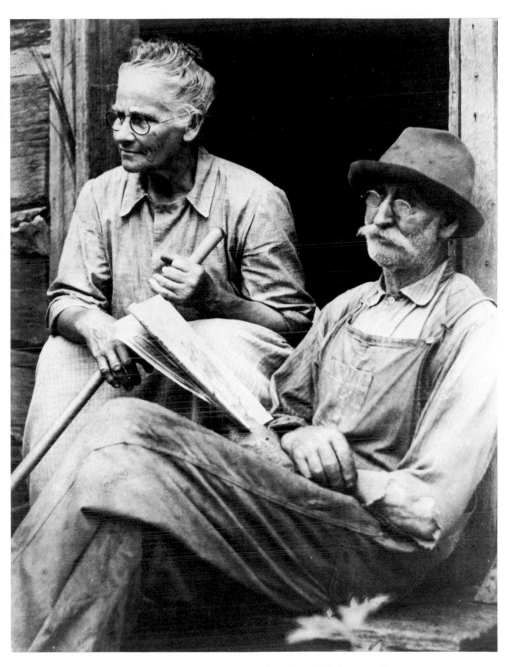

87 DORIS ULMANN 'Mr and Mrs Newt Mann of Holston, Washington County, Virginia' 'Mr Mann was a prosperous farmer in the mountains, but enjoyed telling of early roaming when he went to England on a cattleship' (from a note by M. B Kreger on the reverse of the picture). Doris Ulmann was in Virginia in the late twenties and in 1933–34.

of Blue Lick, Kentucky; Wilma Creech of Pine Mountain, Harlan County, Kentucky, spinning wool on a high wheel. As they worked they told stories or, if they were weavers, sang old-time ballads and carols. Yet they are not simply people of an idyll. Most of them, old-timers in the main, look as if they have lived arduous lives; they are conspicuously worn down and weathered, and in this respect they anticipate the hard primitivism of the Farm Security Administration photography in the later 1930s.

Above all, however, these are portraits of particular characters rather than mere representative types. Doris Ulmann, like Lewis Hine, was a product of the Ethical Culture School; where Hine had redeemed the idea of the immigrant, she redeemed that of the folk – at a time when the folk were in danger of being given mythic status in the wider struggle against the culture of 'half-born men'.

Doris Ulmann's career as a documentarian was short. Most of her pictures of Southerners and of mountain people seem to have been taken in the early thirties, and she died in 1934 at a time when a new generation of American photographers was about to be mobilized for one of the most ambitious of all documentary projects.

In 1935, Franklin D. Roosevelt established the Resettlement Administration as part of his New Deal for the American nation, struggling to cope with the Great Depression. The R.A. was intended to mitigate agrarian hardship, to provide low-interest loans to small farmers, to promote land reclamation schemes, to establish rural villages and to aid migrant workers. In 1937 the R.A. was taken into the Department of Agriculture and became the Farm Security Administration. Roosevelt's Assistant Secretary of Agriculture was Rexford Tugwell, formerly a professor of economics at Columbia University. Tugwell determined on a pictorial survey of American rural areas, and in the summer of 1935 asked an ex-student and assistant from Columbia, Roy Stryker, to take the matter in hand. Stryker, based in Washington, was appointed Chief of the Historical Section and instructed to document the work of the Resettlement Administration. Over the years he employed many photographers. Initially he appointed Arthur Rothstein, a chemistry graduate from Columbia who was just then starting out as a scientific photographer. They were joined by Carl Mydans, a photo-journalist who had already been employed by the R.A. to document suburban resettlement. The group was completed by Walker Evans, who was about to become one of the greatest artists in the history of the medium, and by the painter and illustrator Ben Shahn. In the autumn of 1935 Roy Stryker asked Dorothea Lange, a Californian documentarist, to become a fifth member of the survey group.

164

American farms were in poor shape in the early thirties. Prices for cotton, wheat and corn had declined, and people were leaving the land to find employment in the cities. Worst off were small farmers, of whom there were many in America. In 1929 one quarter of farms produced less than $600 worth of products, including those used on the farm (£125 at contemporary exchange rates). Moreover, farmers had to contend with such blights as the boll-weevil, with soil erosion, which was a result of years of mismanagement, and with mechanization, which reduced the need for hands and drove many tenants off the land.

But the problem was not simply one of agrarian distress. Farming was not just another activity: it was thought of as the cornerstone of American civilization. Thomas Jefferson, author of the Declaration of Independence, had envisaged a republic of yeoman farmers. Theodore Roosevelt, President and supporter of Riis and Curtis, held to the same vision. In 1908 he set up a Commission on Country Life, and declared himself thus: 'No nation has ever achieved permanent greatness unless this greatness was based on the well-being of the great farmer class, the men who live on the soil; for it is upon their welfare, material and moral, that the welfare of the rest of the nation ultimately rests.' The commission concluded that the farmer's problem was that of 'the separate man', who stood alone against organized interests. In the thirties he continued to stand alone, and a significant number of F.S.A. photographs celebrate these independent yeomen. At the same time organized interests were more active than ever, bearing down hard on exploited sharecroppers.

'The separate man', tilling his fields alone, held an honoured place in    *84*
thirties mythology. After erosion and the boll-weevil, his principal foe was the well-heeled city man, motorized agent of remote financiers. However, the problem was compounded by the fact that rural distress was most widespread, and most severe, among blacks and poor whites in the Southern states. Neither group was much esteemed. Such advocates of the South as the Nashville Agrarians believed that virtue was derived from the soil, yet they saw no virtue in the lower classes who lived closest to the soil. In 1932 Erskine Caldwell added to the South's problems by his publication of *Tobacco Road*, in which tenant farmers appear as stunted degenerates.

These were some of the difficulties which confronted F.S.A. photographers. Their immediate subject was agrarian distress, but inevitably this raised larger issues of meaning and identity. Moreover, they were being asked to consider and to portray people, especially in the South, who had already been effectively typecast as hopeless cases.

Initially the F.S.A. photographers concentrated on rural poverty. Mydans

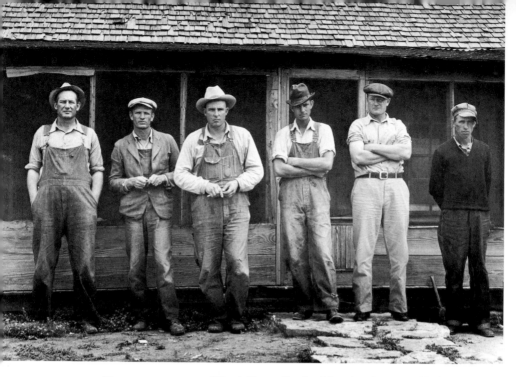

88 DOROTHEA LANGE 'North Texas. Sunday Morning, June 1937' Published in the Plains section of *An American Exodus* by D. Lange and Paul Taylor (New York 1939). 'All displaced tenant farmers. The oldest 33. All native Americans, none able to vote because of Texas tax poll. All on WPA. They support an average of 4 persons each on $22.80 a month. "Where we gonna go? How we gonna get there? What we gonna do? Who we gonna fight? If we fight what we gotta whip?"' An F.S.A. photograph.

was asked to 'do cotton' in the South, and then in 1936 he reported on New England, before leaving to become a photographer for Henry Luce's new magazine *Life*. Lange recorded the plight of newly arrived immigrants in California. Shahn toured extensively in the South, and took pictures in Ohio in 1938, but he only made three trips in all for Stryker's group. Evans also travelled in the South, which he liked: 'The South was the best place to photograph. It had more atmosphere, the most haunting region with its smells and signs; a more captivating atmosphere of place.' He was, however, a difficult employee, and parted company with the F.S.A. in 1937. Arthur Rothstein, who had originally worked back at base, began to make field trips in 1936 and visited Oklahoma and the Dakotas. He became one of Stryker's most reliable reporters. The other mainstay of the organization was Russell Lee, appointed in 1936 to take Mydans's place. He concentrated largely on the Mid-West.

F.S.A. photographs were used in Department of Agriculture brochures and in the press. In 1937 the newly established *Look* magazine ran a series of illustrated articles on rural poverty under screaming headlines: 'Humanity Hits Bottom in the Deep South', 'Caravans of Hunger . . . For Their Children Filth and Flies'. *Look* used significant fragments from the pictures of Rothstein, Shahn and Lange, and painted a grim picture of conditions. Bad news could not be endured for long, and by 1938 F.S.A. reporters were beginning to take more affirmative pictures of rural life. In 1938 Roy Stryker employed Marion Post Wolcott, who in the next few years became a virtuoso photographer of bountiful America. Others followed: Jack Delano, John Vachon and John Collier. By then the photographic programme had expanded. Their subject was society at large, including industry and the towns as well as the perennial South.

In fact, bad news had peaked in 1937 with the publication of *You Have Seen Their Faces*, written by Erskine Caldwell and illustrated by Margaret Bourke-White, who was one of America's most highly paid and successful photographers. Their book, much maligned in American photographic history, dealt with the South from Tennessee to Alabama. By comparison

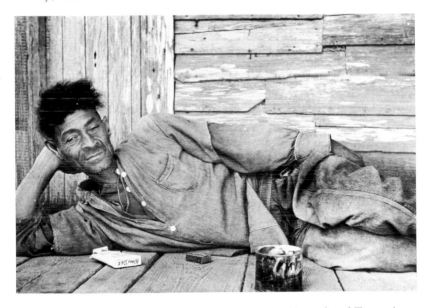

89   BEN SHAHN 'Plaquemines Parish, La. Oct. 1935. An Unemployed Trapper' Featured in *Look* magazine, 25 May 1937, as one of California's wandering farmers. An F.S.A. photograph.

with much else published on the region it is a caricature. Bourke-White's Georgians are no pin-ups; some are sly and some are hopeless – 'I've done the best I knew how all my life, but it didn't amount to much in the end.' Preachers emerge as crooks, and working men as dupes – 'Bringing the white-boss's fine cotton along', at Lake Providence, Louisiana. Yet it is touched by a convulsive humour, of a sort which never surfaces in F.S.A. pictures. At Natchez, Mississippi, they came across an aged couple in a ruined shack: 'I spent ten months catching planks drifting down the river to build this house, and then the flood came along and washed the side of it off. Doggone if I don't like it better the way it is now.' Their work lacked sobriety; it was ironic and extreme – and, worst of all, it parodied such wholesome images as that of the yeoman farmer and his wife. American painters worked in a similar vein at that time, and they too stirred up opposition. Paul Cadmus's murals of Coney Island were denounced by officials as a libel on the resort, and Thomas Hart Benton's local history murals in the State House at Jefferson City, Missouri, unveiled in 1937, also told a raw and animated story which gave offence.

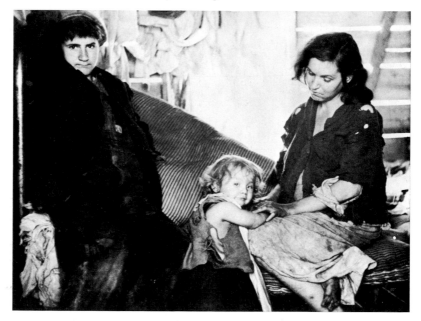

90   CARL MYDANS 'The mother and two children who are living in a one-room hut built on an abandoned Ford chassis on U.S. highway No. 70 in Tennessee. March 1936' An F.S.A. photograph.

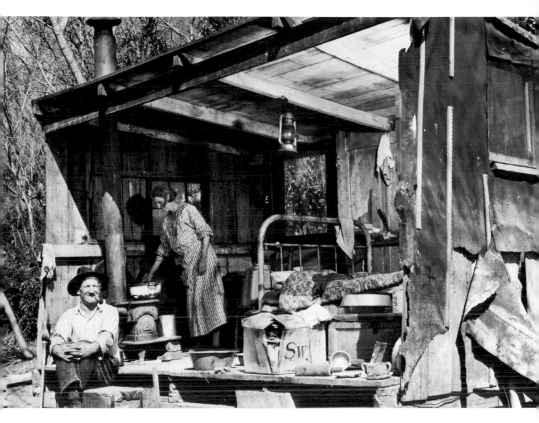

91  MARGARET BOURKE-WHITE 'Natchez, Mississippi' 'I spent ten months catching planks drifting down the river . . .' Published in *You Have Seen Their Faces* by Erskine Caldwell and Margaret Bourke-White (New York 1937).

F.S.A. reporters, by contrast, held themselves in check. They were government employees, subject to a wide range of political pressures. As a result their pictures are altogether more dispassionate and less mediated than those of Bourke-White. They disclose conditions with exemplary clarity, which goes some way towards explaining why they have been so admired in later years when agrarian poverty has ceased to be an issue.

They outlived their immediate usefulness and survived to become so widely studied and appreciated in the 1960s and 70s because they provide unprecedented evidence of a society in the making. The America of the F.S.A. photographers is a work in progress, improvised out of the roughest available materials – warped boards and corrugated paper, held by tin-tacks and twine. Time after time, in front of these pictures, one can follow the

169

maker's hand, gauge his intentions and many of his disappointments. Nail marks show, and the action of the elements, which strips paint from the boards and posters from the wall.

Other photographs of damaged places and of dispossessed people show something similar; yet never exactly of this kind. The America visible here is a place of fabrication and assemblage, of house walls ingeniously patched up from whatever comes to hand, and of trucks elaborately stowed for the journey. Such images invite an imagined re-enactment; they draw us into their complexities – not entirely because the photographers have willed it this way, but because, for once, everything stands revealed amongst people forced into the open. By comparison, European cultures appear opaque, sustained in places inherited and worn smooth by long use. In American conditions in the thirties there were few hiding places, and the migrants were an easy prey to photographers.

In the second place these photographs continue a project set in train by Atget. They tell of a society at large in a landscape loud with instructions and blandishments, vigorously inscribed. The lives of these Americans proceed against the background of a bold promissory heraldry; it is this which takes up space and draws the eye in these photographs rather than the land itself – although that does appear in strong picturings of dustbowl farms and of 'fruitfullest Virginia'. Even in normal views on to normal days the billboarded landscape holds out its promises. In a Lange photograph, used in H.C. Nixon's sober analysis of Southern agriculture, *Forty Acres and Steel Mules* (1938), a bullock at noon drags a cart past a Ford Agency: 'All Signs Point to Ford V-8'. And in the same book Rothstein pictures a dour black family, resettled in Johnson County, North Carolina, outshone by a bleached Santa Claus pouring out his cornucopia in a Camels cigarette ad. Which is to say that these various hard rows of the thirties are hoed with one eye on that break in the clouds where the Promised Land stands bright with images of Fellowship and Commodity. Nowhere else in the photographic archives is this intertwining of the ideal and the actual so apparent; nowhere else is the shape of a future so boldly and enticingly written across the face of the present. F.S.A. America is a cultural theatre of sorts in which we are confronted both with a hectic work in progress and with visionary emblems, tracings of an ultimate destination.

Other, and plainer, F.S.A. pictures participate in this same drama. Many are of nothing more than cabins, barns, stores and rural churches. They are buildings, but they are also signs, geometric markers which punctuate and make an order in Nature's raggedness. European vernacular buildings seem, by comparison, more like organic growths, integrated in their settings.

92 ARTHUR ROTHSTEIN 'The Wife and Children of a Sharecropper. Washington County, Arkansas, August 1935' Featured with 90 in 'Sharecropper Children', *Look* magazine, March 1937. An F.S.A. photograph.

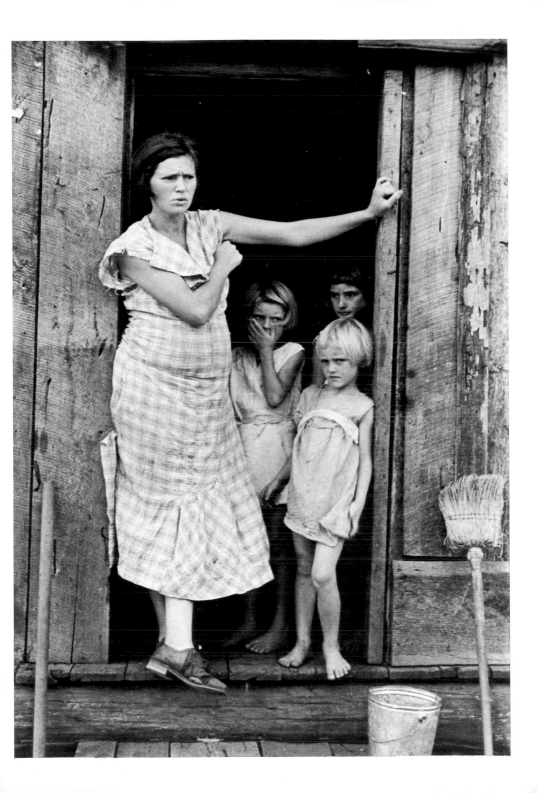

American Man, on this evidence, is a committed constructivist, stamping his patterns on the earth, rather as the topographical photographers had done with their own systematizing art in the 1860s and 70s.

Walker Evans, Stryker's problem photographer, reflected at length on these issues. Evans's pictures had appeared in an *avant-garde* magazine, *Hound and Horn*, in the early thirties. He had illustrated Hart Crane's *The Bridge* (1930), and contributed a set of photographs to Carleton Beals's *The Crime of Cuba* (1933). In 1933 he completed a photo-survey of Victorian domestic architecture in the Boston area, and this was exhibited at the Museum of Modern Art in New York. He was well established, and had his own ideas.

Evans's F.S.A. photographs are, in several respects, complex. Many are of encumbered rooms, packed store interiors, cluttered barber shops. They are

93   WALKER EVANS 'Negro Barber Shop Interior, Atlanta, March 1936' Illustration No. 6 in *American Photographs* (1938).

94 RUSSELL LEE 'Three Members of Ladies' Quintet at a Community Sing, Pie Town, New Mexico, June 1940' An F.S.A. photograph.

encyclopaedic, rich with details of daily life and needs in such places as Sprott, Moundville and Vicksburg. To sort through the shelves of one of his general stores is to come away with a fair idea of life in that particular neighbourhood. Like the storekeeper who is his subject, Evans makes, and allows us to make, inventories. We can count the bags and boxes, just as in front of a timber church in South Carolina we can count the boards and window panes as one can in front of all his façades. His joiners have more in their mind's eye than the need for shelter; their geometric boardwork, on gables, walls and floors, gives back a nuanced light in a hundred ways as it falls along buckling wood and through the worn slats of verandas. The materials, roughly milled planks and trimmed uprights, are as plain as the artisan's units of squares and triangles in which they are arranged; and it is on these that weather and light work their complex variations. Within these grids and symmetries nothing is identical, everything, each board and window pane, is particular; but it is only because of arrangement along an axis that comparison becomes possible, and with comparison differences

95  WALKER EVANS 'Shoeshine Stand Detail. Southeastern United States. *c.* 1936'

begin to emerge. Evans's delight was in the particular. He perceived, as Atget had done, that we sense nothing in isolation, that we sense this for what it is only by reference to another thing which it is not.

At the heart of Evans's documentary is a belief in Everyman as an artist. Although he did take pictures of people in context he is perhaps best known for his still lifes: storekeepers' shelves, shopfronts, the walls of living-rooms in rural dwellings. These, photographed frontally, form precise collages which speak of a way of life. Yet Evans provides more than evidence, for he sought out and enhanced whatever was scrupulously arranged. Common-place objects, preserved by Evans, take on the air of cherished relics. There is something like a correspondence, even a fusion, between his own art and that of the joiners, farmers, barbers and storekeepers – the original makers whose work is respectfully acknowledged, honoured and brought carefully into public view by the photographer.

His major memorial, and one of photography's prime exhibits, is *American Photographs*, published by the Museum of Modern Art in 1938. The book is

174

in two sections: in the first fifty pictures Evans ranges widely across American society; in the second set of thirty-seven his subject is architecture. This instruction appeared on the original dustjacket: 'The reproductions presented in this book are intended to be looked at in their given sequence.' *American Photographs*, its first section at least, is a composite work in fifty images. Sander had arranged *Face of Our Time* somewhat similarly, but Evans's America is an altogether more complex place. He may have found a model in documentary film. In 1927 Walter Ruttmann had pictured a day in modern Berlin in his film *Berlin, Symphony of a Great City*. Ruttmann added one city tableau to another: crowds on subway steps, traffic in a street, a shop window. But where such modern documentary was profligate, Evans was careful and sparing, and his images carry a wealth of precise meaning, both singly and in unison.

Evans is more likely to have been stimulated by the great composite pictures of American life painted in the early thirties by the Mexican muralist Diego Rivera. These were elaborate, and often highly critical, surveys of industrial society, and Evans certainly knew of them, for he had photographed Rivera's murals at the New Workers' School in New York for Bertram Wolfe's *Portrait of America* (1934). Rivera was an angry commentator who made his points brusquely, in pictures thronged with grotesques and paragons who played their parts against crowded vignettes from everyday life. Evans, a calmer analyst, made use of a similarly dislocated pictorial syntax in *American Photographs*.

His subject was society in formation, society making itself in the light of ideals and models. He appears to have been no believer in nature's benign effects. Indeed, if he admits nature at all it is as a negative state towards which things eventually decline once the tide of human affairs has subsided. He terminates the main section of his book with an image of a decayed Southern mansion and an uprooted tree, a culminating symbol of nature as bad weather, to which he refers from time to time in pictures of fading paintwork and frayed paper.

If Stieglitz's generation consulted the clouds and waves, Evans's consult each other. Either that, or they attend to images. There is no natural behaviour in Evans's America. His protagonists grow to fit their uniforms, and one sequence in this series shows that process in action. Children learn to match the decorum practised by their elders, and young girls shape themselves in accord with the dreams of fashion houses. Two young workers, freshly shorn, epitomize the spirit of American manhood, and two lovers at Luna Park appear to enact a happy ending from a Hollywood movie. They have no choice but to live such mediated lives, for they live

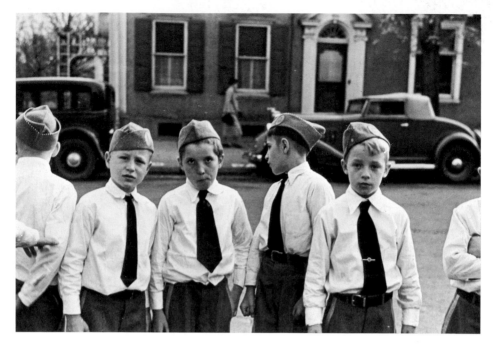

96 WALKER EVANS 'Sons of the American Legion, Bethlehem, Pennsylvania, Nov. 1935' The three central figures here constitute illustration No. 31 in *American Photographs* (1938).

under the influence of pictures – Evans's book is rich in advertising imagery. Appearances are made, he suggests, and supports his view with carefully studied images of a photo-studio, barber shops and a dressing room.

Evans's Americans, insofar as they aspire to ideal states outlined in advertising imagery, are close kin to Sherwood Anderson's 'half-born men'. Yet they never quite enter that company. Circumstance and mood ensure that the ideal is rarely achieved. His most elegant subject, a Cuban dandy, muses on bad news. A marble warrior stares the length of a tangled main street in a quiet Pennsylvanian town, and a sculpted hero addresses an indifferent sky at Vicksburg. Evans, an ironist through and through, concludes that culture is provisional, maintained with difficulty in the face of time and the decay which time brings. Conscious of these attritional forces abroad in the world, Evans cherished anything which told of care and attention: a roadside market stall scrupulously arranged, Bennie Sims's fastidious shoeshine stand, trim shelves in a general store, swept floors and a purposeful kitchen. He answered to art however it presented itself.

Evans's years with the F.S.A. were fraught; he failed to turn in enough

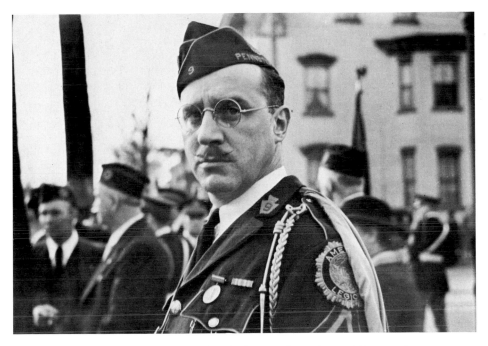

97 WALKER EVANS 'American Legionnaire, Bethlehem, Pennsylvania, Nov. 1935'
The head and shoulders of the principal figure here make up illustration No. 32 in
*American Photographs* (1938).

pictures, and failed even to report his whereabouts. Eventually, anxious for
more scope, he undertook a project for *Fortune* magazine in the summer of
1936. The idea was that Evans and a friend, the writer James Agee, should
spend time with a white tenant family in the Deep South, and that they
should prepare a long report for the magazine. Evans was on loan from the
F.S.A. The two men spent three months in Hale County, Alabama, with
three families. After a while an article emerged, but it was never used by
*Fortune*. Finally, in 1941, Agee's text, greatly expanded, and Evans's pictures
appeared in *Let Us Now Praise Famous Men*. Agee is perhaps the best guide to
the meaning of Evans's pictures. This is some part of what he says about one
tenant home:

that there can be more beauty and more deep wonder in the standings and spacings of
mute furnishings on a bare floor between the squaring bourns of walls than in any
music ever made: that this square home, as it stands in unshadowed earth between the
winding years of heaven, is, not to me but of itself, one among the serene and final,
uncapturable beauties of existence.

Evans photographed, discreetly, in the same vein.

## The Human Condition

*Civilization under stress – photographic responses to economic crisis, war, industrialization and mass society, 1930–50*

GERMAN PHOTOGRAPHERS during the 1920s, and the architects, designers and artists with whom they worked, envisaged mankind at large in a purpose-built setting. The plain geometries of this new environment, evident in any number of housing projects, sports centres, open-air schools, public libraries and broadcasting stations built between the wars, were to serve as a foil to a resurgent humanity. In addition the new age was not to be narrowly nationalistic; it was to be an era of universal collaboration. Out of this ethos came 'human interest' photography, which was to be Europe's dominant mode until well into the 1950s.

The term 'human interest' eventually became a catch-phrase, and the photography to which it applied nothing more than another genre. Yet at the outset, and for a long time, it was a mode of central importance. Its originators worked in Germany, mainly for two rival magazines: the *Berliner Illustrirte Zeitung* and the *Münchner Illustrierte Presse*. The editors of both magazines had used photographs during the twenties, principally as single images. In 1928 they began to publish sets of interrelated pictures, and did so increasingly during the coming years. Their photographers were reporters such as Erich Salomon, Felix Man, Wolfgang Weber and Kurt Hübschmann. Some were independents, some worked through the agencies Dephot and Weltrundschau, and others were, for short periods, staff photographers. They came from varying backgrounds, and few were trained photographers.

Their work had been anticipated in some respects by earlier photo-journalists. One of these was Andrew Pitcairn-Knowles, an Englishman who had taken pictures for the Berlin magazine *Sport im Bild* before the Great War. Pitcairn-Knowles had travelled widely through Europe and had reported on such diverse subjects as cock-fighting in Belgium and hunting in Corsica. Although his sporting Europeans are photographed in context they have been given ample warning, and thus hold themselves in characteristic poses. The new photo-journalists, by contrast, prepared candid reports on a society in action, taken in passing. Wolfgang Weber's unemployed Bavarian peasants, the subject of an article in the *Berliner Illustrirte* in September 1931, expostulate with the authorities. Felix Man's trainee film stars,

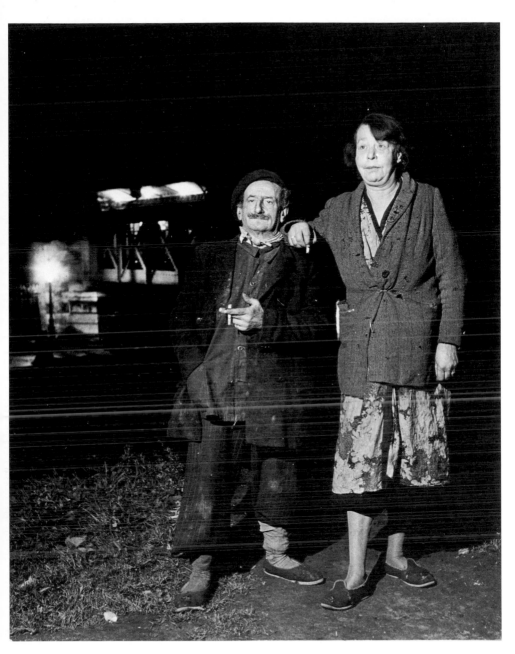

98   ROBERT DOISNEAU 'Down and Out in Paris' 1951.

photographed at the Berlin film school for the *Münchner Illustrierte* in 1930, play their parts with gusto. Erich Salomon's celebrities, seen at congresses and conferences throughout Europe and collected in his book *Famous Contemporaries* (1931), express themselves forcibly and look bored by turns. New photo-journalism was a candid art which told the truth about high-toned dinner parties and the London poor, both photographed by Alfred Eisenstaedt for the *Münchner Illustrierte* in 1932.

The candour evident in this 'human interest' photography is of a special sort. It has something to do with scandal and exposé: e.g. Eisenstaedt's attention to the back streets of London and Felix Man's report on night-time drifters in Berlin for the *Berliner Illustrirte* in 1929. But in the main the new photo-reporters sought to register vitality. They focused on activists: on Mahatma Gandhi, 'The man who challenged the British Empire', on Dr Eckener, the intrepid Zeppelin pilot, on boxers, athletes and acrobats — assertive modern types.

They were in a position to do so for several reasons. Camera technology had evolved. Dr Oscar Barnack, who designed movie cameras for the firm of Leitz in Wetzlar, had developed a lightweight Leica camera which was produced commercially for the first time in 1924. In the same year the firm of Ernemann in Dresden began to make the Ermanox camera, notable because of an exceptionally fast lens which allowed indoor photography in normal electric light. Tim Gidal, an independent photo-journalist at that time, notes in his account of the era, *Modern Photojournalism* (1973), that there was a gap of around five years before these new cameras were much used by reporters. He argues that it took a new generation of cameramen to see their potential. He also notes that the naturalism which they sought had been established in the mid and late twenties by such Russian film-makers as Pudovkin and Vertov, and in Germany by *People on Sunday* (1929), a film directed by Robert Siodmak from a script by Billy Wilder. *People on Sunday*, acted by amateurs and set out of doors in the Berlin area, features exactly the sort of ebullient citizens who figure in the essays of the photo-reporters.

This ebullience came to an end in 1933, following Adolf Hitler's appointment as Chancellor in Germany. Fearing for their independence, and for their lives, editors and photographers fled Germany for the United States, France, Britain and Switzerland. Stefan Lorant, innovative editor of the *Münchner Illustrierte*, moved to Britain in 1934 and helped to found the magazine *Weekly Illustrated*, and in 1938 he became editor of *Picture Post*. Tim Gidal, Kurt Hübschmann and Felix Man photographed for *Picture Post*. In the United States Alfred Eisenstaedt and Martin Munkacsi took pictures for Henry Luce's *Life* magazine, founded in 1936.

99 ANDRÉ KERTÉSZ 'Breton Girls' Printed on the front cover of *Vu* magazine, No. 64, 5 June 1929. The magazine contained an article on Breton folkways illustrated by Kertész, 'En Bretagne, Le Pardon Des Oiseaux'.

German photo-journalists set out to right wrongs, to expose poverty and the effects of unemployment. They themselves were, and they presented their subjects as, indomitable activists. In France photo-journalism took a somewhat different turn. *Vu*, started in Paris in March 1928 by Lucien Vogel, was for ten years the foremost illustrated weekly in France, although it had begun to decline by 1937. It employed some of the principal 'human interest' photographers of the era: André Kertész, Eli Lotar and Germaine Krull in the beginning, and then Kitrosser, Brassaï, Nora Dumas, Roger Schall and Robert Capa by the mid-thirties. Lucien Vogel himself took pictures for extended special issues on the Soviet Union and Germany. *Vu* began as a modernist magazine: its first cover photo was of a Westinghouse Televox robot, and in 1928 it printed spectacular pictures of steelworks by Gutschow and Weiss, and of the Eiffel Tower by Germaine Krull. By the end of the

year, however, modernist celebrations were outnumbered by articles in praise of rural life and exposés of the damage done to traditional France by industry and advertising. André Kertész made several lyrical studies of folk life and traditional labour, in Brittany and Lorraine, and in September 1928 published his article on 'Les Panneaux Sacrilèges' ('Sacrilegious Advertising'), in which he showed the landscape between Paris and Deauville defaced by garish hoardings.

In addition such publishers as Arts et Métiers Graphiques, Librairie Plon, Paul Hartmann and Éditions Jacques Haumont published books of photographic reportage during the thirties.

French reporters were altogether more equivocal about modernity than their German counterparts. They too were ideologists but chose, for the most part, to act on behalf of private life. They became, and remained, skilled observers of everyday subjects. Their principal mentor, in photography at least, was the Hungarian photographer André Kertész. After war service in the Austro-Hungarian army, he moved to Paris in 1925. He quickly established himself and in 1929 impressed his German counterparts with a three-page set of pictures on life in the mother house of the Trappist order, Notre-Dame de la Grande Trappe, in Soligny – published in the *Berliner Illustrirte* and remembered by Tim Gidal as 'a photo-journalistic sensation'.

Kertész's was an enduring and substantial influence, especially in French photography. Although he produced sets of pictures for German magazines he was not a photo-essayist in the German style. He favoured pictures which could stand by themselves, whereas the photo-essayists thought in terms of interconnected groups of images with supporting texts. He looked for exchanges and incidents which might prompt imagination, and was continually on the alert for paradox. In 1927 in a Parisian bistro he noticed a disabled veteran apparently warming his wooden leg by a stove. In 1928 he pictured a priest, Father Lambert, bowed in meditation over a diviner's twig. Some of his subjects are a prey to passing fears: a bowler-hatted gent grasps a stout stick behind his back against two approaching cloth caps on a Paris *quai* in 1926. Others, oppressed and ill-favoured, are mocked by promises extended in advertisers' words and images.

Yet Kertész's actors are not overwhelmed. His irony cuts both ways. The ideal may outshine the actual, but the actual, in the shape of loiterers, passers-by, stooped peasants, outweighs the ideal. His sympathies are for whatever is intimate, casual, particular and out of step. His heroes come from far down the hierarchy, but they hasten anonymously about their own affairs, indifferent to fine buildings and sceptical of the hoardings' messages. Their remote ancestors behaved similarly in the paintings of Daumier. Their

100   ANDRÉ KERTÉSZ 'On the Quais, Paris. 1926' Published in *Day of Paris* (New York 1945).

immediate ancestors hurry through the lithographs of Bonnard and across the pages of many French illustrated books of the 1920s. Kertész arrived in Paris during an era of intense activity among French illustrators, many of whom inclined to informality and irreverence. He showed how these qualities, also evident at that time in the films of René Clair, might be made manifest in photography.

It was not simply a matter of influence, of an impressionable young artist following metropolitan ways. Kertész had begun to take pictures at the age of eighteen when he was employed as a clerk in the Budapest Stock Exchange. He had continued to do so in his army days, and subsequently whilst convalescing. His army photographs foretell much of what is to follow in Paris. He photographed behind the lines: leave-taking, mobilization, a halt on the march, music-making, waiting. Wounded and out of action, he turned his attention to folk life in the villages. By the time he

101   BRASSAÏ 'Street Fair'
1933.

went to Paris in 1925 he was an experienced reporter of those 'little
happenings' with which he and his successors would continue to confront
whatever was dehumanizing in modern life.

Kertész uncovered a whole range of significant imagery. His report on the
Trappists of Soligny was the first of many surveys of religious communities
published in illustrated magazines during the thirties. These Trappists, and
their successors, represent dignity and serenity maintained in the face of
contemporary turbulence. Equally his night-time photographs of bistros,
bars and dance halls, taken in 1926–27, tell of intimate societies and of the
photographer as a familiar, a private man with personal experience.

These hints were expanded on by others, in particular by Brassaï,
originally Gyula Halász from the Transylvanian village of Brasso. Brassaï, a
painter, had arrived in Paris in 1923. He was introduced to photography by
Kertész in 1929 and in 1933 Arts et Métiers Graphiques published sixty-two
of his pictures under the title *Paris by Night*. To some degree Brassaï, and Paul

184

Morand who wrote the text, document the mechanisms of their city: railway stations, tramways, repair work, newspaper printing. But for the most part they present a discreet Paris, rich in distant mystery, a secret city of noctambulists. Brassaï suggests how it is to be alone watching from the shadows. Moreover he shows how the night disturbs normality and makes new emphases around the braziers of nightwatchmen and 'clochards'. Brassaï and Morand, who had written a kaleidoscopic account of New York in 1929, prefer city nights and everything they epitomize. The day stood for normality, discipline and routine. Morand completed his introduction thus. A trumpet sounds at the École Militaire, clogs on the pavement, and the rattle of milk bottles: '"Here is Radio Paris . . . the physical culture course will begin . . . One . . . two . . . breathe in!" I breathe deeply and settle down to sleep.'

Brassaï continued to report on the underworld, out of bounds in Magic City, in opium dens, behind the scenes at Suzy's, along the vice-ridden Rue Quincampoix and the sleazy Rue de Lappe. He introduces Big Albert's Gang, La Môme Bijou, Kiki, Conchita and The Pantheress. He encounters odd characters, but his street people are, as a rule, more stylish than bizarre, and especially engrossed by matters of deportment and dress. Brassaï reflects on these concerns and pieces together a guide to a demotic code in which self-possession is greatly prized. His Parisians present themselves with care. They live (literally) among mirrors, and know how to make an impression, although one which often falls short in the event. Conscious of decorum, they commit themselves guardedly, even to an embrace. Above all they are ritualists, adepts, watchers and participants in the small ceremonials of café life. Watching and waiting, they occupy themselves with whatever comes to hand, with packets, glasses, dice and cigarettes. Handling such things his subjects reveal themselves, personal style emerges. Self-confident veterans of the bistros manage a cigarette fastidiously where a newcomer, a stranger to the art, fumbles. Equally the set of a cap or an arm across a table provide eloquent evidence of mood, style and temperament.

His subjects are on show. The professionals, singers and dancers, posture provocatively and confidently. Café couples under the mirrors movie-act their way through flirtations. A heavyweight prostitute holds a fashion-plate pose under a street lamp. At Suzy's the girls, unclothed, present themselves courteously to an incoming client. Which is to say that secret Paris is no anarchic wilderness. Quite the reverse, in fact: decorous, or at least rule-observing, intimate and even, at times, staid. Nowhere more so than in the bordellos, or 'houses of illusion', where Brassaï, behind the scenes, found routine and practical detail: the staff intent, like any group of relaxing

workers, on a hand of cards, a troublesome curtain secured behind a water pipe.

Brassaï's Parisians are distant relations to Constructivist Man. They act in a conspicuously artificial society where gestures are carefully gauged. Despite their commonplace origins and discredited trades – gangsterism and prostitution, for instance – they too are affirmative figures. Brassaï's underlying subject was conviviality. Everywhere he found signs of complicity, between lovers, between groups of workers, between performers and audience. Even the lights which glow in his dark city appear to beckon and to hint at life out there along the street and across the square. Brassaï also presents himself as an accomplice, a witty and ironic companion: at a fairground he spots a wispy stagehand holding aloft a picture of a prodigiously fat woman on view within a booth; on the banks of the Seine he notes a group of uniformed sailors watching a regatta of fragile sailing boats. Like Kertész he is committed to 'little happenings', a devotee of small transactions, intimate moments, glances. He is a propagandist for what Hannah Arendt, writing in *The Human Condition*, refers to as *petit bonheur*, for that happiness which is to be found away from the mainstream of public life.

Both Kertész and Brassaï are ironists, invariably conscious of illusion and artifice. Although both take candid pictures, neither intrudes to any great degree. Their subjects, in the streets and bistros, are on home ground, in control of the situation. By 1935, however, circumstances were beginning to change, and 'human interest' photography changed accordingly. The European stage, formerly occupied by Salomon's thoughtful and discursive statesmen, was taken over by a new generation of gesticulating activists, strikers and marchers. Hitler's vehemence set a standard quickly matched elsewhere. In France demonstrators took to the streets in support of a Popular Front Government, and the summer of 1936 was marked by sit-down strikes at many major factories in Paris. There was nothing reticent about these strikers who posed dynamically for the cameras of newsmen. Their style spread, and in the spring of 1937 *Life* magazine announced: 'Sit-Down Strikers Proclaim the Spirit of 1937'. By then the Spanish Civil War had begun and it was that, more than anything else, which prompted a new manner in 'human interest' photography. Where Kertész and Brassaï had distanced themselves from their subjects, their successors valued immediacy and looked continually for affecting pictures of man under stress.

One of the first of these compassionate photographers was David Seymour, born David Szymin in Warsaw in 1911 and described by Henri Cartier-Bresson as 'a Parisian from Montparnasse'. David Seymour graduated from the Leipzig Academie für Graphische Kunst and moved to

102 ROBERT CAPA 'Loyalist soldiers find time while preparing for an attack to write letters; during the 1936–7 campaign' (Spanish Civil War). Published in *Images of War* (London 1964).

Paris in 1931. He began to work as a freelance photographer in 1933, and took pictures of left-wing conferences and demonstrations in Paris in 1935–36 before reporting on the Spanish Civil War from 1936 onwards. Although he photographed columns of marching troops and batteries firing in the front line, most of his attention is given to individuals caught up in the hubbub of war. He allows little, or no, distance between his subjects and their audience. We are brought close and asked to share the feelings of an air-raid victim or the optimism of a particular soldier setting off for the front.

Seymour chose to photograph behind the lines, with workers and civilians. Reports from the front itself came largely from Robert Capa, one of the most famous of all war photographers. Capa, a Hungarian, moved to Paris in 1933 after two years in Berlin. He went to Spain on the outbreak of

war and his vivid action pictures direct from the battlefronts quickly established him as a celebrity. In 1938 he took pictures of China under Japanese attack. He returned to Europe for the war of 1939–45, reported on the foundation of Israel, and was killed by a landmine at Thai-Binh in Indo-China in 1954. He was rarely far from the most harrowing action, usually among the dead and dying and the grieving. His most famous picture is of a Spanish infantryman flung backwards by the impact of a bullet; other photographs of grief-stricken women and desolate children are almost as well known.

Capa and Seymour, who was also killed in action (at Suez in 1956), were daring and compassionate reporters. Both broke new ground. Photographs had never before been so immediate and so affecting. At first sight it looks as though the times simply gave them no option: war and its upheavals demanded this sort of reporting. Yet Seymour and Capa were more than newsmen responding to events as they unfolded. Both had a positive vision of man as heroic and fraternal. During lulls in the battle their fighting men relax together and aid the wounded. In refugee camps and bombarded cities women comfort their children. They are representatives less of a particular people afflicted by war than of humanity in general. They suggest universality and permanence and might, in many cases, have stepped directly out of ancient epics. Capa and Seymour sanctify, and give weight to, the present by associating it with the past. Their anxious womenfolk are latter-day versions of the Virgin and of classical Caritas figures; their soldiers look like warriors. Capa made no such claims for his art; he presented himself as a hard-bitten reporter who had seen more than enough of war among troops who were 'completely pooped and thoroughly disgusted'. Yet those very troops relax among fallen masonry under a statue of a winged Victory in an Italian square. Seymour found other symbols of continuity, especially in Europe after the war when he photographed such enduring ceremonies as those of christening and communion and saw children playing at war under ancient carvings of conquerors and captives.

Others responded similarly to troubled times. Dorothea Lange, reporting for the F.S.A., discovered dignity in close association with suffering. Her refugees, Madonna-like, care for their children, and a melancholy travelling-man shows the scars on his hands. W. Eugene Smith, a *Life* photographer from 1938 onwards and one of America's leading postwar photo-journalists, also invoked ancient imagery in extreme circumstances. In the 1960s, for instance, he photographed victims of mercury poisoning in a Japanese fishing community at Minamata. The most striking images in this survey are modern *pietàs* in which a mother cradles an incapacitated child.

103   DAVID SEYMOUR ('CHIM') 'A Public Meeting in Estremadura, just prior to the outbreak of the Civil War. Spain, 1936' Sometimes entitled 'Air Raid Over Barcelona, 1938'.

104   DAVID SEYMOUR
('CHIM') 'Children's Game,
Rome. 1956'.

This mode, in which dignity and suffering go together, originated in the thirties. It was not peculiar to photography. André Malraux, in his novel *La Condition humaine* ('Man's Estate'), published in 1933, set the pattern. His protagonists, revolutionaries involved in an abortive coup in Shanghai in 1927, achieve grandeur in defeat. Moreover, Malraux connects them with an heroic and exemplary past by means of reference to resurrection and martyrdom. At the same time in Britain David Jones was at work on *In Parenthesis* (1937), a long account of the Great War, in poetry and prose, in which that war is imagined as a conflation of all wars, back to Roman, Celtic and Saxon times. He, too, like the photographers, deplored modern impersonality: 'Even while we watch the boatman mending his sail, the petroleum is hurting the sea.'

Capa and Seymour envisaged mankind as heroic in the face of suffering – and even heroic because of suffering. Their contemporary and successor, Henri Cartier-Bresson, worked with a similar scheme in mind. Cartier-Bresson, whose name came to be virtually synonymous with photo-reporting in postwar Europe, began to take pictures in the early thirties under the influence of André Kertész. Some of his earlier pictures are distanced and discreet in the manner of Kertész and Brassaï, but in the main human figures occupy the forefront of his stage. He broadened the notion of suffering on which Capa and Seymour based their photography. His subjects scarcely ever endure the perils of war; instead he presents them coping with everyday impediments, with the weather, with boredom and inconvenience. Nor are they imagined as heroes; rather as intractable individuals, intent on affairs of the moment. Nonetheless he believes, like the war reporters, that humanity is best revealed in the course of action – no matter how insignificant that action might be.

Cartier-Bresson's special subject is French society. Indeed, he is a prime originator of a modern image of the French as an idiosyncratic people. Their idiosyncrasies, however, are tempered by prudence, in which the photo-grapher has an especial and continuing interest. His subjects habitually look out for themselves. Even when the game is up something might still be salvaged. In a celebrated picture from 1932, of a flooded roadworks in the Place de l'Europe, Cartier-Bresson catches the instant just before a leaping man touches down on still water. It is miraculous that he should catch just that moment before the mud sucks and the ripples spread, and remarkable that a dancer's supple image on a hoarding should, with Kertészian irony, mock the victim's stiff-legged lurch into the wet. But the picture is eloquent beyond virtuosity and irony; the sandspit and ladder pushed out into the flood tell of improvisation, of a last resort in the face of a hopeless situation. That is: the camera captures an instant, but it also gives a ground plan of a predicament against which the moment can be weighed and understood.

His pictures, though, are rarely as spectacular as this. The decisive moment, which is Cartier-Bresson's term for revelatory instants, often holds no more than a glance or the barest gesture of an ordinary day. At times the action may be minimal, his subjects at ease to the point of torpor – as was the case one Sunday with a picnic group in 1938 on the banks of the Marne. In this, one of his most famous pictures, meaning depends on placing and difference, among the members of the party and between them and their boats. The diners, replete, weigh heavily against the graceful lines of their skiff on the water. In their settled gravity they embody contentment and represent the French as comfortable gourmands. Equally they are distinct

characters, capable of their own particular appraisals of the day and its pleasures. One, an odd man out, sits behind the others. Higher up, before the river bank dips, things can be better managed. This is the place of a judicious man with an eye for comfort.

Prudence may be a matter of comfort, but it may also be a matter of class, position and maturity. In Brussels in 1932 he came across a pair of men peeping through a canvas screen. One glances around warily; his colleague, a younger man in cap and jacket, sticks to his task entranced. It is the older man, in overcoat and bowler, who shows unease; curiosity and dignity are incompatible, but curiosity persists. Caution has any number of sources: it might stem from a sense of decorum, from a need for comfort, and in France – it appears – from a proper respect for the authorities. One encounter which catches the photographer's eye from time to time features the law and the lower ranks. Park-keepers go through the motions of their job at the sight of jackboots and braid. Notables stand uneasily to attention in the presence of authority.

105   HENRI CARTIER-BRESSON 'Brussels' 1932.

106   HENRI CARTIER-BRESSON 'The Franco-Belgian Frontier' Published in *Cartier-Bresson's France* (London 1970).

No matter how august the circumstances, Cartier-Bresson implies, life goes on and arrangements are made. With this in mind he frequently invokes great themes: The Nation, Love, Liberty. At the Liberation of Paris in 1944 he spots a group of amateur machine-gunners performing for a variously interested and sceptical audience. In 1969 he noted that the Franco-Belgian frontier, one winter's morning, was a dismal spot where the guard swept wet snow from the road. Embracing, his young lovers keep their smouldering cigarettes at a safe distance.

Cartier-Bresson's appreciation of the French is only matched by that of Robert Doisneau, probably the most genial photographer in the history of the medium. Doisneau trained as an engraver in the 1920s and in the thirties worked partly as an industrial photographer and partly as a reporter for the Rapho agency. Where Cartier-Bresson emphasizes the prudential nature of his subjects, Doisneau's people are dreamers and enthusiasts, creatures of imagination. Children playing in a wrecked car on a dump in 1944 see themselves as dashing motorists. A tramp and his lady in a seedy Parisian nocturne of 1951 present themselves with the dignity of grandees. Or they *98*

are specialists, dedicated topiarists, gardeners, model-makers and collectors. When none of these things they exchange secrets, tell jokes, dance in the street or dream of forbidden fruit.

Most of Doisneau's reportages were made after the war, and celebrate the transient, scarcely noticeable happinesses of everyday life. Blaise Cendrars, introducing 148 of Doisneau's pictures in a book on Paris in 1956, connects the photographer's work with a mood of postwar optimism. He interprets Doisneau's pictures of Napoleon's Marshals shrouded in pigeon droppings as a satire on militarism and concludes: 'Long live the Dove of Peace! She has the last word. Doisneau did not seek her out, he chanced on her.'

The Dove of Peace, welcomed back in 1945, presided over an extension of 'human interest' photography. Europeans revelled in normality, and sought to persuade themselves that little had changed, that their traditions continued. Mankind, ravaged but heroic in the late thirties, became tranquil once more, and happy to live in tune with the seasons. Europe, France especially, was rediscovered as a largely agrarian world of shepherds, harvesters and rustic craftsmen. Elderly peasants relax at the day's end in dimly lit taverns. Silence reigns in the villages.

This enchanted picture of a settled, traditional Europe shows itself most clearly in the 1950s, in a wealth of photographic books published by Éditions Clairefontaine in Lausanne, Arthaud and Éditions Verve in Paris, and Thames and Hudson in London. In 1950 Clairefontaine published the most benign of all these surveys, Izis Bidermanas' *Paris des rêves*, where anglers, artists and clochards take their ease by the river in a drowsy city. In 1953 Arthaud, publishers of Doisneau's book on Paris, produced François Cali's *France aux visages* in which, as with the Bidermanas book, poetry and images are combined. Cali used pictures by, among others, Brassaï, Doisneau and Willy Ronis (another specialist in *petit bonheur*) to create a picture of a land and a society both ancient and holy. Cali's France is as close to paradise as can be imagined: fertile, even overflowing, orderly, and permeated by tradition. Where the early 'human interest' photographers in Germany before the war had understood mankind to be autonomous, able to choose and to make things anew, this later generation worked with classical precepts in mind and proposed that we be respectful of our inheritance, no matter how mundane it might be. Of all these photographers Willy Ronis was the most persistent in his regard for ordinary life. He had been an independent reporter and illustrator before the war. Afterwards he returned to photo-reporting in earnest and from 1947 turned his attention to a documentary survey of the suburbs of Belleville and Ménilmontant in north-eastern Paris. This resulted in *Belleville-Ménilmontant*, published by Arthaud in 1954, a reassuring study

107  GOTTHARD SCHUH 'Threshing Corn in Sicily' Published in *Instants volés
Instants donnés* (Lausanne 1956).

of settled lives lived out peaceably in a well-founded city. His most successful
picture, 'Le nu Provençal', dates from 1949 and is of his wife, after sleep,
refreshing herself at a basin by a window on a sunlit afternoon. It is an
unequalled embodiment of tranquillity, of being at ease with the world.

In 1952 Éditions Verve published the most famous photographic book of
the era, Henri Cartier-Bresson's *Images à la sauvette*, entitled *The Decisive
Moment* in America. In this handsome book – 126 large-scale gravures, and a
specially designed cover by Henri Matisse – Cartier-Bresson surveys the
world: Europe, India, America, Egypt and Indonesia. The collection
includes pictures from as early as 1932, and encapsulates the history of
'human interest' photography, from the discreet mode learnt from André
Kertész onwards through heroism and suffering into the tradition-conscious
art of the late forties and fifties. To some degree he chronicles daily life in
distant places – a quayside in China, a market place in Java, a street in India –
but his Easterners are devout people with worshippers and holy men among

their number. In 1955 Verve published his second major book, *Les Européens*. In this he reports on life returning to normal among the ruins of Germany, and on Mediterranean cultures proceeding against a background of ancient statues and buildings.

However, the most lyrical, and in ways the most complex, 'human interest' photography of the postwar years was Swiss: the work of Werner Bischof, Gotthard Schuh, Paul Senn, Jakob Tuggener and Emil Schultess. It centred around the *Zürcher Illustrierte* magazine and *Du*, founded in 1941. *Du*, the cultural monthly, continued to be a force in photography for several decades.

Swiss photographers, perhaps prompted by Gotthard Schuh's lyrical survey of Bali, *Island of the Gods* (1940), became Europe's most passionate seekers after an unblemished Utopia. Werner Bischof, like Ponting before him, found his in Japan. The results were published in an elegant picture book of 1954 – the year in which he was killed in a car accident in Peru. Bischof, like his contemporaries, reported on such major catastrophes as famine in India and war in Indo-China. But wherever he went, and however serious the conditions, he saw extraordinary signs of grace. His pictures are a distillation of everything which 'human interest' photographers had striven for since the late twenties. He found the culminating image of conviviality in a group of Hungarian peasants in a tavern, the most perfect expression of devotion in a Shinto shrine, idyllic versions of rustic labour in Cambodia, Lapland and Peru. In addition he was an unequalled photographer of children, many of whom appear as dwellers in a fairy story. Bischof's is a final, idealized version of 'human interest', purged of those irregularities and local incidents which had caught the interest of Kertész and the French school.

In the great 'human interest' roll call of 1955, Edward Steichen's *The Family of Man* exhibition at the Museum of Modern Art in New York, Swiss photography was well represented, as was that of France and America. There were few British participants: George Rodger, with the important Magnum agency, showed pictures of village life in Africa; Bill Brandt contributed some London street scenes, and Bert Hardy, a *Picture Post* reporter, exhibited a picture of a Burmese monk and another of a young couple in South London.

British photographers had been as active as any since 1930. They too had celebrated the coming of peace in 1945, and in the thirties they had contended with modernism as André Kertész and *Vu* magazine had done in France from 1928 onwards. Yet the British were, to some degree, out of step with the rest of the world. Their reporters, employed by the popular press

108   WERNER BISCHOF 'Flute Player Near Cuzco, Peru. 1954' Taken on Bischof's last photographic tour, and published in *Incas to Indians* (London and Paris 1956).

and by *Weekly Illustrated* – a gravure-printed magazine founded in 1934 and very similar in appearance to *Vu* – attended wholeheartedly to ritual and ancient custom. They strove to suggest a traditional national identity during a period of acute economic and industrial crisis. In this respect they anticipated 'human interest' tendencies of the forties and fifties. Suffering and the dignity of man concerned them scarcely at all, for they were insulated from the traumas of Fascism and the Spanish Civil War.

Moreover, British photographers worked in a culture which was well endowed with, even over-rich in, pictorial traditions. Britain had many photographically illustrated popular newspapers. Some of these predated the First War, and by 1930 photo-journalism was a well-established trade, rich in pictorial formulae. Photographers were also influenced by an especially vigorous tradition of cartooning and caricature. In general the culture was conservative, weighted down by a powerful inheritance. In such conditions the idea that society might be remade was scarcely understandable. Nor, in these deeply traditional circumstances, were psychological insights, of the sort provided by Kertész and Cartier-Bresson, either valued or obtainable. The British were actors involved in a much-loved play.

Irrespective of background and milieu, British photographers worked within these terms. Two such apparently dissimilar artists as Cecil Beaton and James Jarché were equally products of this long-running drama, and both helped towards its maintenance. Jarché rose through the journalistic ranks to become the star reporter of the thirties. Beaton was in high society throughout his life and, as well as taking pictures, designed stage decors and costumes. During the 'human interest' era he was Britain's principal fashion photographer and portraitist, and he was also a reporter in such theatres of war as India, China and bombed London.

Beaton's pictures are as elegant as any ever taken; they are also highly artificial, staged scenes. In 1927 he took the poetess Edith Sitwell at Renishaw Hall: the photographs look like nothing so much as events from a theatre of marionettes. His subjects are often mirrored or mingled with figures in tapestries and paintings, or lit in such a way that a face becomes a mask. In the East he photographed bleached flour sifters, who seem like apparitions blended with their settings. At the battlefronts he took pictures of soldiers handsome and trim enough to seem like actors in an heroic war film.

Above all he pioneered a cool portrait style which set a standard for postwar portraitists. In a note on his own career he refers to a wartime picture of Quintin Hogg, Q.C., as among the most influential of his photographs. This shows his subject, arms folded at a plain table against an austere background, looking dispassionately into the lens. Beaton adds that Irving Penn, one of America's most stylish photographers of the fifties and sixties, 'was magnanimous enough to say that this series had put him on the road from which he has since seldom swerved.' This picture is somewhat in the style of the New Objectivists of the twenties; it is radically against the grain of the compassionate forties. In this, and in other pictures, of Gertrude Stein and Alice B. Toklas, and of Walter Sickert and his wife, he introduces the idea of the Other as unknowable, as indifferent presence.

109   CECIL BEATON 'Quintin Hogg, Q.C.' *c.* 1945.

110 JAMES JARCHÉ 'A London Chef' 18 October 1934. Taken for *Weekly Illustrated*, but not used.

Yet Beaton might have been given a place in *The Family of Man*, for he also took exhilarating pictures of scampering children, and in the late thirties undertook a survey of street life in New York, published in 1937. His New York pictures are in the style of Shahn, fastidiously composed: they are arrangements, works of art, in which New Yorkers feature only in so far as they complete a pattern.

James Jarché could hardly have been more different. He was at home among the working classes and his portraits have enormous warmth. Yet they too give little away, offer few psychological insights, for his subjects are collaborators in a search for quintessential images of cooks, fishermen, dockers, miners. They are story-book characters, more Dickensian than modern: Jack tars, rustics, toffs. Jarché exploited these traditional genres throughout the thirties and presented the British with a picture of themselves

111   BILL BRANDT 'In the Kitchen' Published in *A Night in London* (London and Paris 1938), where it was paired with a picture of a drawing-room in Kensington.

as robust ancients and as 'personalities'. In addition Jarché and his contemporaries picture Britain itself as a picturesque land of thatched cottages, spreading chestnut trees, dreaming spires and venerable castles on imposing crags.

Britain was not entirely insulated, however. Foreign practices were adopted, but years after their introduction abroad. Night and action pictures in cafés and circuses, of the sort which Eli Lotar had taken for *Vu* in the late twenties, came to Britain after a lapse of almost a decade. In the late thirties British photographers, especially Edward Malindine, who worked for *Weekly Illustrated* and for the best-selling *Daily Herald*, began to picture British workers as dynamic heroes, in a style which Russian photographers had developed in the twenties and which Roger Schall, with *Vu* magazine, had made his own in 1934. Eventually, with the arrival of many refugee editors and reporters from the German press, in-depth reportages were published – but only in 1938 with the establishment of *Picture Post*. Stefan Lorant, the Hungarian editor of *Picture Post*, created a magazine in the German manner, with extended documentary features on the People at work and play, and as they endured industrial depression and slum housing in the cities. Prior to the establishment of *Picture Post* British documentarians had focused primarily on rural life and on troubled traditional trades such as fishing, shipbuilding and mining. The German refugees brought with them a more dynamic idea of social life than had previously obtained.

During this period Britain's only equivalent to the French author-photographers Kertész, Brassaï and Germaine Krull was Bill Brandt, whose books *The English at Home* and *A Night in London* were published in 1936 and 1938 respectively. Despite a certain amount of foreign influence, in particular that of Brassaï's *Paris by Night*, both surveys are rooted in British traditions. *The English at Home* has social hierarchy for its subject; it takes us inside aristocratic and professional households and into working class homes ('Workmen's Restaurant' juxtaposed with 'Clubmen's Sanctuary'), and caters for a national interest in class differences. In addition it features many traditional types: bookmakers, racegoers, cockneys, street traders, clubmen and gentlemen. *A Night in London* tells a story, mainly of a rake's progress through the darkened city intercut with scenes from respectable life, and owes as much to Hogarth as it does to Brassaï.

Like Cartier-Bresson and Doisneau, Brandt also gave thanks for the coming of peace – in *Camera in London*, published in 1948. This London, which includes instances from his earlier books, is a tranquil city – not quite as pastoral as Bidermanas's Paris, but a leisurely place from which the noise of traffic has been all but banished. Brandt's Londoners read by open windows,

112 EDWIN SMITH 'Salisbury Plain, Wiltshire' Illustration No. 68 in *England* by Edwin Smith and Geoffrey Grigson (London 1957).

move unhurriedly through the streets or enjoy a convivial evening out. Altogether it is a dreamer's city seen under soft sunlight, river mist and moonlight, animated, in keeping with the times, by dancing children and young lovers.

French photographers asserted the continuity of French culture with pictures of traditional life in villages and vineyards. The British, by contrast, preferred to praise the enduring landscape and ancient architecture. Some of Brandt's finest pictures from the forties are of darkly shrouded landscapes in Scotland and Yorkshire, epic sites worthy of romantic tales. Edwin Smith found persuasive evidence of continuity in the traditional architecture of Britain. His *English Cottages and Farmhouses*, published by Thames and Hudson in 1954, shows a world of stone, thatch and medieval timber carefully preserved. He, like Kertész and Brassaï, worked on behalf of *petit bonheur* but, given British reservation about psychological insight, his emphasis is on a different sort of private experience, that of a traveller in search of a welcoming space.

# Self-asserted, Self-absented

*From subjectivism to a self-denying photographic art in the seventies*

In photography the recent past is marked both by a new selfconsciousness and by an acute sense of tradition. Up to the 1950s photographers worked for the sake of societies which might be informed, if not always improved. Or they strove to declare impersonal truths – as Stieglitz did. Whatever the case, they deferred to ideas and to forces which were larger than themselves. From the 1950s onward these impersonal forces were questioned. Photographers continued to focus on nature and on society, but became increasingly concerned to declare personal viewpoints. They emphasize more and more, and especially in the United States, that the world is seen through individual eyes. One consequence of this is that pictorial formulae are everywhere contradicted. Another consequence is that recent work seems academic, only to be understood by reference to what has gone before. Certainly there is some truth in this. The immediate past has become influential, but rather as an imposition to be cast off than as an example to be followed. The recent history of photography is more reactive than continuous; it moves between extremes of self-presentation and self-denial. It is also, in large part, an American history – or appears so at the moment. Where painting is a public and institutional medium, photography allows greater scope for private reflection. It is likely that some of the most substantial photographic art of the past two decades has still to declare itself.

Human interest photography culminates in the *Family of Man* exhibition. From the late twenties through to 1955 photographers continued, despite a succession of cataclysms, to put their faith in conviviality and the dignity of man. Gradually this unifying vision faded, although it never completely disappeared. Perhaps the need for images of better times arose from experience of the disasters of war, and once such times arrived photographers, documentarians especially, switched their attention to the darker side of social life and searched for whatever was haunted or depressed. They contradicted the hopeful and graceful imagery of their predecessors with pictures of man troubled and alienated in urban wastelands – mostly American. They also gainsaid those benign views of social life fabricated by their contemporaries in advertising. In addition, vanguard photography

113    RICHARD AVEDON 'Robert Frank, Photographer, Mabou Mines, Nova Scotia, 7.17.75' Published in *Portraits* by Richard Avedon (New York and London 1976).

became more concerned than ever with mysteries and nuances of personal perception. Under the old rules meaning was social and accessible: Capa and Seymour, for example, addressed their public in traditional terms. In the sixties and seventies this common language was used sardonically – if at all. Confidence in public symbols and a common destiny waned. Photography's new idiom was to be intimate, disconcerting, at times inscrutable.

One of the first, and eventually the most influential, of the new photographers was Robert Frank, a Swiss whose pictures had been featured in *The Family of Man*. Frank's major work was *The Americans*, published by Delpire in Paris in 1958. *The Americans*, photographed with the aid of a Guggenheim Fellowship, is one of photography's outstanding works of art – comparable to Walker Evans's *American Photographs*. It is a survey-reportage in the tradition of Werner Bischof's *Japan*, but assembled according to entirely different principles.

Frank's starting point is a mythical America of The Flag, the Fourth of July, political parades, barber shops, ranches, cowboys, coffee shops, interstate highways and the South. Its names carry an aura of high romance – Beaufort, Belle Isle, Butte – an aura which is consistently opposed by the photographs. At Sante Fe he finds a squad of lonely fuel pumps, a barren road and a strip of indifferent scrubland. Traditional America appears in the form of a lounging cowboy by a trashcan in New York City. Belle Isle is a sea of cars, and Los Angeles a neon arrow and a hunched pedestrian. Not surprisingly, *The Americans* was either shunned or denounced by American critics. In the sixties, however, it was an influential book, and by the seventies Frank's harsh, contradictory vision was a norm in American photography.

Frank effectively challenged a whole range of the sort of pictorial clichés which appear in tourist brochures. He envisaged an alienated anti-America of mean streets. But *The Americans* is much more than an exercise in destructive antinomianism. In fact Frank's America, fly-blown though it might be, is seen and imagined in radical terms which owe little to any tradition in documentary. Jack Kerouac, introducing the American edition in 1959, places Frank 'among the tragic poets of the world' and speaks of 'mysteries' and of 'the cemeterial California night'.

He identifies Frank's ability to find portents in the most ordinary places. Many of his personnel brood, a prey to melancholy secrets. He singles out mourners and worshippers, and finds a multitude of cultic signs wherever he goes. Three crosses stand by a roadside in Idaho under a revelatory light from heaven. St Francis exorcizes a fog-bound Los Angeles. A white-robed priest kneels by a river at Baton Rouge. Commonplace spots, too, show signs of mystery and ritual. US 285 in New Mexico glows eerily under a heavy sky,

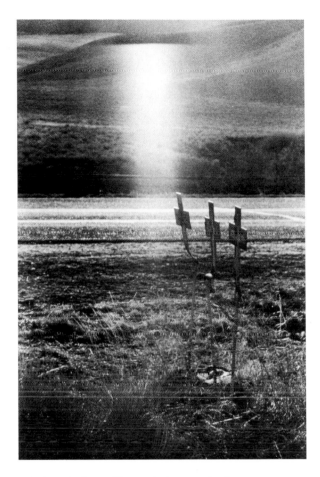

114 ROBERT FRANK 'Crosses on Scene of Highway Accident – U.S. 91, Idaho' From *The Americans* (1958/9).

and in dark cafés lights make cryptic inscriptions. Shop windows and other tableaux chanced on have the look of shrines, in which juke boxes, shrouded cars and barber chairs serve as devotional objects. Everywhere light struggles with darkness.

Frank dramatized the ordinary world of the human interest photographers. He had done so before he travelled widely in the United States. In 1956 Delpire and *Photography Magazine* brought out *Incas to Indians*, a book on Peru illustrated by Frank, Werner Bischof and Pierre Verger, an experienced reporter whose *Mexico* had been published by Paul Hartmann in 1938. Bischof and Verger focus on pastoralism and folk life. Frank, represented by fourteen pictures out of sixty, invokes Goya and the Bible: oppressed figures struggle towards appointments with destiny and

207

quarrymen labour, Christ-like, under their burdens. His sorrowing Peruvians seem well acquainted with grief, loneliness and betrayal.

Robert Frank gave a tragic inflection to the human interest mode. Gotthard Schuh, another Swiss of an older generation, made a similar shift in emphasis. Schuh, picture editor for the *Neue Zürcher Zeitung* between 1941 and 1960, took some of the most idyllic photographs of the thirties and forties. He surveyed his career to date in *Instants volés Instants donnés*, published by Éditions Clairefontaine in 1956. Amongst canonical pictures of young lovers and sporting children he makes scattered references to alienation in photographs of introverted café-goers and divided couples. But Schuh's break with tradition is a discreet questioning compared to Frank's violent contradictions.

At much the same time in Germany the idea of photography as an impersonal, public art was also under question. In 1952 Otto Steinert published the first of his *Subjective Fotografie* anthologies; the second came out in 1955. The human condition was never an issue in Subjective Photography. Steinert's artists searched the world for bizarre finds and chose mystifying and vertiginous viewpoints. Insofar as they favoured close-ups and aerial views, they worked in the same vein as the *Photo-Eye* photographers of 1929, but they were far more Surrealist than objective, more concerned with private meanings than with social planning. Photography, Steinert suggested through well-chosen pictures by such established artists as Bill Brandt and Roger Schall, could be a medium for personal expression.

William Klein, author and photographer of *New York* (1956) and *Rome* (1959), made the same claim, and made it more vigorously than any of his contemporaries. Klein discovered the city as a kaleidoscope of bright lights, numbers and names. The full title of his first book reads *Life Is Good & Good For You in New York. Trance. Witness. Revels.* His New Yorkers, under blaring architecture and baroque lights, jokingly enact their way through extreme situations: a laughing man strangles his companion by the window of a photo-shop; children rehearse stick-ups and pose energetically as heroes and models. Preachers and placardists vie for attention against a declamatory background: 7-UP. YOU LIKE IT . . . IT LIKES YOU. BUY YOUR LUCKIES HERE. ITS SLO-BAKED WONDER BREAD. Klein reverses conventional emphases and shows a bride and groom lurking in the background of a wedding group. Pedestrians stare wildly around or gesture vividly to no apparent purpose. His city is an experience rather than a place. Atget, Doisneau and other urban reporters had represented their cities coherently, from the viewpoint of a pedestrian taking stock of streets, alleys

115   WILLIAM KLEIN Untitled. This picture originally appeared in Klein's *Rome*
(Paris 1959), in the section *Cittadini di Roma*.

and *quais*. Klein's New York is altogether more fragmentary and unstable – glimpsed in an instant from a switchback, or seen obscurely through passing reflections in a window.

Rome is little different. It too is alive with signs, with nervous children jumping in the limelight, grimacing citizens, street traders and eroded divinities jostled by the traffic. It is as claustrophobic as New York, and as mysteriously dark.

Robert Frank saw America with the eyes of a reverent and melancholic sinner. William Klein appears rather as a believer in demons and a malign humanity. Above all, though, he envisages society and its works as insistent, as a source of pressing claims on his attention. New York and Rome allow no space for reflection. Their whirling inhabitants and brusque notices impose themselves immediately. In this respect William Klein was at one with, and even ahead of, his times, for the Pop artists of the late fifties and early sixties were just as preoccupied by insistent urban imagery and social artefacts. They too emphasized the social and artificial nature of their experience and avoided pictorial depth just as consistently. Despite such perfect credentials Klein has been given no place in histories of Pop art.

Klein's precursor was Weegee, a news photographer and author of *Naked City*, another survey of New Yorkers, published in 1945. None of Weegee's people (small-time racketeers, candidates for the electric chair, the hoodlum element, bobby-soxers and many more) made it to *The Family of Man*, for few were ornaments to humanity and most were in the grip of the city, gawping at fires and other spectacles. William McCleery, editor of *PM Picture News*, referred in his foreword to 'Weegee's subjective portrait of New York' and made a muted claim on behalf of the photographer's compassion, but compared with *Life* magazine reporters he was scarcely compassionate at all. He was the first modern photographer to represent the city as a phantasmagoria, and in 1945 such a view was exceptional. Nonetheless, *Naked City* ran into three editions within a few months and in 1946 it was followed by *Weegee's People*, a somewhat kinder survey of burlesque elements in New York life.

Weegee was an abrasive, even abusive, realist in the style made public by Thomas Hart Benton, Paul Cadmus and Margaret Bourke-White during the thirties. William Klein brought a hectic exuberance to the same mode, and helped establish it as the dominant manner in photography during the sixties. Klein's successors, however, were less than exuberant. Most of them were Americans, and most of them were saddened by a society which seemed impervious to visionary promptings. Weegee and Klein had exulted in society's turbulence. Bruce Davidson, Danny Lyon, Diane Arbus, Simpson

116　BRUCE DAVIDSON Illustration No. 10 in *East 100th Street* (New York 1970)

Kalisher and others who came to the fore in the sixties dealt in alienation, danger and loneliness.

Those American visions of heroism, dignity and a paradise on earth which had surfaced in the work of F.S.A. photographers in the thirties did not die; they retained their power, but more as lost hopes everywhere contradicted. American photographers of the sixties and after invoke and negate human interest stereotypes in dark parodies of earlier, more optimistic, work.

To some degree this pessimistic documentary has been assessed in career surveys published in the late seventies, one of the most comprehensive of which is Bruce Davidson's *Photographs* of 1978. Bruce Davidson began to take pictures in the 1950s, and in 1958 joined Magnum Photos, the international picture cooperative founded in 1947 by David Seymour, Robert Capa, George Rodger and Henri Cartier-Bresson. Davidson worked on magazine assignments for *Fortune*, *Esquire* and the *Saturday Evening Post*, and then in 1970 Harvard University Press published his major documentary survey *East 100th Street*, which was the result of more than a year's picture-taking in one of the most depressed parts of Spanish Harlem. *East 100th Street* is as thorough an exposé of harsh living conditions as any ever published, and also one of the most puzzling.

Davidson's tenement people are poor, but scarcely destitute. Many live in sparsely furnished rooms, but just as many live among TV sets and consumer goods. In the main they are unimpassioned, even torpid, like people waiting without a future, spiritually dormant or shocked into a state of dispassion by the ruined streets. Davidson and the tenement people were enduring a period when the flowers of evil appeared to be in full bloom. In 1969 he had collaborated in a Magnum book, *America in Crisis*, a photographic enquiry into the state of a nation where the assassination of public figures was almost commonplace. Portraits of J. F. Kennedy crop up in the mean rooms of *East 100th Street*, as a reminder of earlier promises destroyed.

Davidson seems to have been wary of the mainstream of American culture from the outset. The projects to which he was most committed feature outsiders, both voluntary and involuntary. In 1958 he photographed a circus dwarf, mocked by average men, and in 1959 he found animation and a group spirit in a troublesome teenage Brooklyn gang. In 1965 he met 'natural' people in the shape of Willie Royka and his family, trapping muskrats and collecting scrap metal in the New Jersey Meadows on the outskirts of New York. Later that year a journey to Wales provided images of miners as incarnations of the human spirit surviving against all the odds – a spirit conspicuously absent throughout the motorized West and in one of San Francisco's 'topless' restaurants photographed on later assignments.

117   LEONARD FREED 'Blind DeDe Pierce – one of the last old New Orleans Jazz men' Published in *Black in White America* (New York 1968).

The people of *East 100th Street*, Willie Royka and the Brooklyn gang, were remote descendants of *The Family of Man*. They were less hopeful and less graceful. Mainly they were less decorous, inclined to stare back and to loom large in the frame. Their forbears had been chosen by Capa and Seymour because they somehow embodied human potential. These latecomers present themselves unenhanced. *East 100th Street* reads like a series of meetings with dour individuals, and as such is entirely in keeping with its period. Photographers in the late sixties, working to keep pace with and to do justice to their experience of the civil rights movement in the United States and the Vietnam war, expanded on the whirling, confrontational style proposed by Weegee and Klein. They took pictures of a series of encounters, and invited their audience into the thick of the action.

Danny Lyon was one of these photographers. Whilst still at university he photographed the civil rights movement in the South in the early sixties and began a series on motorcyclists in 1963, which was published as *The Bikeriders* in 1968. Although in part a report on enthusiasts at races and field meets, *The Bikeriders* also had its threatening side in the shape of iron-crossed Chicago

213

Outlaws. He went on to find a grimmer context in Texas penitentiaries, on which he reported at length in *Conversations with the Dead* (1971). Lyon in Texas brings us face to face with varieties of menace and despair. By contrast the motorcyclists, photographed several years before, keep their distance.

Leonard Freed worked towards a similar expression of personal experience in *Black in White America*, published by Grossman in 1968. The pictures were taken from 1964 onwards, during civil rights agitations. Sometimes, but not often, Freed distanced himself, as F.S.A. reporters had done in the thirties. Usually he takes us close to grinning or morose faces, or brings the rush of a street to the page. Analysis is less of his intention than sympathy. His pictures are a record of, and an invitation to, hectic involvement.

Leonard Freed, Bruce Davidson and Philip Jones Griffiths – author of *Vietnam Inc.*, which showed the Vietnam war as a phantasmagoria interspersed with lyrical moments – re-create their experiences of war, depression and the campaign trail. They are witnesses who return from the front line with stirring evidence of hardships undergone. By the mid-seventies, however, hardship had vanished from the scene, and so had most traces of that sympathetic personal involvement which had been characteristic of the photography of 1970. *Vietnam Inc.* and *Black in White America* came at the end of an era, which had begun around 1930, in which photography's highest calling was that of reporter and witness.

In the seventies photo-journalists yielded their place to television cameramen. In the United States *Look* magazine closed down in 1971, and *Life* magazine in 1972. Both had been established in the depressed thirties, and their photographers had been celebrities, known to millions as they reported from battlefronts and famine zones. In addition, photography was changing its institutional standing – and not simply as a result of decreasing opportunities in the mass media.

Sculptors and painters became increasingly interested, during the second half of the sixties, in questions concerning the identity of art works. Images were constructed, painted, photographed, duplicated and described in words; some artists concluded that the truth of the art work lay in the idea of the art work. Whatever the case, artists often relied on photographic evidence to chart the progress of these works, and audiences became accustomed to displays of such evidence in galleries once reserved for marble, bronze and oil. Sculptors who worked on remote sites and with transient configurations were especially dependent on photographic evidence. Site photographs by Carl Andre, Jan Dibbets, Hamish Fulton, Richard Long and Dennis Oppenheim were exhibited and published. In Germany Bernhard

and Hilla Becher nominated such industrial buildings as pithead winding towers and gas storage tanks as anonymous sculpture and presented this sculpture photographically. Distinctions between 'art' and 'photography' were no longer so evident as they once had been.

During the sixties photographs were also collected and exhibited as never before. Previously collectors and exhibitors had discriminated in favour of fine prints intended for special treatment. All the rest – snapshots, industrial and architectural pictures, news photos – were shelved and mainly forgotten. Gradually the idea took hold that this neglected work of journeyman-photographers might also be worth scrutinizing, and that it might even have merit. First among these scrutineers was John Szarkowski, Keeper of Photographs at the Museum of Modern Art in New York, for which, in 1964, he organized an influential exhibition, *The Photographer's Eye*. In this he assembled items from the medium's 'fine art' and 'functional' traditions and assembled the whole ahistorically, in terms of categories inherent in the medium itself: e.g. 'The Detail', 'The Frame', 'Time'. He associated his quite novel approach with that in John A. Kouwenhoven's *Made in America* (1948), 'which studied the relationship of our vernacular and formal traditions in architecture, design and painting.'

This new approach opened up a wealth of untrodden ground to historians, curators and collectors. More importantly it helped to modify photographic practice. Photo-journalistic criteria put a premium on coherency. The photographs of Henri Cartier-Bresson and Werner Bischof, for instance, are eminently interpretable; they make their points clearly. Reclaimed snapshots, by contrast, are less than lucid; they tell of intimate, even unfathomable, affairs hesitantly set down. Equally the major exhibitions of the sixties established relativism as a new norm for photographic audiences. *The Photographer's Eye* brought together far-flung examples from the archives, and so too did Nathan Lyons's *Photography in the Twentieth Century* (1967), prepared by the George Eastman House of Photography for the National Gallery of Canada. Such exhibitions proposed that we should allow ourselves to be questioned rather than persuaded by photographs. This side of the 'new approach' was exemplified by John Szarkowski in his book *Looking at Photographs* (1973), in which he hints at meanings and makes and withdraws suggestions – like a letter-writer coping tentatively with a wealth of new experience.

Some American photographers had been working discreetly in this vein from the early sixties. Public preoccupations with the civil rights movement and the Vietnam war kept them from prominence, but once those pressures eased they emerged to set a pattern for the seventies. In a prescient George

Eastman House exhibition of 1966, *Toward a Social Landscape*, Nathan Lyons introduced three of these photographers: Lee Friedlander, Garry Winogrand and Duane Michals. The same show included work by Bruce Davidson and Danny Lyon, and it rehearsed two of the main directions taken by American photographers in the years ahead.

Friedlander's pictures, in this exhibition and subsequently, are relatively hard to read in that they, like those of William Klein in the fifties, feature reflective and semi-transparent surfaces; they are both mirrors and windows at once, complicated by pictorial insets. They raise any number of difficulties, with regard to spacing and meaning, and suggest that plain streets and landscapes might be rife with enigma. These are less the melodramatic enigmas of a Surrealist than surprises – that quiet towns can yield such bizarre conjunctions: jetliners show themselves in a tangle of wires and poles along a street, figures blend mysteriously with their shadows.

Friedlander's sustained concern has been with 'vantage point', another category in *The Photographer's Eye*. Choice of vantage point allows the artist to declare a personal way of seeing which prevails even in the most unpromising terrain. Garry Winogrand, by contrast, is as attentive to 'time' as he is to 'vantage point'. He notes moments, more startling than decisive, as figures walk from shadow into light or gesture urgently in commonplace surroundings. Again, they have little to do with insight, in the sense in which that term might apply to a picture by Cartier-Bresson. Winogrand's moments are registered, that is all: 'For me the true business of photography is to capture a bit of reality (whatever that is) on film . . . if, later, the reality means something to someone else, so much the better.' Duane Michals, too, made a similar kind of oblique presentation: bare spaces showing signs of, or awaiting, habitation, and elegant snapshot portraits, more intimate than representative.

Friedlander, Winogrand and Michals selected viewpoints, moments and places peculiarly their own. Diane Arbus, their contemporary, also searched for autographic material and found it not in moments or in chance configurations but wherever common practice was contradicted. Arbus, photography's most desperate ironist, committed suicide in 1971, and almost at the same time became America's most talked-about photographer. She had been a fashion photographer, but after 1959 began to work on projects of her own. The material she gathered between then and 1971 was published by *Aperture* in 1972 and exhibited in the same year at the Museum of Modern Art, New York.

Diane Arbus favoured the confrontational mode used by some of her contemporaries. She worked close to her subjects, like Davidson and Freed,

118   DIANE ARBUS 'Man in an Indian headdress, N.Y.C., 1969' Published in *.diane arbus.* (New York 1972).

but does not seem to have sympathized as they did. Her people present themselves to the camera; some pose, others simply appear, dispassionately. Together they stand the social world on its head. Her transvestite menfolk are as gracious as dowagers or as haughty; others are coolly seductive. Women, stoic and imposing as W.H. Jackson's Indian warriors in the 1870s, play heroes' parts. Patriots, spindly and acned in the main, give a poor account of themselves. The only undeniable tough guy in the set is a Mexican dwarf. The martial arts are represented by a frenzied stick of a child armed with a toy grenade. Giant infants howl in close-up.

Diane Arbus wilfully inverts our cherished stereotypes and remakes the social world according to a contradictory scheme of her own. She, like many of her protagonists, goes against the grain. She was also much obsessed by artifice and took pictures of a floodlit castle in Disneyland, a stranded façade and a lyrical wallpapered landscape. Elsewhere children in a park imagine a cigarette-smoking adulthood, and depressed young lovers make desultory moves towards togetherness. Nudists pose as they might in habitual dress.

In short, her subject was convention and its meaning in a socialized world. Her people swap roles to be more truly themselves, and merely exchange one form of socialization for another. But, she suggests, there may be no alternative to acting, for the only signs of happiness in this picture gallery are amongst the most elaborately disguised and transformed. Moreover, the saddest people here are those least transformed. Only in masks, feathers, capes and glitter do they come alive, and even then some bring their pedestrian dourness with them. She discovers a fundamental melancholy in the human condition, a melancholy only dispelled by artifice and imagination. The 'real' world, a gloomy backdrop, is best shut out. Arbus and her often very outlandish people remake conventions to suit themselves. Their starting point is routine and the further they depart from it the happier they seem to become.

Licensed by a liberalization of museums and publishing houses, and by the example of Frank, Klein and Arbus, photographers released subjective, and even subversive, material which they had accumulated over the years. One such was Simpson Kalisher, a freelance reporter and advertising photographer since 1948, whose *Propaganda and Other Photographs* was published in 1976. These fragments from American streets show Kalisher as a specialist observer of urban alienation and, like Diane Arbus, a brutal parodist of pictorial stereotypes. Casual hands, in unselfconscious imitation of Joe Rosenthal's heroic marines photographed at Iwo Jima and commemorated in the famous statue in Washington, hoist a lamp standard on a fairground. Apprentice *mafiosi* revel in target practice and blood flows in the streets. But by 1976 the bitter years of American photography appeared to be over.

In this tolerant climate dispersed work was reassembled and major artists emerged who were only slightly involved in the American mainstream. Manuel Alvarez Bravo is an artist of this sort. Many of his pictures were taken, in his native Mexico, during the 1930s. In part he was influenced by Edward Weston, to whom he submitted pictures for criticism. He knew Paul Strand, and had looked at photographs by Stieglitz and other North Americans. During the forties and fifties he worked as a movie cameraman

and took very few personal pictures. In the sixties he resumed his career as an artist, and finally in 1978 the Corcoran Gallery in Washington printed eighty-three of his pictures in an exhibition catalogue. Examples had appeared before, most notably in the innovating *Aperture* magazine in 1968 and in an exhibition catalogue from Pasadena (1971).

On the evidence of anthologized pictures Bravo might appear as just another human interest reporter with Surrealist inclinations. His assembled work tells a much more elaborate story. He did not shrink from the facts of death, and one of his most famous pictures, of 1934, shows a worker murdered in the street. He was represented in *The Family of Man* by a picture of an improvised shrine on stony ground, and *Aperture* sustained this 'Mexican' image by reproducing other melancholy remnants. But death figures less for its own sake than as a counterpoint to Bravo's abiding concern for vitality and fullness, embodied in opulent studies of nudes and children. He deals, like Edward Weston, with mutually enhancing contraries: dust and indifference against living tissue. Weston saw a hard, resistant earth which rose up against him. Bravo, by contrast, notes the contingencies of human existence.

In particular he dwells on transience: his Mexicans are taken in passing, often as they move along the street – they are transients, both literally and metaphorically. Human life proceeds in a temporal continuum and against a large and indifferent background, which Bravo acknowledges in pictures which are conspicuously fragmentary, brusquely taken from a world which extends on all sides. The dead man of 1934 lies along the street as arbitrarily cut by the picture's frame as by the assassin's bullet. Elsewhere the wind blows and ironically ruffles the feathers of a dead bird.

Such conditions make consciousness itself an issue for Bravo. He makes precise and wide-ranging observations on states of being. The dead lie still and the most handsome of the living luxuriate in the sun. Sleepers dream. Activists are absorbed by distant events, or by the task in hand. There are those who wait and those who relax, and each time Bravo finds a form to match: where people retreat inside themselves he expands their context, when they look around he shows them face-to-face. Equally, and fittingly, he attends to touch, sound, appetite, vision, both in actuality and in symbol – through pictures of musical instruments, 'a box of visions', the serrated leaves of an agave, feet on stone, treading with care, squirming, balancing. Only Courbet, a hundred years before and in another culture and another medium, was so preoccupied by the nature of sentience.

Bravo's is less an art of separable masterworks than an ensemble in which image casts light on image. The exhibition-conscious seventies provided an

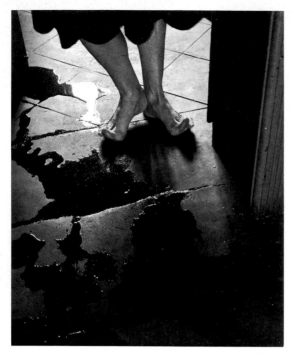

119  MANUEL ALVAREZ BRAVO
'El Umbral' (The Threshold)
1947.

120  RAYMOND MOORE  ▷
'Wiltshire, 1975' Published in
*Murmurs at Every Turn: the
photographs of Ray Moore*
(London 1981).

adequate format for such varied and reflective work, and a broad
background against which it might be understood. In Britain similar
circumstances worked in favour of Raymond Moore, another photographer
with transience and being as the subjects of his art.

Any photographer practising in Britain from the fifties through to the
eighties has had to negotiate powerful influences. In the first place, the
inescapable presence of contending British traditions of social reporting and
romantic landscape art. Secondly, American subjectivist photography,
widely distributed and publicized through this period. Ray Moore, active as
a photographer since the fifties and intermittently sponsored by the Welsh
Arts Council and the Arts Council of Great Britain, both survived and built
on these influences and emerged with a body of work comparable to that of
Manuel Alvarez Bravo.

Like Bravo he values whatever is particular, and works to make it show
itself. Bravo evokes touch and sound: the splashing of water, the heat of a
pavement, the wind on feathers and ribbons, the grip of a snail on a pumpkin.
Moore intensifies vision in photographs organized like the opened pages of a
book. His landscapes unfold around a central axis, wall or road. The halves of
these vistas may look alike, but invariably the ground tips differently and

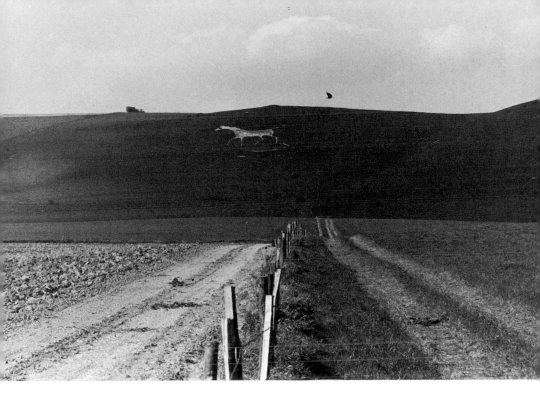

light makes distinct emphases. The pictures offer grounds for comparison, and thus the most ordinary of items disclose themselves. If not organized in this way his pictures work along horizons considered as base lines, against which such landscape elements as poles, bushes and buildings can be weighed and placed.

Time, too, is as distinctly envisaged in pictures of sudden occurrences, tugging winds, shifting fogs. The world has its moments, lyrical epiphanies in which minor marvels declare themselves. They are not an artist's constructs, rather nature's revelations given in an instant and as quickly taken away. At least in most cases they are; sometimes from a particular point of view he finds striking conjunctions which never existed in nature. Thus he acknowledges his own part in the matter, but it is never an intrusive part. Will reaches an accommodation with nature, and allows nature the upper hand.

Ray Moore's work resembles, and is to a certain extent influenced by, that of Minor White, an American landscapist, teacher and co-founder of *Aperture* in 1952. White's very substantial career was summed up in 1969 in an Aperture monograph, *Mirror Messages Manifestations*, an autobiography in images and words. White's photographs are more celestial than temporal.

221

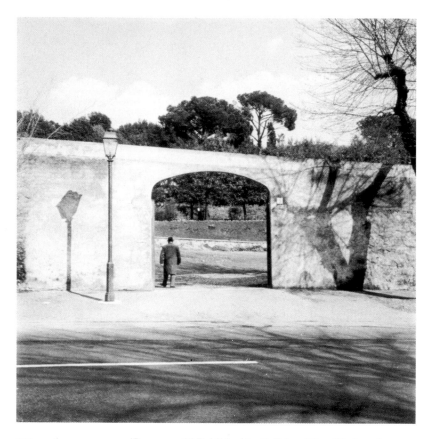

121   HARRY CALLAHAN 'Rome. 1968' Published in *Callahan* (New York and London 1976).

Many are of ice, foam, abraded rock, fragments from the wilderness. They are, conspicuously, strong pictures – even insistent. His landscapes, like those of Edward Weston, invoke desperate extremities in that they combine an abundance of beauty, in the shape of surfaces caressed by light, and an abundance of primordial symbolism: rock which flows like muscle, echoes of the sun and moon and human organs in folds and breaks in the mysterious primal substances which he chose to photograph. More than any of his contemporaries he was an extremist who sought experience of the sublimity of the first or last day, when transience, society and the minor frets of subjectivity no longer matter. Ray Moore took these metaphysics and made them once more provisional and fragile. The world beyond the lamp posts still shines with an original splendour, but light fades and the road beckons.

A similar road beckoned for Harry Callahan, another artist who benefited from the liberalization of photography in the seventies. Callahan, a teacher-photographer like Ray Moore and Minor White, has a far more varied *œuvre* than most of his contemporaries. He took minimalist pictures of wires, tramways and architecture in and around Chicago in the late forties and early fifties, and activist street pictures in the same years. Stieglitz-like, he photographed his wife Eleanor in the same years and envisaged her variously as an embodiment of grace, dignity and fertility. Like Minor White he found dark mysteries in primal landscape in the sixties. In the seventies he made austere pictures of sky, water and sand on the coastline at Cape Cod.

He tends, like Minor White, towards extremes of grace, heroism and the primordial. But, like Ray Moore, he also mitigates these masterful tendencies. His later photographs combine the elements in broad and imposing masses, like silvered versions of paintings by Rothko. Yet they also carry plentiful traces of casual humanity, responsible for puckered footmarks in the sand and impudent boats on the ocean. Like Ray Moore he also attends to particulars, and cherishes depth, weight and the moment. On a chill spring day in Rome in 1968 he noted an average street scene of road, pavement, wall, trees and a pedestrian passing through an arched gateway. There are no dramas, but everything is registered and intensified. The stroller, bulkily coated, passes through the gate and makes a vivid space of it. A lamp standard, ironically, casts its broad shadow on a pale wall and a bare tree stands in contrast to evergreens on the horizon. Through such rhymes and reversals he draws attention to things in their particularity. In 1962 he wrote that he was 'interested in revealing the subject in a new way to intensify it', and that is exactly what he does, again and again.

Harry Callahan, Ray Moore and Manuel Alvarez Bravo demonstrate, as Stieglitz had done, that photography is a fit medium for major art. They are not, however, wholly in the mainstream of seventies photography for, although tactful, they are not self-denying, and self-denial and restraint are hallmarks of much of the (published) new photography of the seventies. Leonard Freed and Bruce Davidson present evidence of their journeys through troubled lands. Lee Friedlander finds his own idiosyncratic signature written down American byways. Emmet Gowin, whose book *Photographs* was published in 1976, charts a richly imagined family life with wife and relatives in the privacy of Danville, Virginia. Their successors increasingly refrain from such shows of the impassioned or singular self, and take the world as it comes or as it cares to show itself.

Some American photographers had done so since the 1940s, in particular the portraitists Irving Penn and Richard Avedon, both of whom seem to

have approached their subjects as dispassionately as any ethnologist. In *Worlds in a Small Room* (1974) Irving Penn presents ten sets of mainly tribal people beautifully disposed on plain, pale grounds. Isolated thus and placed in a gentle side light they loom large, look handsome and still keep their distance. Avedon's harshly lit celebrities and notorietiès, collected in *Portraits* (1976), are even more radically decontextualized. His subjects face up to the camera, as unadorned, dour or fatigued as they happen to be.

But American photographers became disinterested by degrees. One of the first signs that harsh, high drama was on the way out came with the successful publication, in 1973, of Bill Owens's *Suburbia*, a documentation of ordinary life in California's Livermore Amador Valley, where Owens worked for a

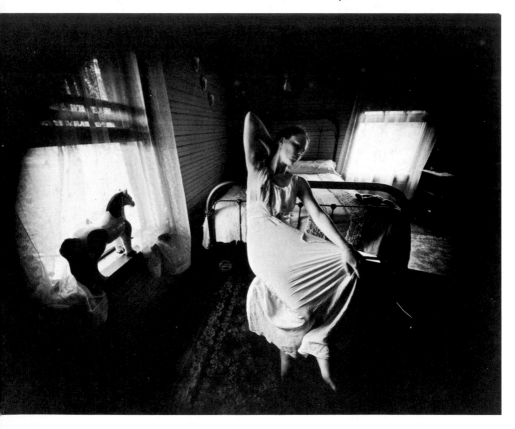

122   EMMET GOWIN 'Edith. Danville, Virgina, 1971' Published in *Emmet Gowin Photographs* (New York, 1976).

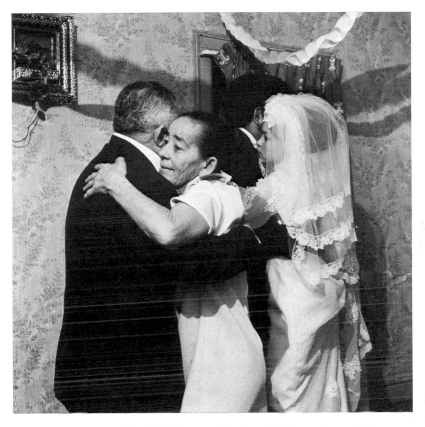

123   MILTON ROGOVIN Untitled. Illustrated in the exhibition catalogue *Milton Rogovin: Lower West Side, Buffalo, New York* (Albright-Knox Art Gallery, 1975).

local newspaper, the *Livermore Independent*. His book is, in part, ironic in that he notes a distance between the ideal domesticity of advertising images and cluttered real life. But in many cases he simply records and allows the photographs to speak variously for themselves. His next essay in saturation documentary was *Our Kind of People: American groups and rituals* (1975), which featured a multitude of organizations, from the Rotary Club and Job's Daughters to the Non-Smokers' Bridge Association. Taken in more formal circumstances, this second survey was even more tactful than the first. It reads like an unemphatic version of, and antidote to, Diane Arbus's strongly flavoured sample from American life. Even ordinary Americans, Owens suggests, come alive at the sight of spangles, sashes and cap badges.

Bill Owens travelled as a local reporter, and his subjects revealed themselves as they might want to be seen by friends and neighbours. Across the country, in Buffalo, Milton Rogovin, a veteran photographer and optometrist, made comparable low-profile pictures of the people of the Lower West Side. Milton Rogovin presented himself as, and served as, a portraitist in a fragmented neighbourhood: Indian, Black, Puerto Rican, Italian, Irish, Arab. He assembled and exhibited (in the Albright-Knox Art Gallery, Buffalo, in 1975) one of photography's most penetrating social surveys in which different generations and racial groups reveal their own ideas of decorum. They view his camera as an agent for posterity and present themselves accordingly, finding many forms for their pride, love, self-respect. Rogovin, a discreet presence, makes no impositions, and America's

124   ROBERT ADAMS 'Farmyard, Thurman, Colorado, 1969' One of a pair of pictures, taken at different distances, of the same site, usually published together.

125   PAUL CAPONIGRO
Untitled. Published in
*Paul Caponigro* (an
Aperture monograph;
New York 1972).

cultural and generational diversity reveals itself as never before. His is one of the great, and not sufficiently recognized, achievements of the self-absenting seventies.

Milton Rogovin, discreet though he is, seems almost garrulous by comparison with Robert Adams, one of the most reserved photographers of the seventies. Adams, author of *The New West* (1974) and *Denver* (1977), is a thoroughly dispassionate surveyor of suburban housing, prosaic roads, commercial and industrial land. His pictures appear to be about nothing very much, least of all about himself. They might have been taken for the benefit of architects and urban planners in need of reliable evidence on site and climate. They hint at a practical reading and, once that hint has been taken, disclose extraordinary richness. Adams notes, rather than draws attention to, changing seasons and times of day. The Colorado sun casts strong shadows at midday; sinking, it lights the hills and leaves the plains and towns obscure; further into the evening lamps begin to go on in houses and along the streets and eventually they outshine the sky. The seasons also make and leave their marks. In every case he invokes a larger order, of time or space, against which human constructs appear as no more than minor interruptions.

Paul Caponigro allows human, especially contemporary, making even less of a role in slowly modulated sections through land, water, rock and cloud. He has maintained the tradition of Stieglitz and then of Weston through the sixties and seventies in America, and, although he refers to self in his writings on his own art, his primary concern, in words and images, is with

the impersonal, transcendent 'thread which holds all things together' and with 'the landscape behind the landscape'.

In Britain, at much the same time, Paul Joyce has been exploring similar themes in primal Welsh and Cumbrian landscapes, marked by man's puny inscriptions. But British photographers have never given themselves entirely to, nor fully acknowledged, Caponigro's 'forces moving in and through nature'. When Bill Brandt made his sombre landscapes in the 1940s they were landscapes of feeling, rather than embodiments of a transcendent force ringing through nature. Paul Joyce allows for a harmony in nature, but habitually underlines his own part in the discovery of that harmony. He emphasizes viewpoint in a way which rarely happens in American photography; mountains and subtle horizons extend beyond foregrounds rich in autographic items, shadows of man and machine and all sorts of puzzling and expressive debris. Self, distracted by picturesque and incongruous details, may be inconsequential when matched against the large world, but it is insistent, inescapable.

Mountains, skies and far horizons belittle human affairs. Yet represented in photographic monochrome they are reduced and made manageable – by virtue of the fact that monochrome searches out edges and makes of landscape an inscription. Colour, on the other hand, makes different claims on attention; it inheres in surfaces, stresses plane rather than edge and invests material with its own density. Colour is unarguably there – real – in a way in which monochrome never is. Ambitious photographers, concerned for legibility, have all but ignored colour, as though its very autonomy might loosen their ability to reduce and to make plain.

Joseph Cornell, an American artist and Surrealist arranger, referred cogently to photography's problems with colour in an ensemble of 1966, 'The Sorrows of Young Werther' (Hirshorn Museum, Washington). In this boxed arrangement a photograph of a female nude on a forest floor serves as a background – a remote, imaginary background – to an embossed paper figure of an azure child and dog. From all that we know of photography's objectivity and the artificiality of embossed paper figures the photograph (by Wynn Bullock, one of America's outstanding symbolists of the fifties and sixties) ought to be the more convincing half of this pairing, yet it shrinks into insignificance alongside this blue whimsy. Colour has a mute presence which abstract monochrome can never match.

In the seventies, however, some American photographers began to work with colour – as though attracted by its autonomy. They broke sharply with recent traditions of legibility; no one more so than William Eggleston, author of *William Eggleston's Guide*, published in 1976 by New York's

Museum of Modern Art, with an introduction by John Szarkowski. In terms of reportorial picture-making William Eggleston's photographs are baffling, but so too are the paintings of De Hooch and Vermeer to which some of these photographs can be likened. The forty-eight photographs of the *Guide* were taken in the southern United States, although they might, I think, have been taken anywhere. Sometimes he makes points of the sort which can be made in monochrome: on the Black Bayou Plantation, for example, a litter of white plastic canisters on a gravel road rhymes with a clutch of white clouds on a blue sky. In Algiers, Louisiana, a bright brown hound laps from a beige pool, as though draining the landscape of its colour. In a graveyard in Tallahatchie County, Mississippi, the cool greys of headstones are echoed and outshone by a blue-black jacket and white shirt.

Mainly, though, the *Guide* has to do with picture-making rather than observation and metaphor. Like De Hooch, William Eggleston founds his pictures on sets of a few distinct hues clearly stated: green/red, red/blue. Whatever else is there connects with these dominant primaries. The saturated blue of a sky links with the greyed blues of shadows, which also carry tonally muted traces of other saturated primaries elsewhere in the picture. In most cases a central motif or emblem pairs two primaries which are then mediated across the remainder of the picture.

William Eggleston is a picture-maker in an ancient sense. Colour chains of the sort he uses (red to blue through a variety of greyed purples, for example) interested such European painters as Giorgione and Carpaccio from 1500 onwards. They were of especial interest to quietists, artists in search of impersonal harmonies: De Hooch working the colours of a room around the vivid materials of a gown; Bonnard, in this century, blending casual diners into the yellow light of a blue room.

William Eggleston, in his *Guide* at least, worked at the edge of town, in suburban rooms, and in peaceable, deep spaces where the ground, walls and sky modulate by degrees. Other colourists chose other sites, especially city streets where colour presents itself differently – in discrete units of different hues backed by monochromatic walls and sidewalks. Helen Levitt, a recorder of street life in New York since the 1940s, either sets friezes of polychromatic figures against dark grounds or keys the whole of the picture into a dominant primary blue or red.

But there are no dominant formulae in recent colour photography. William Eggleston appears to be the most systematic colourist of the seventies, and Joel Meyerowitz the most variable. Meyerowitz, author of *Cape Light* (1978) and *St Louis and the Arch* (1980), explains himself in an interview printed as an introduction to *Cape Light*. He emphasizes that

colour answers to his need for description, and that description means sensation. He refers to himself as Aeolian, as a harp through which the wind VI blows to make nature's music. On Cape Cod this music is made by a caressing light which plays on the dunes and plain architecture of Provincetown and Truro. It is the sort of light which is honoured by the painter Edward Hopper, who also worked in that region. Like Hopper, Meyerowitz pictures a luminous physical environment of a disarming vastness and beauty. In front of such radiant views nature cannot be denied. In another set of photographs, of New York City, published in an exhibition catalogue, *American Images* (1979), Meyerowitz again acknowledges an impersonal largeness when he sets the spire of the Empire State Building against a variety of plain streets and parking lots.

Sometimes Meyerowitz constructs his pictures, composing isochromatically with a limited range of hues differently lit and toned – a sunlit colour and elsewhere a block of the same hue in shadow. In the main, though, he prefers expansive views in which colour and tone modulate by degrees. His statements and art are those of a romantic, seeking assimilation in nature or looking for moments which make him catch his breath. He finds the one experience on Cape Cod and the other on the streets of New York, where colour photography makes revelations out of what faded into the background of black and white pictures. Colour allows habitual contexts to be seen afresh, and makes possible an innocence of vision.

It also opens photography to a whole range of concerns which come traditionally within the aegis of painting. Robert Walker, a Canadian, has density and weight of colour for his subject in pictures where variously saturated hues describe objects which in turn weigh on struts and supports. He works with colour as Miró does in paintings where intensely coloured elements declare themselves emphatically on pale grounds. Manuel Alvarez Bravo, in the sixties, when colour was of concern to only a few American V photographers, made pictures such as 'Verde', in which a green wall ironically carries the colour of foliage implied by the dark shadows of a leafy tree. VII In 1979 Harry Callahan made just such a witty substitution with a detail of a building in Ireland in which a colour-washed wall doubles as the sky.

Photography in the seventies became a largely, though not uniquely, American medium. Photographers in the United States were able to call on goodwill and considerable resources. Major projects were realized, such as the *Court House* scheme, funded by Joseph E. Seagram, Inc., which resulted, in 1978, in one of photography's most stylish publications. In 1979, in conjunction with the American Telephone and Telegraph Company, McGraw Hill published *American Images*, a scrupulously printed survey, in

126 LAURENCE CUTTING 'Weighing-in Room Entrance, Ripon Racecourse' May 1977.

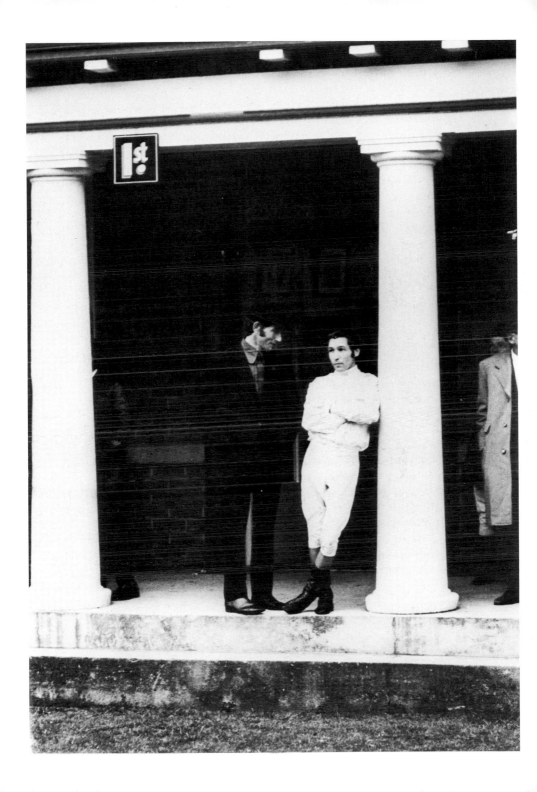

colour and monochrome, of pictures by twenty contemporary photographers.

In Europe contemporary photography makes no such public impact. A wealth of historical material and exotic Americana has vied with present production. Nonetheless, European photographers have been active. In general they have paid more attention to photography's past than have their American counterparts. Involved in social documentary projects, they seem to find traditional modes adequate. Pierre le Gall, a purposeful documentarian working in France during the 1970s, relied on the sort of psychological realism first developed by Kertész and then expanded on by Cartier-Bresson, Doisneau and Ronis. In *L'Armée au quotidien*, an inquiry into the army life of French conscripts published in 1975, he introduces his soldiery as natural civilians, fatigued, thirsty and untidy. His view of military life is unrelieved by glamour of any sort, and as such it has equivalents in German documentary of the seventies, in which cities and suburbs are pictured as irremediably dull. Le Gall's conscripts, at least, exchange jokes and wait for better times.

Europe in the seventies was organized, affluent and dominated by routine: a perfected culture, getting and spending on a regular basis. It was something to be avoided, even opposed. In Britain Christopher Killip found one tradition-conscious enclave to be placed against the machined surfaces and regular patterns of modern mass culture. He photographed amongst farming and fishing communities on the Isle of Man, and in 1980 the Arts Council of Great Britain published his book *Isle of Man: a book about the Manx*. Le Gall worked along lines established by reporters in the thirties. Killip makes use of a portrait mode developed by Paul Strand. His Manxfolk confront the camera, and, whether genial or suspicious, emphasize that their beautiful land is both inhabited and made. Thus Killip challenges the idea that particular landscapes are common property. He uses Strand's formal manner for a quite particular purpose of his own.

Killip puts Strand's pictorial idiom to a new use. Laurence Cutting, involved since the early sixties in a photographic survey of the British racing community, uses similar photographic procedures to those of the American F.S.A. documentarists. He follows the suggestion made by the cultural historian John Kouwenhoven, and repeated by John Szarkowski in 1964, that vernacular art has complex purposes which repay attention. In part, and like Killip, he presents another enclave, a small world with its own archaic procedures and values, remote from the prose of suburban styling. He also notes interactions of sites and events, in the form of buildings designed to frame the rituals of a formalized society. Documentary of this sort, which is

minutely attentive to detail, runs the risk of finding no audience at all, for it asks us to be selflessly interested in another culture.

The same might be said of the German photographer Kurt Benning, who has applied himself to matters of time, and of presence and absence – photography's elusive concerns. Benning's pictures, exhibited in twos and threes in anthologies, are rich in traces of events intended or complete. He suggests that the present, in particular the photographic moment, exists provisionally under the weight of other times and other intentions only to be obscurely apprehended in the present. Boarded shops, scrawled notices, deserted rooms, empty garments and even the severe lines of formal gardens tell of others' intentions. He dwells on the possible meanings of detail, another category propounded by John Szarkowski in *The Photographer's Eye*.

Benning's preoccupations with absence and presence, past and future, neglect and intention make of him an artist who asks to be considered in the same context as, say, the painter Cy Twombly. Moreover Benning is a draughtsman and painter before he is a photographer. Other European photographers have similar allegiances. Heinrich Riebesehl, the German author of *Situationen und Objekte* (1978) and *Agrarlandschaften* (1979), is more magic realist than documentarian. His sponsors quote a host of earlier painters and photographers, mainly from the 1930s, and take it for granted that he should work with reference to past art. Riebesehl situates such strong figures as farm implements and grain silos on plain grounds. Thus isolated, they assert themselves and take on the air of monuments prepared for surrealistic tableaux. Riebesehl, a pupil of the subjective photographer Otto Steinert, infiltrates magical and ritualistic elements into the otherwise self-denying documentary style of the 1970s. He hints at cryptic personal meanings and suggests that imagination is able to serve itself even with the most commonplace material.

Riebesehl, Benning, Cutting and Killip are European photographers who acknowledge and even rely on the art of the past. They establish connections, and negotiate equably with their precursors. By contrast American photographers challenge tradition. They hope for absolutely new beginnings, or develop intensified versions of existing styles, arguing that the begetters of these styles failed to recognize their potential. As a result American photography in the seventies has thrown up quite diverse imagery; certainly much more diverse than that to be found in Europe, where cultural constraints everywhere check the romantic quest for priority and originality.

128    HEINRICH RIEBESEHL 'Schillerslage (Hannover), October 1978' Illustrated in
*Heinrich Riebesehl: Agrarlandschaften* (Bremen 1979)

# Bibliography

## 1 Seeing Nature

For information on the pioneering era see H.J.P. ARNOLD *William Henry Fox Talbot* (London 1977, New York 1978) and GAIL BUCKLAND *Fox Talbot and the Invention of Photography* (London and New York 1980). The catalogue *Hippolyte Bayard, ein Erfinder der Photographie* (Museum Folkwang, Essen, 1959) is well illustrated and informative, as is ANDRÉ JAMMES *Hippolyte Bayard* (Lucerne and Frankfurt 1975). For French photography in the 1850s see JAMES BORCOMAN *Charles Nègre* (The National Gallery of Canada, Ottawa, 1976) and an exhibition catalogue, *French Primitive Photography* (Alfred Stieglitz Center of Philadelphia Museum, 1969, issued as *Aperture* Vol. 15, No. 1). Entries by EUGENIA P. JANIS in the catalogue *The Second Empire: art in France under Napoleon III* (Philadelphia Museum of Art, 1978) are also illuminating. *Photography: the first eighty years* (an exhibition catalogue published by P. & D. Colnaghi & Co. Ltd, London, 1976) and *Regards sur la photographie en France au XIX$^e$ siècle: 180 chefs d'œuvre de la Bibliothèque nationale* (Paris 1980) are both informative. See also *John Dillwyn Llewelyn, 1810–1882: the first photographer in Wales* (catalogue for a Welsh Arts Council exhibition, Cardiff, 1980).

## 2 Instantaneous Pictures

A full account of Hill and Adamson is given by COLIN FORD and ROY STRONG in *An Early Victorian Album: the Hill/Adamson Collection* (London 1974, New York 1977). For the pictures of J.M. Cameron see COLIN FORD *The Cameron Collection* (London 1975) and GRAHAM OVENDEN *A Victorian Album: Julia Margaret Cameron and her circle* (London and New York 1975). There is virtually nothing to be found on the career of H.P. Robinson, although he published prolifically in his day: e.g. his book *The Elements of Pictorial Photography* (London 1896). See also NIGEL GOSLING *Nadar* (London 1976, New York 1977). EDWARD W. EARLE ed. *Points of View: the stereograph in America: a cultural history* (New York 1979) gives many details of the history of stereoscopic photography.

## 3 Documentary Meanings

HELMUT and ALISON GERNSHEIM's *Roger Fenton, Photographer of the Crimean War: his photographs and his letters from the Crimea* (London 1954) is invaluable and entertaining; it was republished by the Arno Press (New York 1973). His landscape and other work is considered by JOHN HANNAVY in *Roger Fenton of Crimble Hall* (London 1975). GEORGE N. BARNARD's *Photographic Views of Sherman's Campaign*, originally published in 1866, was republished by Dover (New York 1977) with a preface by BEAUMONT NEWHALL. *Gardner's Photographic Sketchbook of the War* by ALEXANDER GARDNER (1866) was republished by Dover as *Photographic Sketchbook of the Civil War* (New York 1959). For American topography see *Era of Exploration: the rise of landscape photography in the American West, 1860–1885* (an exhibition catalogue for the Albright-Knox Art Gallery, Buffalo, 1975). This can be supplemented by BEAUMONT and NANCY NEWHALL *T.H. O'Sullivan, Photographer* (George Eastman House,

Rochester, 1966) and Beaumont New-
hall and Diana E. Edkins *William H.
Jackson* (New York 1974). American
portraiture is scrupulously analysed in
Harold F. Pfister *Facing the Light:
historic American portrait daguerreotypes* (a
Smithsonian Institution exhibition cata-
logue, City of Washington, 1978) and in
R. Sobieszek *The Spirit of Fact: the
daguerreotypes of Southworth and Hawes,
1843–1862* (Rochester 1976). For an
overview of this period, and beyond, see
*The American Image: photographs from the
National Archives, 1860–1960* (New York
1979).

### 4 Small Worlds

There is no detailed account of John
Thomson's career. A wealth of infor-
mation is contained in Nancy Newhall
*P. H. Emerson* (New York 1975).
Michael Hiley *Frank Sutcliffe, Photogra-
pher of Whitby* (London 1974) is a full
account, fully illustrated. *The North
American Indians: a selection of photographs
by Edward S. Curtis*, with an introduction
by Joseph E. Brown (*Aperture*, Vol. 16,
No. 4, 1972) provides a serviceable
introduction. Curtis has not been well
served by historians, and Herbert Pont-
ing scarcely served at all.

### 5 Truths Beyond Appearance

Weston Naef's *The Collection of Alfred
Stieglitz: fifty pioneers of modern photo-
graphy* (a catalogue of photographs in the
Metropolitan Museum of Art, New
York, 1978) is as detailed as can be
desired. For British photography *c.* 1900
see Margaret E. Harker *The Linked
Ring: the secession movement in photo-
graphy in Britain, 1892–1910* (London
1979, New York 1980). *Pictorial Photo-
graphy in Britain, 1900–1920* (an exhi-
bition catalogue prepared for the Arts
Council of Great Britain by John
Taylor, London, 1978) is informative.
See also Beaumont Newhall *Frederick
H. Evans* (issued as *Aperture*, Vol. 18, No.
1, New York, 1975). Edward Steichen's
prime works are beautifully illustrated in
Dennis Longwell *Steichen: the master*

prints, *1895–1914* (for the Museum of
Modern Art, New York, 1978; London
1978). One way to make sense of data
presented by the photographic history of
this period is to consult Dolf Sternber-
ger *Panorama of the 19th Century*, with a
preface by Erich Heller (New York
1977), originally published as *Panorama
oder Ansichten vom 19. Jahrhundert* (Ham-
burg 1955).

### 6 Looking to the Future

Giuseppe Primoli's life and works are
chronicled and illustrated by Lamberto
Vitali in *Un fotografo fin de siècle* (Turin
1968). Paul Martin is considered by Roy
Flukinger, Larry Schaaf and Stan-
dish Meacham in *Paul Martin, Victorian
Photographer* (London 1977). See also
*George Hendrik Breitner: Gemalde, Zeich-
nungen, Fotografien* (Rheinisches Landes-
museum, Bonn, 1977). *Photo-Eye*, edited
by Franz Roh and Jan Tschichold,
and originally published in Stuttgart in
1929, was republished by the Arno Press
(New York 1973). Many texts from this
period are reprinted in D. Mellor ed.
*Germany: the New Photography, 1927–33*
(Arts Council of Great Britain, London,
1978). Karl Steinorth surveys the
Stuttgart *Film und Foto* exhibition of
1929 in *Photographen der 20er Jahre*
(Munich 1979). For the work of Heart-
field, Hannah Höch and their con-
temporaries, see Dawn Ades *Photo-
montage* (London and New York 1976).
See also Vittorio Vidali *et al. Tina
Modotti: fotografa e rivoluzionaria* (Milan
1979) and *Alexander Rodtschenko: Foto-
grafien 1920–38*, with an introduction by
Evelyn Weiss (Cologne 1979). For a
view of an American New Photo-
grapher see Graham Howe and G. Ray
Hawkins eds *Paul Outerbridge Jr: photo-
graphs 1921–39* (New York and London
1980). Hugo Erfurth's *œuvre* is hand-
somely presented by Bernd Lohse in
*Hugo Erfurth, 1874–1948: der Fotograf der
goldenen zwanziger Jahre* (Munich 1977).
Many texts and pictures appear in
Andreas Haus *Moholy-Nagy: Fotos und*

*Fotogramme* (Munich 1978, London and New York 1980) – the most comprehensive account of any photographer from this period. These are no more than some outstanding samples from an extremely rich literature.

## 7 European Society and American Nature

An introduction to August Sander's career is to be found in GUNTHER SANDER *August Sander: photographer extraordinary* (London 1973). See also *August Sander: photographs of an epoch*, an Aperture publication with an historical commentary by ROBERT KRAMER (New York 1980). Sander's landscapes are reproduced in WOLFGANG KEMP *August Sander: Rheinlandschaften, 1929–1946* (Munich 1975). Sander's *Antlitz der Zeit* was republished by Schirmer/Mosel (Munich 1976). A broad survey of Eugène Atget's work appears in *Voyages en Ville* (Paris 1979). Otherwise see WILLIAM HOWARD ADAMS *Atget's Gardens* (London and New York 1979) and HANS GEORG PUTTNIES's essay and notes in *Atget* (an exhibition catalogue published by the Galerie Rudolf Kicken, Cologne, 1980). A scrupulously printed survey of Stieglitz's pictures appears in DORIS BRY *Alfred Stieglitz, Photographer* (Boston and London 1965). Pictures by Weston appear in brilliant detail in BEN MADDOW *Edward Weston: fifty years* (New York 1973, London 1977). *California and the West* (1940) by CHARIS WILSON and EDWARD WESTON was republished by Aperture (New York 1978). The two-volume *Paul Strand: a retrospective monograph* (New York 1972, London 1976) surveys a long career fully. His *Time in New England* was republished by Aperture (New York 1980), which organization also republished (New York 1980) NANCY NEWHALL *Ansel Adams: the eloquent light*, first brought out by the Sierra Club in 1963. For an overview of Adams's career see his *Yosemite and the Range of Light* (New York and London 1979).

## 8 American Society

JACOB RIIS's *How the Other Half Lives* (1890) was republished by Dover (New York 1971). *America and Lewis Hine: photographs 1904–1940* (New York 1977) contains a fine essay by ALAN TRACHTENBERG. Dover republished (New York 1977) LEWIS W. HINE *Men at Work* (1932). For F.S.A. photography see: ROY EMERSON STRYKER and NANCY WOOD *In This Proud Land: America 1935–1943, as seen in the F.S.A. photographs* (New York 1973); F. JACK HURLEY *Portrait of a Decade: Roy Stryker and the development of documentary photography in the thirties* (Baton Rouge 1972); WILLIAM STOTT *Documentary Expression and Thirties America* (New York 1973); HANK O'NEAL *A Vision Shared: a classic portrait of America and its people, 1935–1943* (New York 1976). For particular photographers, see: F. JACK HURLEY *Russell Lee, Photographer* (Dobbs Ferry 1978); THERESE T. HEYMAN *Celebrating a Collection: the work of Dorothea Lange* (The Oakland Museum, 1978); JOHN SZARKOWSKI *Walker Evans* (New York 1971, London 1979); WALKER EVANS *First and Last* (New York and London 1978); ARTHUR ROTHSTEIN *The Depression Years* (New York 1978). *You Have Seen Their Faces* (1937) by ERSKINE CALDWELL and MARGARET BOURKE-WHITE was republished by Arno Press (New York 1975). See also *The Photographs of Margaret Bourke-White*, edited by SEAN CALLAHAN (New York 1972).

## 9 The Human Condition

There is no principal history of 'human interest' photography, but TIM GIDAL gives an invaluable introduction, history and memoir in *Modern Photojournalism: origin and evolution, 1910–1933* (New York 1973). For individual photographers, see: *André Kertész: sixty years of photography, 1912–1972* (New York and London 1972) and ANDRÉ KERTÉSZ *Distortions* (New York 1976, London 1977); *Willy Ronis: photographies* (Paris 1980); *Henri Cartier-Bresson, Photographer* (New York 1979, London 1980);

BRASSAÏ *The Secret Paris of the Thirties* (London 1976, New York 1977); *Brassaï* (published for the Museum of Modern Art, New York, 1968); *David Seymour – 'Chim'* (New York 1974); *Robert Capa* (New York 1974); ROBERT DOISNEAU *Drei Sekunden Ewigkeit* (Munich 1980); *W. Eugene Smith: his photographs and notes* (New York 1969). For British photography see BILL BRANDT *Shadow of Light*, with an introduction by MARK HAWORTH-BOOTH (London 1970, New York 1977) and *Bill Brandt: a retrospective* (an exhibition catalogue published for the Royal Photographic Society with an introduction by DAVID MELLOR, Bath, 1981). See also JAMES DANZIGER *Sir Cecil Beaton,* (London and New York 1980). Photography in this era is surveyed in *The Family of Man* (a book of the exhibition of that title, published by the Museum of Modern Art, New York, 1955). Other broad surveys appear in *The Concerned Photographer* (New York 1968) and in *Life: the first decade, 1936–1945* (New York 1979, London 1980). Some of the photographers involved are interviewed by PIERRE BORHAN in *Voyons voir* (Paris 1980).

10 **Self-asserted, Self-absented**
There are several key works in the modern era. WILLIAM KLEIN'S *New York* (Paris 1956) is the first. ROBERT FRANK'S *Les Américains* was published in Paris in 1958, and an American version the year after, since which time it has been regularly republished. *Diane Arbus* was published by Aperture in 1972 in conjunction with a major exhibition of her photographs at the Museum of Modern Art in New York. ROBERT ADAMS'S *The New West* came out in 1974, and *William Eggleston's Guide* in 1976 (Museum of Modern Art, New York). British photography in the seventies has been surveyed in *British Image* (Arts Council of Great Britain, London, first issue 1975). For an overview of German photography see *In Deutschland:Aspekte gegenwärtiger Doku-*

*mentarfotografie* (Rheinisches Landesmuseum, Bonn, 1979). For American portraiture, see RICHARD AVEDON'S *Portraits* (New York and London 1976) as well as *Avedon: photographs 1947–1977* (New York 1978, London 1979), and IRVING PENN'S *Worlds in a Small Room*. This is only the barest indication of what has been published since the mid-fifties.

In general, see: BEAUMONT NEWHALL *The History of Photography, from 1839 to the present day* (based on his catalogue for the exhibition *Photography 1839–1937*, which he organized for the Museum of Modern Art in 1938 – a detailed account updated in 1964; London 1973); HELMUT and ALISON GERNSHEIM *The History of Photography: from the camera obscura to the beginning of the modern era* (first published in 1955, and revised and enlarged since then), hugely informative, especially on technical developments (on this see also VALERIE LLOYD'S 'Notes on the photographic processes' in BRUCE BERNARD *The Sunday Times Book of Photodiscovery* (London and New York 1980)); *Photographers on Photography,* edited by NATHAN LYONS (Englewood Cliffs and London 1966), the principal critical anthology of photographers' comments on their own subject (see also PAUL HILL and THOMAS COOPER *Dialogue with Photography* (New York and London 1979)); *Bilder for Miljoner,* RUNE HASSNER'S catalogue survey of press photography (arranged for the Malmö Konsthall in 1977), an informative survey of photo-reportage; SUSAN SONTAG *On Photography* (New York 1977, London 1979), a collection of vigorous critical pieces originally prepared for the *New York Review of Books*; ROBERT DOTY ed. *Photography in America*, with an introduction by MINOR WHITE (produced for an exhibition of the same title at the Witney Museum of American Art, New York, 1974; London 1974); CLAUDE NORI *French Photography* (New York and London 1979).

# The Development of Photography
## A brief chronology

### 1820–1840

A period of photographic experimentation. At Chalon-sur-Saône, J.N. Niépce worked, after 1813, to improve the recently invented process of lithography. He hoped to develop a process in which light might replace lithographic chalk as a means of drawing. By 1827 he was using the term 'heliography' (sun drawing), with reference to the copying of engravings by photographic means. In December 1829 he undertook to work in partnership with L.J.M. Daguerre, a former scene-painter who, in 1822, had originated the Diorama (an advanced type of panoramic display). Making his panoramas, Daguerre had experimented with the camera obscura and had become absorbed in the problem of fixing an image cast by light. Niépce died in 1833, but his findings helped Daguerre capture images on silvered copper plates. Daguerre found that latent images in iodide of silver could be developed by exposure to vapours of mercury. These images could be fixed by immersing the plates in a solution of common salt in hot water. The first successful daguerreotype dates from 1837. Daguerre tried to form a company to exploit his invention; but, having failed, he offered rights over the process to the French state, which awarded him a pension in return.

In England, W.H. Fox Talbot began, in 1833, to try to fix images on light-sensitive paper. He had succeeded in this by 1835. His developer was gallic acid, and the result a paper 'negative' which was made translucent by waxing, and used to make positive prints. Fox Talbot was the originator of photographic printing. The process, from which came Talbotype or Calotype prints, was made public in 1839 (as 'Photogenic Drawing') and protected by patent in 1841. In France, Hippolyte Bayard also succeeded in making photographs on paper in 1839, but these were direct positives and, furthermore, Bayard did not promote his inventions with anything like Daguerre's flair. The term 'photography' (from the Greek *phos*, 'light', and *graphos*, 'writing') began to be used, in both English and German, in February 1839.

### 1840–1870

A wealth of technical improvements followed the announcement of photography. Petzval, a Viennese mathematician, and Voigtländer, an optician, worked, after 1840, to improve lenses; this resulted in the orthoscopic ('correct seeing') lens of 1857. Early lenses relied on flint and crown glass, which had limitations that were eventually overcome in Jena glass – invented in 1842 in France, and then developed in Germany by Schott of Jena and by Zeiss, an optician. Following experiments by Sir John Herschel in England, Niépce de Saint-Victor – a cousin of Nicéphore Niépce – experimented successfully with glass negatives coated with albumen (white of egg). This rendered details scrupulously. The plates had to be exposed while still moist, and exposure times were slow; the process was ideal for landscape, architecture and art reproduction. Albumen paper was introduced by Blanquart Evrard in 1850 and was widely used through the rest of the century: in 1894 the Dresdner Albumin

Papier Fabrik A.G., the largest manufacturer of albumen paper in Europe, used 60,000 fresh eggs a day. In 1851 Frederick Scott Archer's wet collodion process was introduced. Collodion, a sticky substance derived from guncotton dissolved in ether, was spread on glass plates, with added potassium iodide; it was extremely light-sensitive and reduced exposure times from minutes to a matter of seconds. Despite this advantage wet collodion remained a cumbersome process. In 1855 Dr Taupenot published the first effective dry-plate process, and by 1860 mass-produced dry plates were on sale in England. However, photographers preferred wet collodion well into the 1870s.

Photographers tried to gauge public interest and the range of their markets. Fox Talbot published *The Pencil of Nature* between 1844 and 1846. Maxime Du Camp, a writer and friend of Flaubert, took pictures in Egypt, 1849–50, as did Félix Teynard in 1851–52. Roger Fenton photographed in Russia in 1852 and followed the progress of the Crimean War in 1855. In 1854 August Salzmann documented ancient architecture in Jerusalem. The greatest of the many architectural projects undertaken in the fifties was that initiated in 1851 by the Commission des Monuments Historiques to record the threatened architecture of France. Surveys, especially architectural, abounded. Claude Charnay took pictures of Mexican buildings in the late fifties; Linnaeus Tripe worked in India and Burma in the same years.

Photographers organized. In 1851 the Société Héliographique was formed in Paris, and in 1853 the Photographic Society in London. Photography became a populous profession. In the early fifties *carte de visite* portraits became fashionable, and the photographic image came of age: pictures supplemented names and identity became a matter of images rather than words. Disderi exploited the *carte de visite* most fully,

using a camera which took ten photographs on a single glass plate. These miniature photographic portraits were widely collected in the sixties – by, among others, Queen Victoria. The *carte* craze lasted through the rest of the century, as did the market for stereoscopic pictures. Stereoscopic representation had interested scientists in the 1830s and before. Researches by Sir David Brewster in Edinburgh and Jules Duboscq in Paris led to the development of stereoscopic cameras and viewers in the 1850s, and by 1856 viewers were to be seen in every drawing room. In 1861 Oliver Wendell Holmes invented the hand stereoscope. Americans were the principal devotees of stereoscopic pictures – until the 1890s when stereo cards began to go out of fashion.

Printing techniques improved. In 1864 J. W. Swan introduced the carbon process, which resulted in durable prints with a very fine tonal range. Carbon printing allowed high-quality mass production for the first time, and the process was used by Adolphe Braun in Alsace to produce copies of old master drawings. In Britain rights were acquired by the Autotype Company which printed John Thomson's *Illustrations of China and Its People* in 1873–74.

### 1870–1900

In 1871 Dr R. Maddox of Southampton published details of a new photographic emulsion using gelatine and bromide of silver. This was refined through the seventies and from 1878 gelatine dry plates were on the market. They were fast and convenient, and gentle on cameras – previously rotted by wet collodion. Since the 1850s researchers had been interested in magazine cameras and in the roller-slide mechanism, which used two rollers within the frame of the camera. In 1875 Leon Warnerke, in London, developed such a camera, which took a spool of stripping film, an expensive substance manufactured from collodion and india rubber applied to

glazed paper. Celluloid, invented in 1861, was steadily improved and in 1888 John Carbutt of Philadelphia began to manufacture flexible negative films based on celluloid. George Eastman and W. H. Walker, in the United States, also experimented with flexible film and lightweight cameras. In 1888 George Eastman introduced the Kodak, which incorporated a roll-film arrangement: 100 pictures, which were developed at the Eastman factory and returned, with the reloaded camera, to the owner. From 1889 the Kodak used a nitro-cellulose film of a sort developed by the Rev. Hannibal Goodwin in 1887. Albumen paper, manufactured mainly in Germany, remained in use; it was eventually superseded, during the 1890s, by gelatine-chloride printing-out papers, which were a great deal quicker than albumen and both cheaper and more permanent. Automatic printing machines were developed to take advantage of the new rapid papers.

An appetite for detailed empirical information resulted in intensified experiments with instantaneous picture-making. Eadweard Muybridge, a British topographical photographer working in California, set out to analyse the action of a galloping horse, and succeeded in 1877–78, with the financial backing of Leland Stanford. From 1884 onwards Muybridge continued his researches at the University of Pennsylvania. Similar work was done at that time by E. J. Marey in Paris, and slightly later by Ottomar Anschütz in Breslau. The same impulse led to the development of 'animated photography', and of the Kinetoscope, the Cinematograph, the Theatrograph, and the Animatograph. In Britain W. Friese-Greene patented his process in 1889. Thomas Edison and the Lumière brothers pioneered the process in America and France respectively. Hand cameras allowed amateurs to capture movement at street level. Some of these were cumbersome: Paul Martin's 'Facile' hand camera,

developed in 1889, weighed over four pounds when loaded with twelve $3\frac{1}{4}$ in. × $4\frac{1}{4}$ in. (8·3 cm. × 10·8 cm.) plates, and looked like a small suitcase. Genuine pocket cameras evolved in the late nineties, as did daylight-loading roll film. Light meters also became necessary as fast gelatine dry plates came into use: in 1878 Leon Warnerke introduced the 'Sensitometer'. Other innovations followed as photographers attended more and more to objects in motion and to public events. Focal-plane shutters, especially good for 'fast work', became popular in the 1890s: a Goerz-Anschütz shutter permitted ninety different speeds ranging from 1/10th to 1/1200th of a second. To help capture the instant manufacturers produced twin-lens and reflex cameras, which enabled operators to watch for the right, if not for the decisive, moment. The new photographic industry was organized internationally: in 1900 the present diaphragm aperture system (f.1 to f.64 and beyond) was established at an international congress in Paris. Inventors, in the 1890s, were especially active, and dreamed of such breakthroughs as photographically-printed newspapers.

As though in opposition to the empiricism of Muybridge, Marey, Anschütz and the hand cameramen, artist photographers became increasingly interested in symbolism, and in underlying orders beyond appearance. The art movement centred on photographic societies, which were especially widespread in Britain – numbering 256 in 1900. The British middle classes were enthusiastic founders of learned societies and publishers of journals – which is one reason why so much is known about the technical history of the medium in its early years.

In 1882 Georg Meisenbach of Munich patented a halftone photo-block process which could be used with type in ordinary letterpress printing. In 1890 Max and Louis Levy, in Philadelphia, introduced the first commercial halftone

screens, using a sandwich of lacquered glass plates etched with parallel lines. Frederick Ives, another Philadelphian, worked on a system which used dots rather than lines, and many American magazine illustrations were printed by this system in the 1890s. The first halftone reproduction from a photograph appeared in the *Daily Graphic*, New York, on 4 March 1880. The first halftone print from a Meisenbach autotype block appeared in the *Illustrirte Zeitung*, Leipzig, on 13 October 1883. The monthly magazine *Paris Moderne* was first published in the autumn of 1896; it featured candid photo-essays on Parisian life. In 1898 the French sports magazine *La Vie au grand air* was founded and soon began to make use of photo-reports.

### 1900–1920

In 1907 the Lumière brothers began the commercial manufacture of 'Autochrome' plates at their Lyons factory. This was the first popular colour process, invented in 1904; it used dyed potato starch grains, coated with silver bromide emulsion, on glass plates. The autochrome image was either projected or inspected in a hand viewer. The process continued in use until the 1930s. Frederick Ives of Philadelphia had experimented with more intricate colour systems in the 1890s.

Photo-reporting became a profession. The *Daily Mirror*, founded in London in November 1903, was the first daily newspaper anywhere to be illustrated exclusively with photographs. Among its first photo-reporters were the Grant brothers and Thankful Sturdee. In addition, news agencies such as Central News Ltd were established. Herbert Baldwin worked for Central News and noted in his book on the Turco-Balkan War of 1912 that he used a half-plate Goerz camera taking 5 in. × 4 in. (12·7 cm. × 10·2 cm.) flat film (postal advantages) and, in reserve, a 3½ in. × 2½ in. (8·9 cm. × 6·4 cm.) Zeiss-Palmos. The

Goerz had been developed in the 1890s in conjunction with Anschütz, the animal movement specialist. Other press cameras were the French Gaumont 'Spido' (1900) and the Contessa 'Nettel' (manufactured in Stuttgart from 1903) – both with Zeiss lenses. Stereoscopic companies also evolved into picture agencies: Underwood and Underwood, for example, for whom Herbert Ponting photographed in Japan.

Printing processes developed. Karl Klíč, who had invented photogravure in 1879 (an expensive and delicate method of printing used by T. & R. Annan in Glasgow, by P.H. Emerson, and by subsequent art photographers), developed rotogravure in 1890; this allowed the gravure process to be used on rotary cylinder presses. In 1905 *Das Illustrirte Blatt*, in Germany, was the first weekly to be printed in rotogravure. In 1911 it was followed by the *Frankfurter Illustrierte* and in 1912 by the *Weltspiegel* in Berlin. The process made possible long-run, high-quality printing. It was fully exploited only in the 1930s.

### 1920–1933

Still photography, especially reportage, had its heyday after the Great War. In 1911 Oscar Barnack went to work on microscope production in the Leitz factory in Wetzlar. Interested in cinematography, he developed in 1913 a lightweight camera which might be used as an exposure meter prior to filming. The camera took movie film with a frame size of 24 mm. × 18 mm. ($\frac{7}{8}$ in. × $\frac{5}{8}$ in.); to permit enlargement he doubled the frame size to 24 mm. × 36 mm. ($\frac{7}{8}$ in. × $1\frac{3}{8}$ in.) and chose film strip with space for thirty-six pictures. The design was improved, Dr Berek's anastigmatic lens added, and in 1924 the Leica went into production – 180,000 were produced in the first twelve years. Meanwhile the Ernemann company in Dresden had developed the Ermanox, with its extremely fast Ernostar lens, which made indoor photography in

ordinary electric lighting a possibility. The means were at hand for a new kind of candid, spontaneous reportage, and around 1930 that came into being.

Germany was well supplied with illustrated journals. The most famous of these, the *Berliner Illustrirte Zeitung*, had been founded in 1890. In the early 1920s its editor Kurt Korff and director Kurt Szafranski began to employ such young photo-journalists as the Hungarian Martin Munkacsi. In 1921 the Communist *Arbeiter Illustrierte Zeitung* began publication in Berlin; it featured work by the photomontagist John Heartfield. The *Münchner Illustrierte Presse* was founded in 1923, and many local and sectional magazines followed. Competition stimulated invention. One star of the Berlin journal was Erich Salomon, an Ermanox user up to 1932, and specialist reporter of political conferences. A principal editor of the Munich magazine was a Hungarian, Stefan Lorant. To serve these burgeoning magazines the photo-agencies Dephot and Weltrundschau were founded in 1928. André Kertész and E. P. Hahn-Gilland were principal photographers with Simon Gutmann's Dephot. In 1929 Lucien Vogel founded the magazine *Vu* in Paris, and this became important in the early thirties. After Hitler came to power innovative photo-journalism petered out in Germany.

### 1933–1980

Refugees from German publishing went to Britain and to the United States. Korff, Szafranski, Eisenstaedt and Munkacsi were connected with *Life* magazine in America, which began publication in November 1936. In 1938 *Picture Post* was established in Britain with Stefan Lorant as its editor. He employed such photographers as Kurt Hübschmann, Felix Man and Tim Gidal. *Picture Post* was one of the most serious of all the illustrated magazines, and helped supplement a sense of national identity in years of crisis. There were many proving

grounds for new photographers in the thirties: the Spanish Civil War, wars in China and Abyssinia, riots and strikes in Europe and the United States. Between 1939 and 1945 most photographers were engaged in war work. Europeans and Americans emerged from the war anxious for news of the world at large. Photo-reports on distant places could be sold virtually before they were taken. In 1947 Robert Capa, Henri Cartier-Bresson, George Rodger and David Seymour set up Magnum Photos, an international cooperative agency for photo-journalists. Wars in Korea, Indo-China and then Vietnam, as well as revolution in China and the dismemberment of empires in the East, ensured a constant supply of vivid reportage. David Douglas Duncan reporting from Korea in *This is War!* (1951) noted in passing one of photography's internal upheavals – the growth of a high-quality Japanese camera industry, on which he and his colleagues more and more relied for their lenses.

In the United States photography's status grew yearly. In 1937 Edward Weston was the first photographer to receive a Guggenheim award. Photographers were regularly honoured thereafter. New York's Museum of Modern Art, which had already exhibited photographs by Walker Evans, Paul Strand and Henri Cartier-Bresson, appointed Edward Steichen as the director of its photography department in 1947. In 1952 Minor White became editor and production manager of the newly founded photographic quarterly *Aperture*, which was to be instrumental in finding a wide audience for serious photography. In the seventies, photographers increasingly found relief from the new seriousness in notational, diaristic modes permitted by the new rapid-action direct-positive Polaroid process. This process, initially using silver halide negative material to produce a positive in one stage, had been pioneered in Europe in 1939, and was originally used

in document copying. After further research in the U.S., a camera using the Polaroid process was developed by Edwin Land in 1947. By 1963 the process had been improved sufficiently to permit the taking of positive colour pictures.

The first practical colour film for amateurs and professionals came on to the market in 1935, although it was only after 1945 that this became widely available. Bulky studio-type colour cameras became obsolete. Printers began to experiment with new methods of colour printing. Commercial production of coated paper began in the 1930s, and heat-drying printing inks were developed for letterpress printing. Many improvements from the 1940s onwards, culminating in the recent introduction of laser scanners and computers, made possible printing of an unprecedented accuracy, and this in turn encouraged a new interest in colour among art photographers. The developments in commercial printing since the 1940s brought the work of photographers within reach of a large new audience, and finally helped establish it as a serious medium for art.

# Picture acknowledgments

We would like to thank the photographers who have kindly allowed us to reproduce their work in this book and we are also grateful to the following for supplying photographs:

Agfa Gevaert, Leverkusen 65, Diane Arbus, © The Estate of Diane Arbus 1969 118; Association des Amis de Jacques Henri Lartigue, Paris VIII; Fondazione Primoli, Rome 57; Robert Herschowitz Ltd, London 3; Lacock Abbey 11; William Larson 70; Library of Congress, Washington, D.C. 1, 28, 29, 33, 34, 84, 85, 86, 87, 88, 89, 90, 92, 93, 94, 95, 96, 97; *Life* Magazine, Courtesy Roger B. White 91; Lunn Gallery, Washington, D.C. V; Magnum (New York) 102, 103, 104, 116, 117; Magnum (London) 108; Metropolitan Museum of Art, New York 24 (David McAlpin Fund 1947), 45, 46, 48 (gift of Alfred Stieglitz 1933), 49, 51 (the Alfred Stieglitz Collection 1949); Richard Morris 17; National Archives, Washington, D.C. 31; National Portrait Gallery, London (© Syndication International) 110; Philadelphia Museum of Art 15, 22 (purchased with funds from the American Museum of Photography), 54, 55 (purchased with funds given by Dorothy Norman), 56 (given by Mr and Mrs Carl Zigrosser), 62, 76, 77, 79 (the Alfred Steiglitz Collection); Popperfoto 44; Rapho 98; Rijksuniversiteit te Leiden 71; Rheinisches Landesmuseum, Bonn 59; Royal Anthropological Institute 25; Royal Photographic Society 23, 47, 50, 52, 53, 60; Sotheby's Belgravia (Cecil Beaton Archive) 109; Schirmer/Mosel Verlag 72, 73; Annamarie Schuh 107; Science Museum, London 9; Mrs Edwin Smith 112; Society for the Preservation of New England Antiquities, Boston 32; Société Française de Photographic, Paris 2, 12, 13, 14; The Paul Strand Foundation, New York, 82 (© 1950, 1971, 1976, 1978, as published in Paul Strand, *Time in New England*, Aperture, 1980), 83 (as published in Paul Strand, *A Retrospective Monograph, The Years 1915–1968*, 2 vols, Aperture, 1971); Jo Tartt II; Victoria and Albert Museum, London 8, 16, 20, 21, 26, 27, 37, 39, 58, 74, 75; Welsh Arts Council 18; Edward Weston 80 (© 1981, Center for Creative Photography, University of Arizona, used by permission).

# Index

*Italic figures refer to illustration numbers*